ATTENTION
IS DISCOVERY

ATTENTION IS DISCOVERY

The Life and Legacy of Astronomer Henrietta Leavitt

Anna Von Mertens

The MIT Press
Cambridge, Massachusetts
London, England

The MIT Press would like to thank the anonymous peer reviewers who provided comments on drafts of this book. The generous work of academic experts is essential for establishing the authority and quality of our publications. We acknowledge with gratitude the contributions of these otherwise uncredited readers.

Jennifer L. Roberts created photographs specifically for this project that are a manifestation of close looking. Her photographs appear throughout *Attention Is Discovery* and use as source material archives related to Henrietta Leavitt and artworks by Anna Von Mertens.

This book was set using a single typeface: Belarius, designed by José Scaglione and Veronika Burian of Type Together (Prague, Czech Republic). Belarius is a three-axis variable font family that can be modified in its serifs (sans to poster slab), width (narrow to wide), and weight (light to extrabold).

Design: John Kramer.

Printed and bound in the United States of America.

Library of Congress Cataloging-in-Publication Data
Names: Von Mertens, Anna, 1973- author.
Title: Attention is discovery : the life and legacy of astronomer Henrietta Leavitt / Anna Von Mertens.
Description: Cambridge, Massachusetts : The MIT Press, [2024] | Includes bibliographical references.
Identifiers: LCCN 2024017327 | ISBN 9780262049382 (hardcover)
Subjects: LCSH: Leavitt, Henrietta Swan, 1868-1921. | Harvard College Observatory—Employees—Biography. | Astronomers—United States—Biography. | Women astronomers—United States—Biography. | Cepheids. | Astrometry—History. | Astronomical photometry—History. | Astronomy—United States—History—20th century.
Classification: LCC QB36.L43 V66 2024 | DDC 520.92 [B]—dc23/eng/20240521
LC record available at https://lccn.loc.gov/2024017327

10 9 8 7 6 5 4 3 2 1

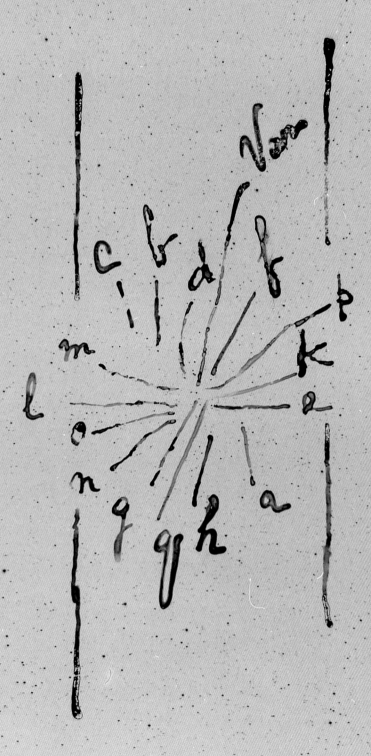

Photograph by Jennifer L. Roberts of a lettered sequence by Henrietta Leavitt on negative glass plate B12574.

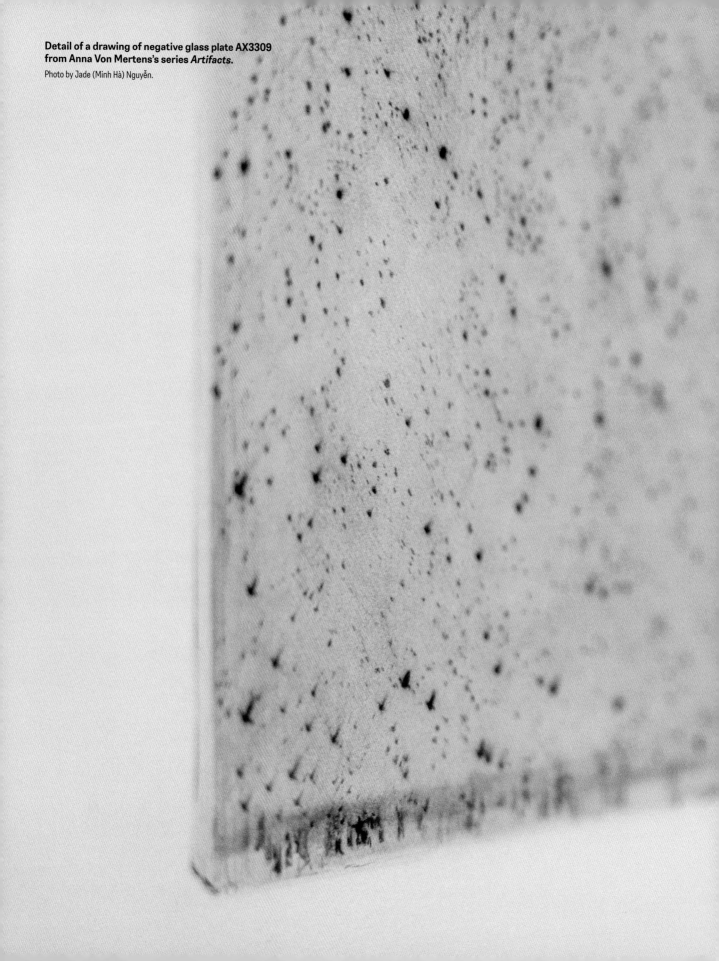

THIS BOOK IS DEDICATED to my dad, Carl Von Mertens (1940–2022), who often cried when he encountered something beautiful. He found the world beautiful, the facts of science beautiful. It struck him, the ways of things—elements, particles, fields, distances. Light's long expeditions. The striking ways humans form understandings of these things, too. Together we loved to consider scientific facts. Henrietta Leavitt's life was one of those extraordinary, astonishing facts.

Attention
Is Discovery
Anna Von Mertens

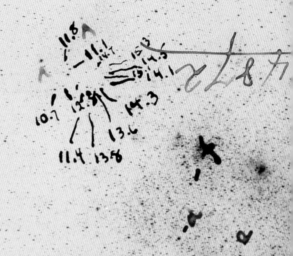

Leavitt's

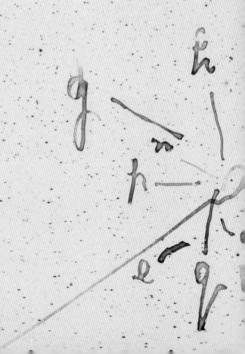

Observable World

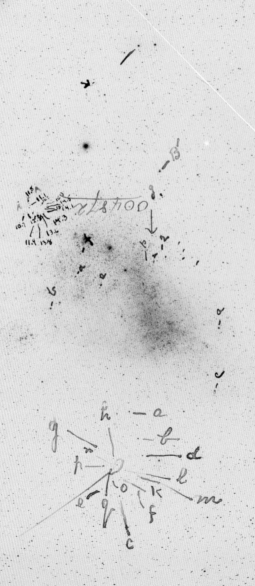

Negative glass plate B20650 of the Small Magellanic Cloud, 8 × 10 inches. Exposure of 240 minutes made with the 8-inch Bache telescope on October 20, 1897, Harvard Boyden Station, Arequipa, Peru.

Astronomical Photographic Glass Plate Collection, Harvard College Observatory.

HENRIETTA LEAVITT worked at the Harvard College Observatory from the turn of the twentieth century until her death in 1921. She sat at her desk studying photographs of the night sky—thousands of glass plates that had been coated with a light-sensitive emulsion and exposed to starlight through a telescope's lens. Most were photographic negatives: each star registered as a speck of emulsion; each plate was a suspension of myriad black dots. Leavitt discovered the period-luminosity relation, which provided astronomers the first means to measure the distance to faraway stars. Before her discovery our imagined universe was flat. There was no sense of depth to the stars, no ability to know where we were in space. Leavitt changed all of this. From a two-dimensional surface, Leavitt revealed an unimaginably vast three-dimensional universe and defined our place in it.

Her method was star by star. Leavitt calculated the position of each star in the sky and estimated its brightness, inking notations directly on the glass plates and penciling her determinations into logbooks. Sometimes she sketched groups of stars for clarification. Most of the stars Leavitt surveyed were exceedingly faint, near the limit of discernibility, and each individual star was camouflaged among the rest. The act of recording her observations must have disoriented Leavitt: after each look away, the path back to a specific star would need to be reestablished. Yet Leavitt was able to situate herself by recognizing patterns and creating a framework of familiarity. One measure of a star at a time, Leavitt's repeated small actions built an expansive understanding.

Cepheid variable stars were Leavitt's beacons. These are stars that brighten suddenly and then dim slowly in a regular, repeating fashion over the course of days, weeks, or months. The black dots representing these variable stars shifted in size, ever so subtly, from plate to plate. To find evidence of these wavering stars, Leavitt would superpose a positive plate (which could be created from a negative, inverting its black stars into white blazes) over a negative plate taken of the same region of sky on a different evening. Due to the exigencies of telescope optics, only a section of the two plates might properly align, but in that limited overlap the black stars of emulsion on the negative would fill in the white circles of stars on the positive. A variable star might emerge in a miniature white halo or inversely as a muted black ring. Once Leavitt suspected a possible variable, she could gather photographs of that region to track changes in that star's brightness over time.

Toward the end of the nineteenth century, fewer than two hundred variable stars were known. They were all lumped into a single category but loosely sorted based on their patterns of variability—some flared into view only to disappear; some oscillated over the course of a month; others seemed to have a near-constant fluctuation of light. Astronomers could only speculate about the reasons for their changeability. It was not yet known what fueled a star's light, much less what

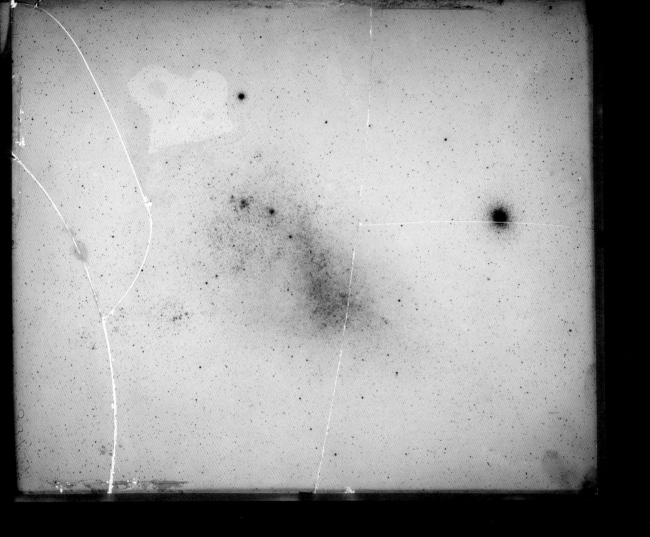

Negative glass plate A3393 of the Small Magellanic Cloud, 17 × 14 inches. Exposure of 300 minutes made with the 24-inch Bruce telescope on November 10, 1898, Harvard Boyden Station, Arequipa, Peru. A note on the plate's jacket states that it was "found broken in stack when moving plates March 21, 1932."

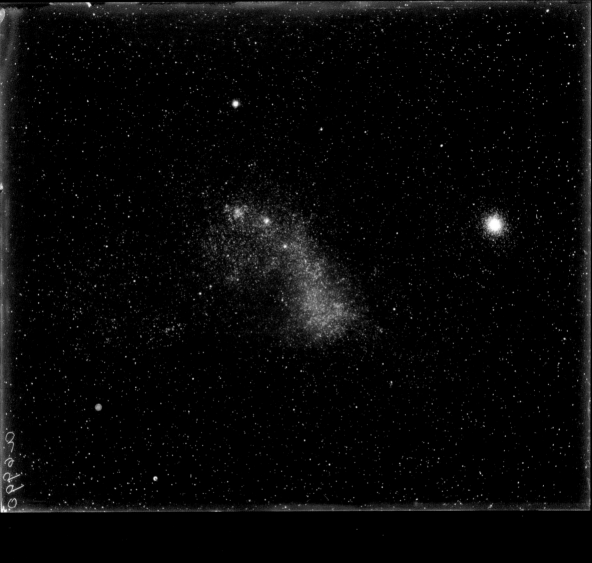

Positive glass plate D11362, 17 × 14 inches. Made on April 26, 1905, from negative glass plate A6990. Leavitt wrote of plate A6990 in one of her logbooks (volume 12, page dated March 14, 1905): "Many stars which on A6990 are too faint to measure give fairly good images. The background in places suggests the presence of stars below the limit of visibility, or perhaps of nebulous or meteoric matter. The images on this plate are uncommonly clear and sharp."

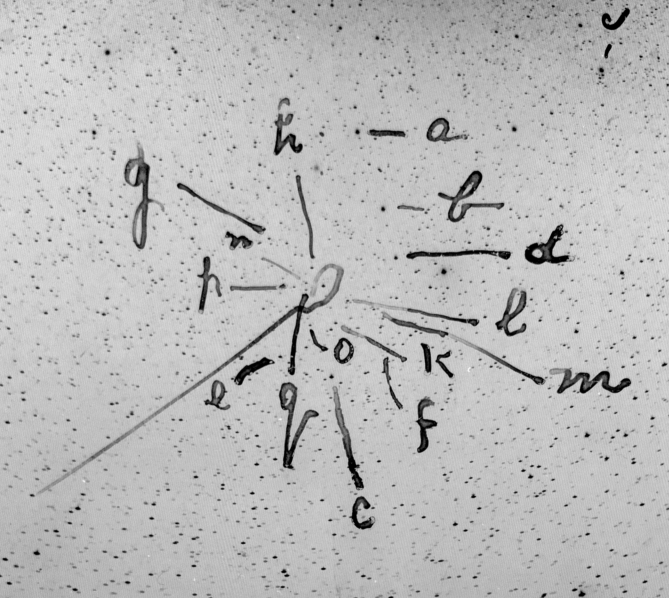

Photograph by Jennifer L. Roberts of a lettered sequence matching Henrietta Leavitt's research methods on negative glass plate B20650. The human eye can discern only small shifts in scale. Too big a leap and the eye registers the difference only in general terms—as bigger or smaller, but not by a precise amount. When following a variable star's changing luminosity, Leavitt might letter a sequence of nearby reference stars, choosing stars separated by equal steps of magnitude. (Keep in mind these steps are not linear; the magnitude scale was long ago established on a logarithmic scale, so each successive integer represents a star that is two and a half times dimmer than the number before.) Looking through a loupe, Leavitt would cast her eye back and forth between a variable and each star in her lettered sequence until she found one that matched its size. Repeating this method across plates, Leavitt could chart a variable's continuous ascent and descent along the magnitude scale, revealing its light curve.

might cause that light to change. Variable stars were a new area of study and a particular area of focus under the leadership of Edward Pickering, the director of the Harvard College Observatory from 1877 until his death in 1919. In her early years at the observatory, Leavitt quickly established herself as the leading expert in identifying variable stars. She went on to discover some 2,400, more than half of all known variables at that time.

After the astounding success of her initial searches locating variables in the Orion Nebula and other similarly nebulous regions, where stars crowded on the glass plates among clouds of light and shadow, Leavitt turned to the Small and Large Magellanic Clouds (two apparitions in the Southern Hemisphere's night sky with an extreme density of stars, not yet known to be satellite galaxies separate from our own) to seek new variables. Longer exposures that resolved these fuzzy regions into profusions of faint stars had become available after Harvard established an observatory in 1891 in Arequipa, Peru, to observe the stars obscured from view in the Northern Hemisphere, and placed there the most powerful telescope in the world at the time. With these plates of the Magellanic Clouds came an inundation of stars. The images were seventeen by fourteen inches in size, larger than the standard eight-by-ten-inch images made by Harvard's other telescopes. Each crate of glass plates made a complicated and perilous 5,000-mile journey: first sent by mule from the observatory to the town of Arequipa, next by train to the port city of Mollendo, the plates were then loaded onto a steamer by a barge, transferred onto a train to cross the Isthmus of Panama, transferred back to a steamer headed for Boston Harbor, and finally delivered to Leavitt's desk in Cambridge, Massachusetts.

Leavitt chased hundreds upon hundreds of variable stars across photographs, often skipping among years (the dates of her comparison plates sometimes leap from 1898 to 1904 or from 1899 to 1896), all while having to correct for a litany of inconsistencies inherent in early astrophotography including plate defects, emulsions with different reaction speeds, incongruous results between images at the center of a plate and its edges, viewing conditions influencing each photograph, assorted exposure times, and telescopes that produced divergent results. Simply the skill of the photographer could affect the outcome: it was known that in two otherwise identical ninety-minute exposures a shift in focus could make the bright stars half a magnitude brighter and the faint stars half a magnitude fainter; they headed in opposite directions. Just because a variable star registered as slightly larger on one of Leavitt's glass plates did not guarantee it had shone brighter on that night.

Leavitt offered this detail, indicative of the nuances and challenges of her task, when summarizing her working methods in a published paper: if she didn't find a previously confirmed variable on a certain plate as she followed the dipping

trajectory of its light curve—when that star's dimming had temporarily pulled it beyond the range of a telescope's sensitivity—she would account for its absence by providing the estimated magnitude of the faintest comparison star that *had* registered. Some of Leavitt's variables had slipped away, teetering at the edge of detection. All of these stars might well have felt out of reach. They were hinted at by the photographic process, but often inscrutably. The word *measurable* frequently appears in her logbooks, as in *able* to be measured. In an entry dated March 14, 1905, Leavitt uses the word four times, including qualifiers: "less readily measurable," "not measurable," "distinctly less measurable," and "easily measurable." Distant stars might appear on her plates, drawn there by the large apertures of Harvard's powerful telescopes and aided by extended exposure times. But however brightly they burned in the heavens, in Leavitt's world these stars were just emerging.

Leavitt announced her discoveries of variable stars from her study of the Small and Large Magellanic Clouds in the 1908 *Annals of the Astronomical Observatory of Harvard College*, the publication used to announce and share the observatory's principal results. Published under her own name (a rarity for a woman at that time), "1777 Variables in the Magellanic Clouds" details her findings. What a surprising, distinct number 1777 is, with all those sevens piling up against that solitary one. An absurd number, in this case, nearing the miraculous. Even so, that number could be taken for granted, its extraordinariness missed; a star that brightens and dims and then brightens again seems straightforward enough. But the pages of Leavitt's logbooks reveal how involved these determinations were. Amid the rows of plate numbers, estimated magnitudes, and lettered sequences of comparison stars are descriptive words in Leavitt's leaning cursive: *apparently, probably real, doubtful, difficult, certainly, well seen.* Leavitt was constantly discerning against illusion what was actual and intrinsic. This intense study imbues her logbooks with a kind of privacy. But another word shows up on these pages again and again: *Announce*, indicating the decisive moment when Leavitt established a star as a variable. Here was subjective determination paired with objective fact.

Sometimes variables hovered in between. One of her descriptions reads, "Variation small, though probably real. Do not announce." For another, "The variation of this star is slight, if it exists. Not to be announced." On a subsequent page a variable tips the scales the other way: "Variation slight, but certainly real." For a seemingly stubborn variable, Leavitt simply wrote, "Difficult. Do not announce." The intimate act of deciphering was in continuous conversation with the public act of declaring, and Leavitt erred on the side of certainty. Under her calculations for a variable star that she numbers 794, she wrote, "Found while observing no. 793," then continued, "Both no. 793 and 794 seem to be truly variable. Faint. Do not

The Small Magellanic Cloud

Var	Bright	Faint
x ~~651~~	6990 6860	6984 6986 6988 6980² 6981 6982 6985

Probably not variable. Has a nebulous appearance, varying slightly
on different plates. Probably in a faint cluster which varies in appear-
ance according to the exposure and quality of the plates.

652	6990 [14.4] 6981 6986	6984 6985 [14.7] 6982 6980 (6988)

Variation well seen, though small

653	6990 [14.2] 6992 (6980)	6984 6988 [14.7] (6981) (6986) 6782 (6985) 6860

Variation small, but well seen

654	6984 6988 [14.2] (6980) (6985) (6860) 3326	6990 [14.8] 6981 (6986) 6982 3393 6913
655	6982 [14.4] 6985 6860 6980 6988 3393	6986 6981 3326 [14.9] (6913)

Found while examining no. 654. Has a slightly nebulous appearance
Variation of both these stars small

656	6984 6988 [14.5] 6980 6982 6985	6990 [15.0] 6981 6986 6860 [15.2]
657	6990 [14.1] 6982 6992	6984 6985 [14.6] 6986 6980 [14.9] 6981 6988

Northern and slightly following star of a very close pair.

658	6990 [13.8] 6980 [13.6]	6984 6988 [14.7] (6981) 6986 6982
659	6990 [14.5] (6980) (6986) (6982)	6984 6985 [14.9] 6981

Northern star of three

660	6990 [14.6] (6989) (6991)	6984 6982 [15.2] 6986 6980 6981 [<15.2] 6988 6992

Apparently of the cluster type. Southern of two stars

661	6984 6988 [14.4] (6982) 6985 [14.3]	(6990) [14.7] 6981 [14.8] (6980) 6986

well seen

662	6990 [14.6] (6980) 6989 (6991)	6984 6985 [15.2] 6986 6981 (6988) 6982 (6992)

Resembles no. 660

663	6990 6982 [14.3] 6913 [6n 6990, 14.1]	6984 6985 6986 6980 6981 [14.6] 6988
664	6990 [14.4] 6982 (6980) 6986 [14.2]	6984 6988 [14.7] 6981 [15.0]

The Small Magellanic Cloud

Var	Bright	Faint
X 665	6990 [14.1] (6988) (6980) 3393	6984 6982 (6981) (6986) 6985 [14.3] 3326 [14.6]

This star seems to be barely variable, but is difficult to observe.
Not to be announced.

666	6990 [14.5] 6986 6992 3326	6984 6980 [15.0] 6988 (6981) 6982 6985 3393
667	6986 [14.5] 6981 6982 3393	6988 (6985) 6990 [15.0] 3326
668	6990 [14.6] 6981 6980 3326 2183 [14.2]	6984 6985 [14.9] 6982 6988 6986 3393 6860
X 669	6990 [14.5] 6992 (6988) 6989	6984 3326 [14.9] 6982 (6985) 6980 3393 6986 6913 [15.0] 2187

Variation small, but apparently genuine. Announce?

670	6984 [6985 [14.8]]	6990 [15.0] 6982 3393 3326 [15.2] 6984 (6980) 6988 6981 6860

The following star of a pair not seen on most of the plates

671	6990 [14.6] 6982	6984 6860 6981 [15.1] 6985 [15.2] 6988 6980 6986

Striking, although faint

672	6990 [13.6] (6980) (6988) 6981	6984 6982 6986 [14.6] 6980 6985
~~673~~ 6990		6981 [14.7] 6985 6988 6980 6986 6982

Probably varies slightly. Drop number. Marked susp. on chart. South f no. 591

673	6984 6985 [14.4]	6990 [14.8] 6860 [15.2] 6981 6988 6980 6986 (6982)
674	6990 [14.2] 6982 6986 (6981) 3326	6984 (6980) 6988 6981 [14.7] (6985) 3393 [14.8]
675	6984 6985 [13.6] (6986)	6990 [14.6] 6981 6988 (6980)
676	6990 [14.2?] 6988 (6989) (6991)	6984 6986 6980 [14.8] (6985) 6981 (6992)

announce." Leavitt placed a small *x* to the left of both variable 793 and variable 794, keeping them (for the moment) in the realm of her logbooks.

I liken this exchange between public and private spheres to Leavitt keeping the heavens in mind even as her research was bound by the two-dimensional surface of the glass plates. The stars in the emulsion differed from their appearance in the sky. The original optical relationship between bright stars and faint stars was disconnected on the plates, redefined as bright stars became overexposed during the longer time needed to pull faint stars into view. The color of a star affected its translation onto glass (red stars barely registered), and any evidence of starlight's assorted colors was lost in the black-and-gray display. Leavitt also needed to remember a star's position at the time of capture as she studied a rectangular patch of sky: when evaluating a star's photographic magnitude, she would apply an absorption correction according to that star's distance from the zenith to account for atmospheric dimming. Despite not being permitted, as a woman, to make nighttime observations with the telescopes; despite never traveling to the Southern Hemisphere and seeing the Magellanic Clouds firsthand, Leavitt was able to hold simultaneously an awareness of the actuality of her glass plates and the reality of the shining stars. Leavitt worked with the heavens in a collapsed and inverted format. Her private world and our shared universe were different, but she brought the two together and saw how to make them fit.

Leavitt's notations on the glass plates often sit next to writing by different hands. She was surrounded by a group of women known as the Harvard Computers—women hired to analyze the information on the glass plates, to determine and catalog the location,

Photograph by Jennifer L. Roberts of page 37 of Henrietta Leavitt's logbook *The Small Magellanic Cloud. (Also Examinations of NGC 6960, 6992). H. S. L.* (volume 12, page dated March 13, 1905).
"Too faint" is in reference to variable 784. Leavitt wrote, "This star probably varies but is too faint for good observation."

brightness, and spectral pattern for all measurable stars. Harvard was the first institution to employ women for this kind of work. Pickering acted progressively but also practically: as he began his directorship in 1877, technical advancements in photography yielded an enormous volume of images that needed processing, and women could be hired more cheaply than men, keeping labor costs within the observatory's limited budget. Men were employed to make the photographs—it was thought that the long, cold night hours weren't suitable for female dispositions—but it was women who sat and studied and made calculations. Men may have taken the photographs, but women made them meaningful.

The space they navigated was uncharted. There was no sense of whether two equally bright lights in the night sky were the same distance from Earth, or if one of those stars was intrinsically brighter but farther away. As she searched for variable stars in the Magellanic Clouds, Leavitt decided to make an important simplifying assumption: she reasoned each was a celestial entity, so the variables she found in each region could be considered approximately the same distance from Earth. Therefore any stars in the Small Magellanic Cloud that *appeared* brighter on her glass plates, for example, actually *were* brighter because their light would have traveled the same distance and been equally dimmed by that distance. The relative brightness of the stars on her plates would be consistent with their relative brightness in the sky. With this postulation, Leavitt was able to pull down the dome of the heavens to touch the two-dimensional surface of her glass plates. For the first time the relationship between these two worlds, now in contact, was direct.

As part of her 1908 paper Leavitt determined the light curves for sixteen of her found variables in the Small Magellanic Cloud, graphing how long each star took to go from dim to bright and back to dim again in relation to the intensity of its oscillating light. Their pulsation periods ranged from just under 2 days all the way up to 127 days. They belonged to a class of Cepheid-type variables, so named after the star Delta Cephei, whose fluctuating light was described by John Goodricke after months of observations in 1784 and 1785. Addressing the variables whose light curves she had established, Leavitt identified a significant characteristic: "It is worthy of notice that in Table VI the brighter variables have the longer periods." Contained within that sentence is the kernel of her discovery of the direct relationship between the length of a variable star's pulsation cycle and its intrinsic luminosity. Leavitt had just noticed something that would change our perception of the cosmos forever. Our known universe—our scope of understanding—was about to expand exponentially.

Noticing might seem to be passive, an act of stumbling across something and remarking on it. But after stating that the variables with the lengthiest periods appeared to be as consistent in their cycles as variables that repeat

their pattern in just a day or two, any notion of passivity is dispelled by the next sentence in Leavitt's paper: "This is especially striking in the case of no. 821, which has a period of 127 days, as 89 observations with 45 returns of maximum give an average deviation from the light curve of only six hundredths of a magnitude." Eighty-nine observations of a single variable (amid the finding of 1,777 of them) to confirm the minutest fluctuation of light is not passive. And the pieces of data Leavitt extracted from her observations were not like consecutive words in a sentence that could be read one after the next. Leavitt describes the pattern of a Cepheid variable's light as "diminishing slowly in brightness, remaining near minimum for the greater part of the time, and increasing very rapidly to a brief maximum," but with each observation of a variable, she never knew where she had landed on that curve or how extended that curve was through time. She had to gather random fragments with sustained attention and carry them with her as she searched through time, negotiated technology, and amid the immensity, not despair. Leavitt figured out how to place these pieces of information to construct an understanding. Noticing is a wielded skill.

Interrupted in her research by an illness that required more than a year's convalescence at her parents' home in Wisconsin, then needing to return to Wisconsin for several months after the death of her father to tend to her mother and help settle his affairs, Leavitt took four years to solidify her data and publish further evidence confirming, in her words, "the simple relation between the brightness of the variables and their periods." Leavitt's findings appeared in 1912 in the *Harvard College Observatory Circular*, the bulletin Pickering introduced ahead of the *Annals* to keep up with the abundance of information

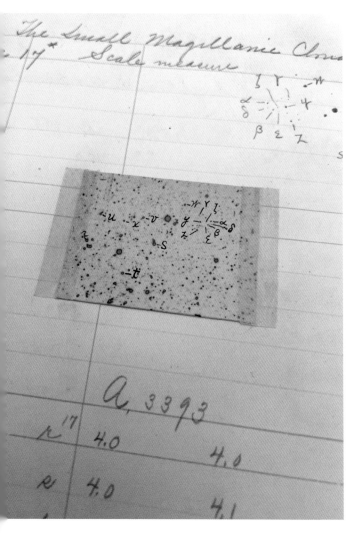

Detail of page 28 of Henrietta Leavitt's logbook *Measures of Comparison Stars. Small Magellanic Cloud. H. S. L.* (volume 19, page dated October 15, 1906). As Leavitt tracked the same sequence of stars on plates A6982, A3393, A6985, and A6990, she made a sketch of their arrangement and taped a contact print of the same grouping adjacent to it. The chiral symmetry between her drawing and the contact print indicates that Leavitt's understanding spanned even this visual flipping of the stars.

Photo by Anna Von Mertens.

and revelations produced at the observatory by Leavitt and her colleagues. Pickering issued the March 1912 *Circular* but gave proper credit in the opening line: "The following statement regarding the periods of 25 variable stars in the Small Magellanic Cloud has been prepared by Miss Leavitt." Her new research substantiated the predictable light pattern of Cepheids she had established in 1908 and demonstrated that the specific length of time a variable took to complete its pattern of dimming and brightening had a direct correlation to its observed brightness. Because Leavitt had correctly assumed that any variables she discovered in the Small Magellanic Cloud were equidistant, this correlation could be considered actual. And because this correlation was so direct (demonstrated by the smoothness of the curve when Leavitt graphed it—"surprisingly smooth, of remarkable form"), it could be considered law. Indeed, this period-luminosity relation, as it first was named, would become the Leavitt law.

Up to that moment astronomers had only the tool of parallax as a means of measurement (exploiting how nearby stars, when seen from two separate viewing positions, appear to shift against the backdrop of far-off, seemingly immobile stars). Astronomers used trigonometry to calculate the dimensions of a constructed triangle. The distance from the Earth to the Sun had been established, so if two points were specified in the Earth's orbit opposite each other (six months apart), the distance between them would be double that, determining the length of the triangle's base. Measuring the shuttling position of a nearby star from those two points produced its parallax angle: the angle at the end of a very long and very skinny triangle. With these two quantities, the height of the triangle could be calculated, and the distance to that star revealed. But the farther away an object is—an object at the end of a *very* long and *very* skinny triangle—the smaller the parallax angle becomes, making it less and less accurate to determine at greater and greater distances. Parallax only works for the stars closest to us. Its efficacy did not even begin to span the stars in our own galaxy, much less those beyond the Milky Way. In fact, there *was* no Milky Way—as a separate galaxy, as an entity—in 1912, when Leavitt published her confirmed findings; there was no sense of the structure of the sea of stars in which we swim, or if galaxies existed beyond our own.

The astronomical community immediately recognized the import of Leavitt's insight. If astronomers calculated the distance to the nearest Cepheids using parallax, they could connect the *true* brightness of a handful of variables to their physical distances from Earth. Danish astronomer Ejnar Hertzsprung first attempted these calculations in 1913. He then aligned each of his determinations of physical distance—now accompanied by an absolute brightness—with the length of that star's pulsation period, found in Leavitt's graphed relationship. Now astronomers could extrapolate. Landing anywhere on the smooth curve she had

established, they could learn the true brightness of a variable based simply on the length of its observed cycle of pulsation, an extraordinary feat. If a variable wasn't as bright as it should be, astronomers could calculate the amount of space causing that light to dim. Astronomers suddenly had a ladder to the stars.

With this knowledge in hand, cosmological discovery ballooned in the span of just over a decade. Following Hertzsprung's calibration of Leavitt's law, Harlow Shapley calculated the distance to variables that he identified in globular clusters. Based on their spatial distribution he was able to estimate the size and shape of the Milky Way—much larger than previously conceived, and our solar system near its edges. Earth had once been presumed to be the center of the universe, and then the Sun; now even our host star was positioned at the periphery. When Edwin Hubble identified a Cepheid in the Andromeda Nebula (as it was called at the time), he used Leavitt's period-luminosity relation to determine that it was so far away, it had to be outside the confines Shapley had established. Galaxies suddenly existed—we were aware of their existence—beyond our own. The debate over whether Andromeda was a spiral nebula located within our own galaxy (which was considered by many to be the extent of our entire universe) or a so-called island universe separate from our own had been put to rest. Hubble then continued to search for variables in spiral nebulae, pushing the boundary of the known three-dimensional space around us. With each Cepheid identified and its distance calculated, each nebula became a galaxy. Building on theories that our universe was expanding, in 1929 Hubble published a paper proving as much. The farther from Earth a galaxy was, the more its received light was shifted toward the red end of the spectrum, indicating greater

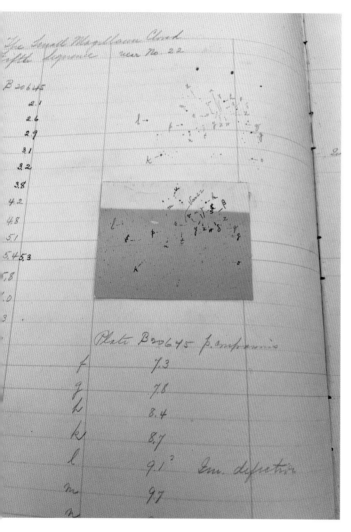

Detail of page 150 of Henrietta Leavitt's logbook *Measures of Comparison Stars. Small Magellanic Cloud. H. S. L.* (volume 14, page dated October 4, 1905).

Photo by Anna Von Mertens.

speeds at greater distances. Not to overstate it, but the universe was exploding. Leavitt's work was at the center of this fundamental reordering of human knowledge. Her attention opened the door to our three-dimensional universe; her discovery founded modern cosmology.

Yet Leavitt never saw the glass plate that would become the most famous in the history of astronomy. It was made in 1923, just two years after her death from stomach cancer at the age of fifty-three. Edwin Hubble had been tracking novae in spiral nebulae at Mount Wilson Observatory, trying to find stars flaring into sight that had not appeared on earlier plates. On the night of October 4, despite poor viewing conditions, Hubble took a forty-minute exposure of Andromeda and identified a suspected nova. Taking another exposure the following evening, the night of October 5 bleeding into the early hours of October 6, Hubble confirmed this nova along with two others, and marked each on plate H335H with the letter *N*: nova, new star. Studying the plate in his office and comparing it with existing plates in the observatory's files, Hubble noticed one of his novae shifted in magnitude. This was not the behavior of a nova, but of a variable. With successive photographs he was able to plot the star's light curve, brightening and dimming in a cycle of roughly thirty-one days. Hubble wrote in his logbook, "On this plate (H335H), three stars were found, two of which were novae, and one proved to be a variable, later identified as a Cepheid—the first to be recognized in M31." Hubble crossed out one of the three *N*s on glass plate H335H and wrote "VAR!" in red ink, including a punctuation mark rarely seen in scientific data. Henrietta Leavitt was the reason that exclamation point existed. Much of her life was poured into that one exclamation point—a lifetime of looking, a commitment to looking, hovering in red ink on glass.

The father of observational astronomy Galileo Galilei wrote in his 1632 treatise, "Such are all things true, after they are found, but the point is knowing how to find them." (Tali sono tutte le cose vere, doppo che son trovate; ma il punto sta nel saperle trovare.) Once something is known, it seems obvious. What Leavitt noticed was so shiningly true—how could it be otherwise? After complexity is distilled, its former intricacies become invisible. Leavitt's discovery was offered to the world and celebrated by that world, but the woman behind it was effaced. When Hubble wrote a letter, dated February 19, 1924, to Harlow Shapley (who by that time had become the director of the Harvard College Observatory) proclaiming his discovery of a variable star in Andromeda—knowing that singular Cepheid could define an expanse of space that proved galaxies existed beyond our own—Hubble's evidence was that its light curve "shows the Cepheid characteristics in an unmistakable fashion." Hubble recognized what Leavitt had already found.

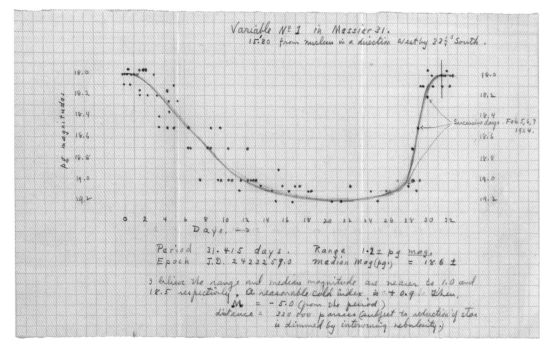

**This graphed light curve accompanied Edwin Hubble's 1924 letter to Harlow Shapley that begins,
"You will be interested to hear that I have found a Cepheid variable in the Andromeda Nebula (M31)."**
Records of Harvard College Observatory Director Harlow Shapley, UAV 630.22 (box 9, folder 3), Harvard University Archives.

The pages of Leavitt's logbooks are orderly, gorgeous in their compositions. Each page has a backdrop of four vertical red ledger lines against five pairs of horizontal ones, against which Leavitt's own geometry takes shape: columns of lettered sequences, plate numbers, and estimated magnitudes; rectangles of bracketed numbers; sometimes a cutout from a contact print to specify a small cluster; sometimes a sketch of a handful of stars. But despite these well-kept arrangements, it is nearly impossible to reassemble her process, to reenact her logic, to see how these parts made a whole. Hubble, too, tracked variables, but his path could be considered more plodding and straightforward. Leavitt skipped through time, across plates, searching in the dark. What a creative act hers seems. Attention can be a quiet activity, belying its force. Held inextricably in attention is the act of understanding. And understanding is a groundswell, a sea change, a new worldview.

I don't need to push Hubble down in order to raise Leavitt up. But the story that has been told—if it has been told at all—is that Leavitt's work was significant, but routine. The man ventured forth while the woman stayed home and tidied up. That narrative, however, could easily be flipped: Leavitt was the visionary; Hubble just followed through on the details.

We can be done with this back-and-forth and appreciate the story of science. Leavitt offered a gift and Hubble accepted it, sending Leavitt's variables far out into the universe, a missive sent forward through time, informed by the light of our past. Our shared, collective understanding.

I WANT TO INTRODUCE a second glass plate that Leavitt never saw: plate AX3309, part of the Harvard College Observatory's collection of astronomical photographs, which shows the Small and Large Magellanic Clouds and the bright star Achernar. This photographic negative was taken in 1934, a time when, thanks to Leavitt's findings, astronomers could calculate and imagine these entities three-dimensionally in space. If it had been taken in Leavitt's lifetime, this photograph would have remained two-dimensional, a field of black dots.

This implicit representation of the mental shift from two to three dimensions, from the unknown to the known, from one individual's desk to the expanse of the infinite, is what first captivated me about plate AX3309. But so did a byproduct of the technology itself: the starlight hitting the emulsion had been warped by the telescope's lens, particularly at the edges of the plate, producing pronounced artifacts. An especially wide field of view exaggerated this effect on plate AX3309 as three-dimensional space was flattened onto glass. The artifacts begin to overwhelm the readable astronomical information, foregrounding the mechanism by which these stars are captured. Looking at this plate, I was reminded of not just *what* I was seeing, but *how*, and in that is a bit of magic. The diffraction of each star's light produces the seeming attachment of wings, and the surface populates with apparent moths, dragonflies, and birds taking flight as the stars stretch away from the plate's center.

As a visual artist, I wanted not only to consider the intensity of Leavitt's attention applied to these glass surfaces, but also to experience and understand her actions through making. I decided to create drawings of these warped stars, noticing how effortlessly their specificity held my attention. Each star contained its own logic, its quiet reasons for its scale and form, its density or translucency. After drawing the photographic plate, I magnified sections of plate AX3309, echoing the way Leavitt used a handheld loupe to bring the stars of emulsion into precise view. Each enlarged section became its own drawing, with these distinct stars spreading across the entire surface of the paper, deckle edge to deckle edge. These drawings do not have a traditional focal point—I deliberately defined the area represented in each drawing with a swift framing so as not to linger over the standard weighted rules of composition—but the transmutation of shapes prompts movement, and the eye catches and follows.

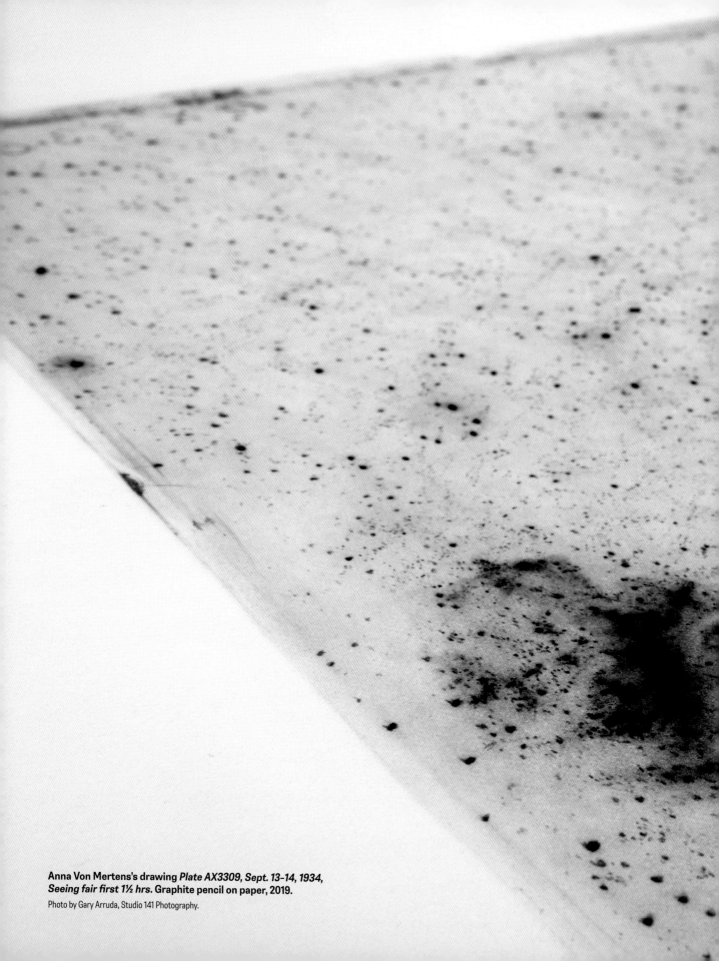

Anna Von Mertens's drawing *Plate AX3309, Sept. 13–14, 1934,*
Seeing fair first 1½ hrs. **Graphite pencil on paper, 2019.**
Photo by Gary Arruda, Studio 141 Photography.

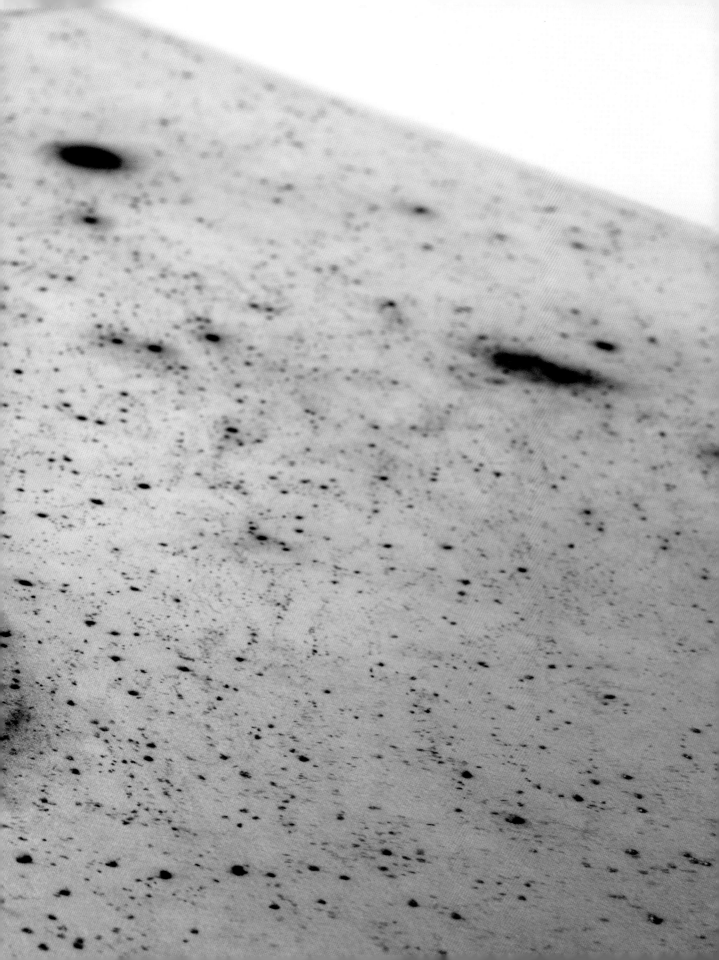

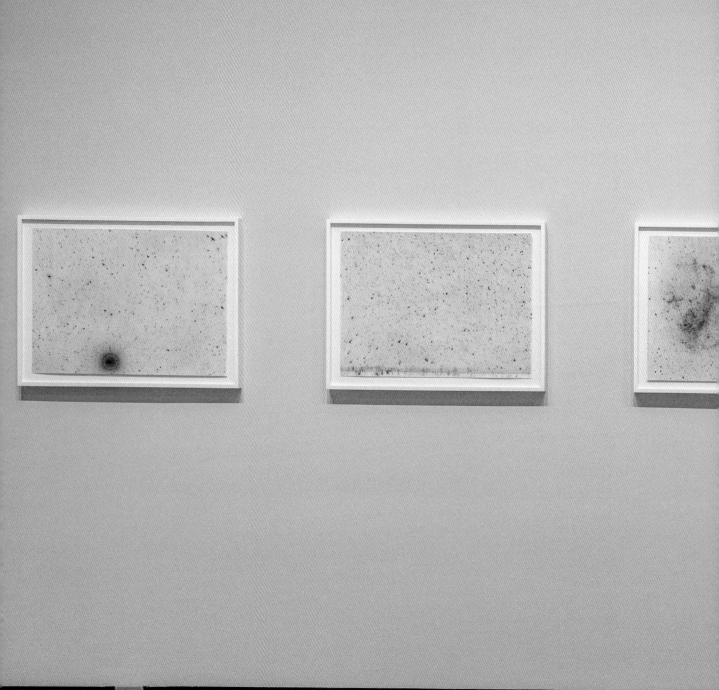

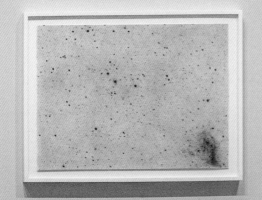
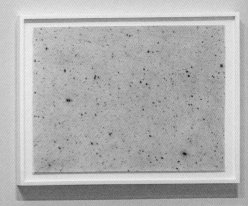

Installation view of Anna Von Mertens's drawing series *Artifacts* as part of her 2023 exhibition at University Galleries of Illinois State University.

University Galleries of Illinois State University. Photo by Jade (Minh Hà) Nguyễn.

For orientation I drew a grid, just as Leavitt sometimes worked by placing what she called a reticule over a printed positive image of a glass plate to create once more a negative, this time with a grid superimposed. I located the position and size of every star within each square of the grid, often losing track of my reference stars and needing to redetermine my way back to where I was. I shaped each star in graphite, each a unique marvel. Then more layers to darken the darks, at times burnishing the paper to a glossy shine. Where needed, I brought back transparency by lifting some of the graphite with an eraser. Uncertain if it was finished, one final pass: make it good.

The end result is resolved. There is no trace left of the grid, the determining, or the building of shapes. Yet the dynamic origins remain. There is an agitating quality to plate AX3309 in these trans-figured shapes that briefly alight. There is agitation in all of the plates Leavitt studied: those innumerable, destabilizing pinpoints of black. Or maybe it could be seen as a kind of liveliness, a recognition of how actively attention needs to be applied. The layers of my drawings may not be evident, but they are present, just as each photographic plate contains the evidence of its history: its reaction with starlight, its transportation from one port to another, its arrival at the so-called Brick Building where the Harvard Computers worked, its time spent under the gaze of a female astronomer. I place time in the artworks I make. So, too, have the plates absorbed Leavitt's looking. Held in them is her presence, presented back to me.

When I first encountered Leavitt's story, I was among the plate stacks. As the faculty director for the arts at the Harvard Radcliffe Institute, Jennifer Roberts had invited me in 2018 to create a research-based exhibition of new artworks. Because of our shared interest in astronomy, we toured the glass plate collection. We stood in the Brick Building, surrounded by tight rows of green metal cabinets housing hundreds of thousands

Anna Von Mertens's drawing (in process) of plate AX3309.
Photo by Anna Von Mertens.

of glass plate photographs, a selection of which had been pulled from their shelves, unsheathed, and displayed on light tables for our inspection. I had not been familiar with Leavitt's story and was immediately struck by its significance. From this woman's commitment to looking and discerning, we were able to construct a three-dimensional universe—yet Leavitt died before knowing the full impact of her discovery. I wondered what her lifetime had held. What can a life of subtle, repeated actions hold? This is a question familiar to me—familiar to all of us—and a question I investigated when making artworks in response to the life that she lived. One resolution to this ongoing inquiry lies in the words I wrote for the publication that accompanied my Radcliffe exhibition titled *Measure*: "A simple action—a stitch, a mark, a calculation, a measurement—and its repetition, require faith. That faith lies in the other meaning of 'measure' as a plan or course of action taken toward a particular purpose. But what our measurements will accomplish we cannot fully know. Through our small actions we move, perhaps getting a glimpse of where we are headed."

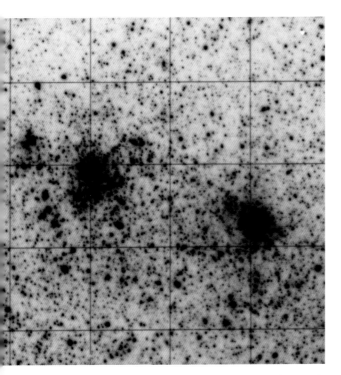

Negative glass plate D11367 (see following page for full plate).
Astronomical Photographic Glass Plate Collection, Harvard College Observatory.

As I developed my project at Radcliffe, and as I have continued to engage with these ideas over the past five years, I have discovered ample evidence that a life spent looking, a life of being interested—our ordinary lives of repeated actions—is a full life. I had thought that what Leavitt gave us was a sense of home, knowing where we are in the universe. That is certainly her legacy. In making artworks inspired by her life and work, in the sometimes silly and sincere reenactment—transformation—that is art, I found another of Leavitt's true offerings: attention is enough.

The pinnacle of scientific success might feel like a moment, like an exclamation point in red ink suspended on glass, but it is also the beautiful, intricate, considered path that leads there. This book is a celebration of that path. *Enough* is not an ending; enough reveals the next step. Attention lets us see all that is present in our observable world. Each one of us is a part of that, as is each object carrying a story, as is each path of light.

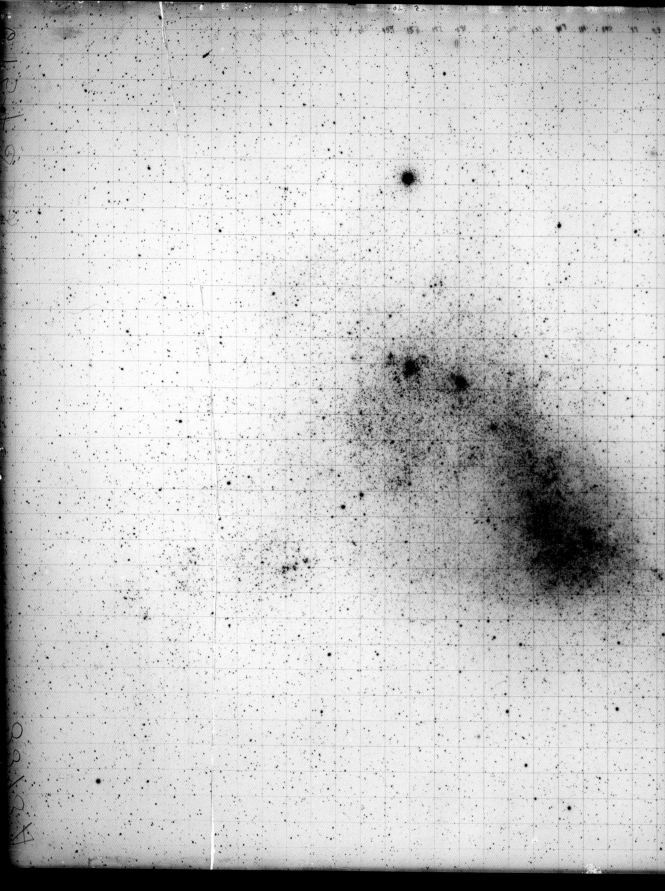

Negative glass plate D11367 of the Small Magellanic Cloud, 17 × 14 inches. Made on May 1, 1905, by stacking positive plate D11363 (made from negative plate A3393) and reseau plate D11296 to create a new plate that reverts to a negative, this time with a superimposed grid.

Astronomical Photographic Glass Plate Collection, Harvard College Observatory.

L EAVITT'S BRILLIANCE was supported by her working relationships. The warmth and respect among the women of the Harvard College Observatory was its own foundation, one that built possibility. The Harvard Computers were brought together by work that they loved, and from that connection made something meaningful. In that lineage, this book takes shape. The richness of Leavitt's legacy rests in the defining and far-reaching significance of her scientific discovery. It also lives in the residue of her findings: what we are able to see in them, and the relationships formed around that seeing. Perhaps one of the most significant things we can do in this life is find something meaningful enough to care about. Gathered here in this volume are people I met because of Henrietta Leavitt; through our shared caring for her story we became friends. Some of their names I mention now, and more individuals who are a part of this community appear in later essays. Their contributions to this project take diverse forms. Together we hope to expand the space around Henrietta Leavitt. Her legacy has been here all along.

I introduced myself to Dava Sobel after a lecture about her book *The Glass Universe: How the Ladies of the Harvard Observatory Took the Measure of the Stars*, a project that knits together a history as complex as the patterns of stars on Leavitt's plates. Dava says she remembers me bounding up to her, full of enthusiasm. (Apparently caring about something makes even a shy person determined.) I later got the chance to walk Dava through my exhibition *Measure*, and afterward the two of us had coffee. We gossiped about what felt like our mutual friends; we agreed that Pickering was a good guy, that the written record of Leavitt's colleague and fellow astronomer Annie Jump Cannon was a mess, and Henrietta we adored. My personal copy of *The Glass Universe* is aglow

with highlighted text. Sticky notes flag many pages. Having overcrowded the top of the book, I switched to the side, creating a cascade of pink. I like to open the book to a random page just to see what I will find. Every time, the handful of sentences that present themselves offer up a multistranded, interwoven passage of research. I am in awe of the work Dava has done to distill the complicated individual and shared histories of the Harvard Computers, and appreciate how that project and our discussions helped shape the historical context for this book.

Dava has given me the additional gift of introducing me to cosmologist Wendy Freedman, the person Dava credits with introducing her, many years ago, to Leavitt's work. As Dava

THIS PAGE AND FOLLOWING PAGES:
Photographs by Jennifer L. Roberts of Anna Von Mertens's drawing series *Artifacts*, a taxonomy of warped starlight.

describes in her 2021 *Sky & Telescope* article (celebrating Leavitt's legacy on the centennial of her death), Dava interviewed Wendy in the 1990s when she was heading the Hubble Space Telescope Key Project to Measure the Hubble Constant. Dava remembers, "Freedman stressed the point for my benefit: the entire research protocol for the Key Project rested on observations made by a little-known woman at the turn of the twentieth century." When I was writing about how the Leavitt law launched modern cosmology and remains central to contemporary cosmology, I got to talk with Wendy about Cepheid variables being at the heart of her research since her early days in graduate school, and how in those stars Leavitt's story has been a constant presence as well.

João Alves, professor of stellar astrophysics at the University of Vienna, was a Harvard Radcliffe Institute fellow during the run of my exhibition. Wildly synchronous things occurred, some of which João writes about in the following pages, such as the idea of stitches riding above and below the galactic plane in the process of discovering the Radcliffe Wave, a string of stellar nurseries that is the largest known coherent structure in the Milky Way. Talking about our artistic and scientific practices, João and I recognized a shared language. We have been in conversation ever since.

When novelist and screenwriter Rebecca Dinerstein Knight heard about my project, she told me she wanted to make a movie that included both Leavitt and me. Movies feel about as far from my quiet studio as it gets, but I love that Rebecca's immediate response was relational, and that she can speak to some of Leavitt's relationships here in essay form. When Rebecca emailed me her first draft, she included this note: "I don't mind at all if you feel that there is simply no place for *Sex and the City* in this book." There is indeed room for Rebecca's analogy, and I appreciate how her writing restores a sense of ambition, desire, and vivacity to the lives of the Harvard Computers.

Maria McEachern, John G. Wolbach Library's reference and resource sharing librarian at the Center for Astrophysics | Harvard & Smithsonian, is well described by Dava Sobel's compliment: "I go to Maria with every question." Her answers underpin my research for this book as well. Dava told me how Maria had recently shared a photograph with her of Harvard Computer Williamina Fleming's gravestone, taken on one of Maria's annual visits to Mount Auburn Cemetery. Now I, too, receive such photographs. Some are included in this book, a testament to her engagement with, and dedication to, the lives of these historic women.

John Kramer designed the publication *Measure*, an object that is a pleasure to hold, as well as see and read. As one of his countless wise recognitions he designed the publication to be eight by ten inches, just as he designed the volume you hold here in your hands, so that some of Leavitt's glass plates could be replicated at a one-to-one scale to give a sense of the world she navigated. I value the many editorial design decisions John made that helped shape this book.

Jennifer Roberts set all of this in motion by inviting me to Radcliffe and was there on that first day among the plate stacks. This past year we continued to conduct material research together, venturing to the Harvard University Archives to examine century-old contact prints of the Small Magellanic Cloud, to the Wolbach Library to wonder at the visual poetry of Leavitt's logbook pages, and to the Harvard College Observatory on many occasions to look at the stars suspended on glass that Leavitt studied. On these trips Jennifer attached to her phone a small macro lens, and used it, steered by her close looking and training as an art historian, to create intimate fields of view that bring forward the richness of these archival materials. Jennifer's photography is a reminder—an irresistible invitation—to pay attention, providing details of the world Leavitt inhabited, as well as evidence of her presence in it. Jennifer also turned her macro lens to my *Artifacts* drawings based on plate AX3309, cataloging the shapes made by starlight bending. I tried to stay out of her way as she created the photographs you see in this book, but occasionally I would peer over her shoulder, watching her viewfinder activate the path I took, which followed the path Leavitt took. These nonsensical shapes, made by starlight but not accurately representing the stars, bring forward what is right in front of us—everything.

I am grateful for the objects that have helped carry Leavitt's story forward, and grateful to the people who tend to her story. Here in this book are some of those objects, some of those relationships, and of course at the center—at the beginning—Henrietta Leavitt herself.

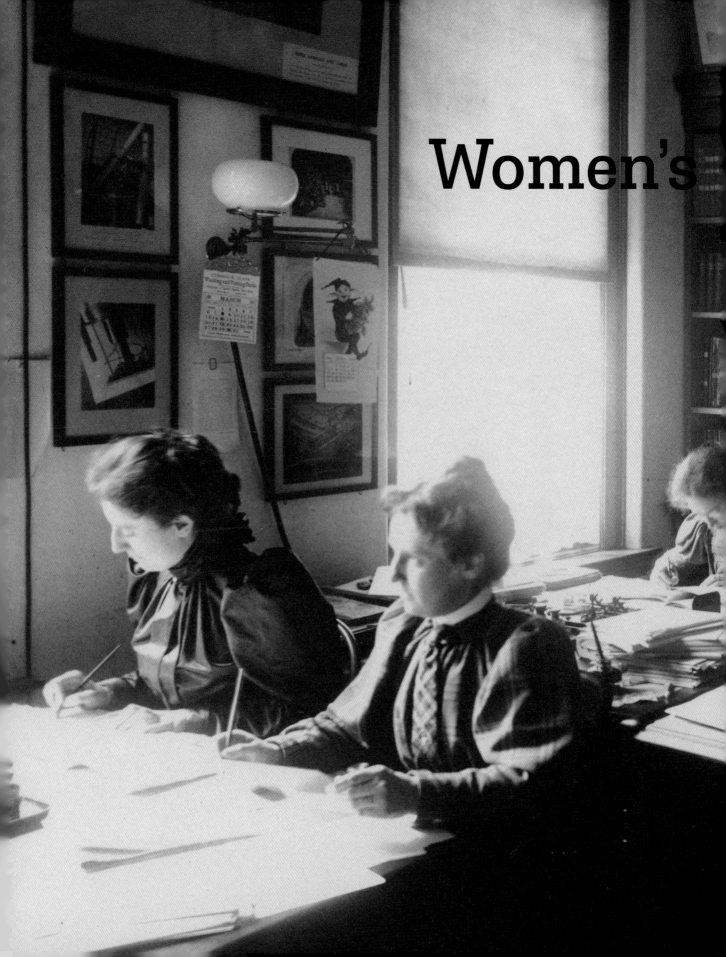

Women's

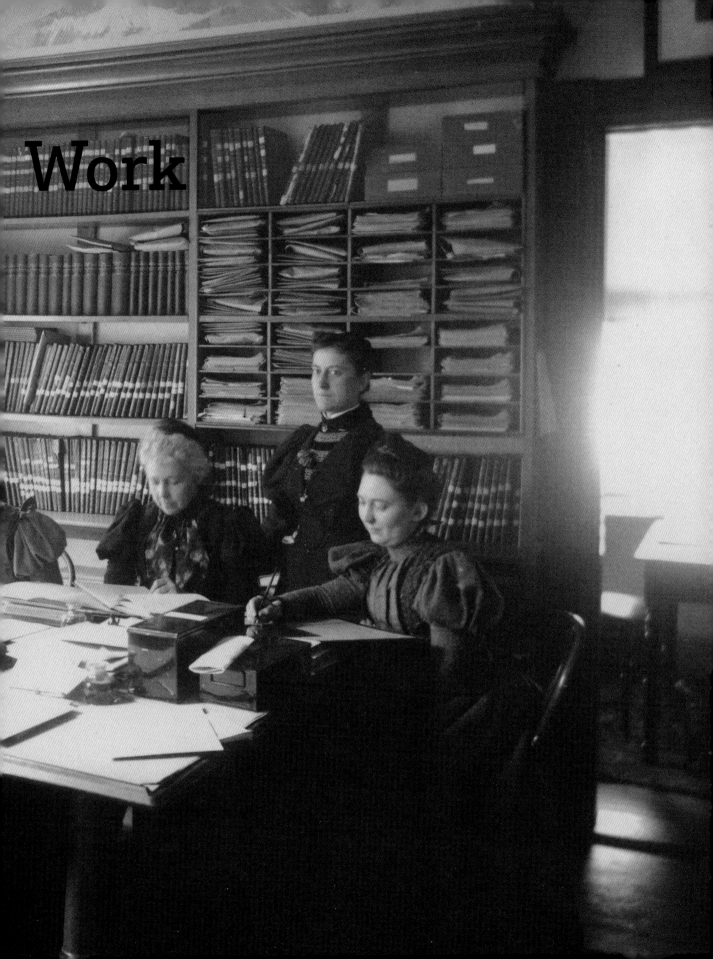

Work

L EAVITT CAME TO HER DESK to study glass plate photographs. Each one in turn rested on an inclined wooden frame so that sunlight, coming through the window in the Brick Building where she worked, could reflect off a horizontal mirror below the glass and illuminate the image above it. A plate number scrawled at the top read in reverse because Leavitt reviewed a plate emulsion side down so she could freely make notations on the glass. A gray tone had developed anywhere starlight had contacted the plate. Light sometimes leaked around the perimeter during a plate's exposure, causing darkening at the edges. When Leavitt examined each plate with a magnifying loupe, the hazy clouds of emulsion resolved into individual black flecks—inverted light—that were subtle, discrete pieces of information to decipher.

On my first visit to the plate stacks with Jennifer Roberts, we stepped into the physical space that Leavitt inhabited and came face-to-face with the glass surfaces that she so closely studied. Our engagement with these objects let us imagine Leavitt's, and the focus required for this work. Reflecting on the experience of viewing one of these plates, in the 2018 exhibition catalog *Measure* Jennifer writes:

> This pinpoint field of specks and lines was Leavitt's world. Day after day after day, she sat and worked on the surface of plates like this, picking out stars, measuring magnitudes, making records in her logbook. It's tempting to see this as a tedious technical exercise—thoroughly unimaginative, merely computational, as dry as the dry plate photographic process that made it possible. But this impression is difficult to maintain after looking at the plate itself. It is a remarkable object that harbors (and generates) all sorts of perceptual and conceptual complexities. Looking at the plate, with its stars and notes, it becomes evident that Leavitt worked every day in an unsettled space, full of mystery and uncertainty. She may have been sitting. But she was not sitting still.

Dry plate technology set Leavitt's career in motion. Collodion wet plate photography had been common during the American Civil War, but the process was laborious and time-bound: coating, sensitizing, exposing, and developing all needed to be completed within a span of fifteen minutes, necessitating a portable darkroom. The invention of silver gelatin dry plates eliminated these cumbersome requirements. They could be stored until exposure, and once exposed, stored again and developed at a later date. Silver gelatin dry plates suspend silver bromides in a gelatin binder on a glass support. Exposure to light breaks this compound, causing the release of bromine gas and the deposit of silver metal, creating a latent image. Originally, gelatin plates were about as sensitive as their collodion predecessors, but experiments in the 1870s demonstrated that prolonged heating of the emulsion substantially increased sensitivity. Further

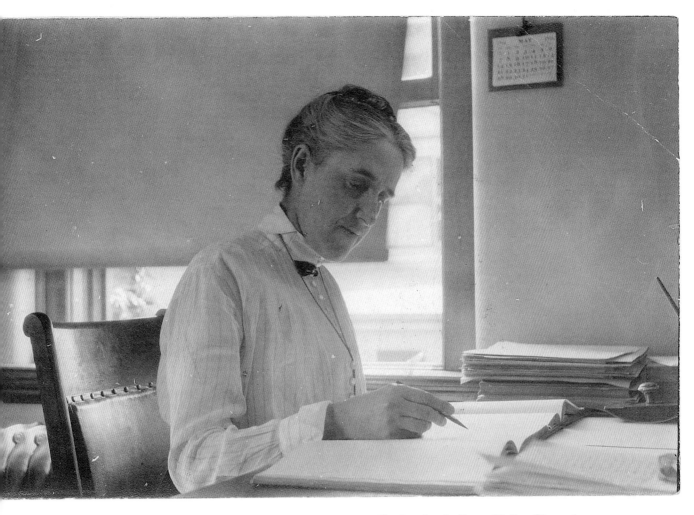

Henrietta Leavitt, Harvard College Observatory.

HUGFP 125.82 (box 2), Harvard University Archives.

PRECEDING PAGE:
Harvard Computers working in the Brick Building, Harvard College Observatory, 1898. From left to right: Sarah Bonesteele (possibly), Mabel Stevens, Edith Gill, Evelyn Leland, Williamina Fleming (standing), Ida Woods.

UAV 630.271 (E4116), olvwork432388, Harvard University Archives.

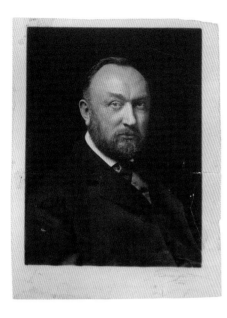

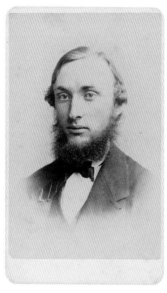

LEFT:
Edward Pickering, director of the Harvard College Observatory from 1877 to 1919.

HUP Pickering, Edward (8), Harvard University Archives.

RIGHT:
Pickering, just prior to joining the Harvard College Observatory, pictured as a young professor at the Massachusetts Institute of Technology, where he joined the school's first instructing staff.

MIT Museum.

Included in Harvard Computer Annie Jump Cannon's obituary of Pickering is the story of how, at age twelve, he made his own telescopes (first using spectacle glasses, then improving to a secondhand lens fitted with a piece of stovepipe) to spy Jupiter's "satellites." Cannon writes, "He often regretted in later life, that no one told him in those days of a simple method of estimating the brightness of the stars, so that he might have done some useful work."

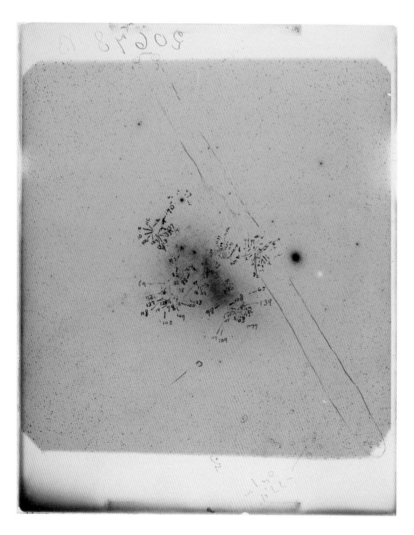

Negative glass plate B20678 of the Small Magellanic Cloud, 8 × 10 inches. Exposure of 270 minutes made with the 8-inch Bache telescope on October 28, 1897, Harvard Boyden Station, Arequipa, Peru. Leavitt likely studied this plate for her 1908 paper establishing the period-luminosity relation that would become known as the Leavitt law. Included are markings from three or four Harvard Computers and a meteor trail discovered by Edward Pickering, circled in red.

Astronomical Photographic Glass Plate Collection, Harvard College Observatory.

improvements were made throughout the decade, including broadening the spectrum of light to which the plates were receptive. With the invention of machine coating it became profitable by 1880 to commercially manufacture silver gelatin glass plate negatives. Leavitt's life from early childhood to her undergraduate years spanned this technological evolution from wet plate to dry plate photography.

Nineteenth-century astronomy in the United States was dominated by wealthy gentleman scientists and focused on the positions and motions of celestial objects. Astrophotography held new promise. Advances in dry plate technology during the 1870s enabled longer exposures, and this accumulation of starlight revealed previously invisible stars. The seven stars of the Pleiades constellation, for instance, were transformed by a three-hour exposure into a cluster of more than 1,400 stars. With this new depth of field, interest in the size and structure of the universe deepened. No longer dependent on the subjective impression of individual observations, astrophotography could make a record of this expanded space for deliberate, repeated study. The photographic plate became a site of shared knowledge.

As astronomical research in the United States shifted from a system of individual amateur astronomers to collective work done in large observatories—with a related shift from the study of planets, stars, comets, and asteroids to broad surveys of information—the first wave of big data entered the field of astronomy. Infrastructure, fundraising, and organization were needed, along with leadership willing to support these new kinds of investigation. All of this became possible with the appointment of a new director to the Harvard College Observatory.

Edward Pickering's background was in education. He taught physics at the Massachusetts Institute of Technology (MIT), where he initiated a hands-on, experimental approach to learning, making students active participants in laboratory experiments instead of passive witnesses. Harvard president Charles Eliot's unprecedented selection of this young physicist (rather than an observational astronomer) to direct the observatory was a recognition of the changing nature of astronomical research. Pickering wanted to study the physical makeup of the stars and the reasons for their differences. But he realized that to know the true nature of the stars, a broad foundation of empirical knowledge was first needed. In astronomer Solon Bailey's comprehensive history of the earlier years of the Harvard College Observatory (Bailey worked for decades at the observatory, during much of Pickering's career and the entirety of Leavitt's), he summarizes what Pickering ascertained at the beginning of his tenure when he surveyed the focus of research at other institutions: "Everywhere there was a great dearth of facts. In such a condition of the science, Pickering decided that the accumulation of great masses of data would constitute the greatest contribution he could make

Spectra glass plate B9431 (distinctive for being the first plate that Annie Jump Cannon ever took observations from) of the Carina region, 8 × 10 inches. Exposure of 140 minutes made with the 8-inch Bache telescope on May 13, 1893, Harvard Boyden Station, Arequipa, Peru.

Astronomical Photographic Glass Plate Collection, Harvard College Observatory.

to the advancement of astronomy. Theories in regard to the structure of the stellar universe could wisely be deferred until better foundations were provided."

The gathering of this informational resource began with photometry, as Pickering knew establishing standard measurements for individual stars would be the basis for all future research. Compilations of stellar magnitudes had been issued previously, but not on a consistent scale. Pickering's first initiative at the observatory was to measure the brightness of stars visible from Cambridge, Massachusetts, by comparing them against a single reference. Devising a new class of instruments, Pickering helped develop several photometers that used two lenses side by side with mirrors and prisms to bring the light of any star crossing the meridian into direct comparison with Polaris, the North Star. Pickering backed up his philosophy with action. Between 1882 and 1902 he used his 4-inch meridian photometer to make over a million photometric measurements. A *million*.

Pickering dedicated himself equally tirelessly to analyzing a star's spectrum, getting closer to the heart of his interest as a physicist. He had eagerly adopted the new technology of astrophotography, a nascent discipline when he became director in 1877, and the ability to photograph stellar spectra was part of this recent technological achievement. A prism was placed in the telescope above the sensitized plate so that during exposure a star's light would be separated into its constituent wavelengths, interrupted by the appearance of vertical lines with varying intensities, widths, and spacing. To transform this dispersed light into wider bands, the mechanical motion of the telescope was slightly offset from the apparent motion of the stars; these two differing speeds spread the lines of spectra into strips, making the patterns decipherable. Pickering and his assistants again modified existing apparatuses by moving the prism from the eyepiece to the light-gathering end of the telescope. With this innovation, hundreds of spectra—no longer just a single spectrum—occupied one photographic plate. The stars could suddenly be studied en masse.

Spectroscopy opened the door to the new field of astrophysics. The interrupting absorption lines appearing in the spectra could be compared to those emitted by isolated elements heated in the laboratory, giving clues to the physical composition of the stars. While it was not yet known what exactly these stellar fingerprints signified, Pickering was confident that the categorization of their patterns would help reveal their meaning.

Despite the potential of dry plate photography to record stellar magnitude and spectra, it took some convincing to make the switch. Williamina Fleming—one of Pickering's first female hires, who was instrumental in classifying the spectra found on Harvard's glass plates—was invited to prepare remarks for the first meeting of the Congress of Astronomy and Astro-Physics

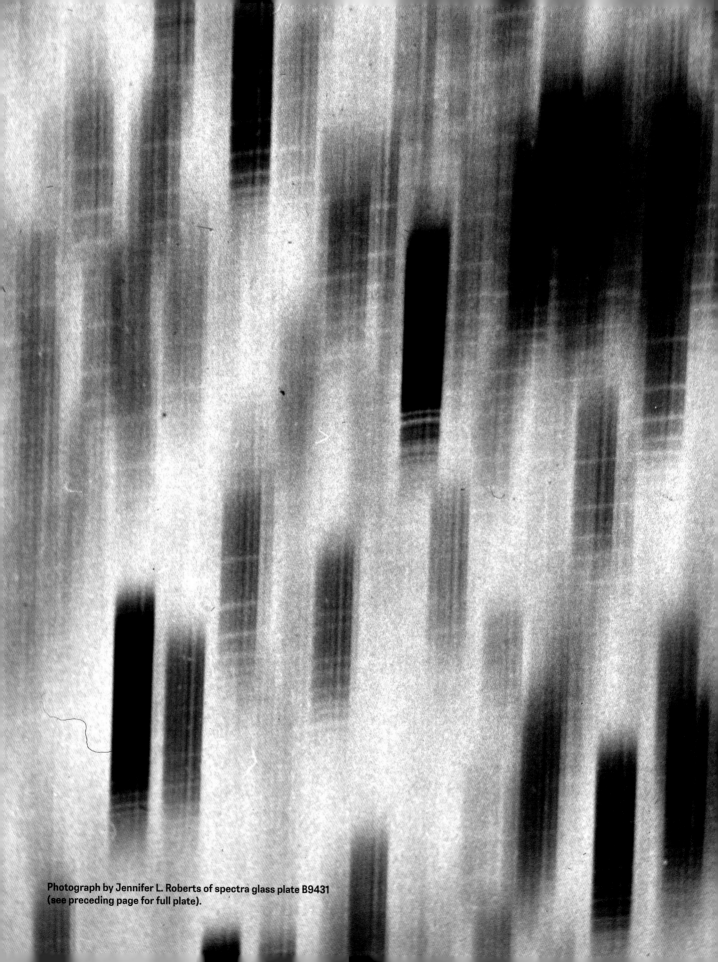

Photograph by Jennifer L. Roberts of spectra glass plate B9431
(see preceding page for full plate).

(an organization whose name reflected the shifting nature of the field as well as the effort to ascribe professional status to its members), which coincided with the 1893 Chicago World's Fair. In her written speech, titled "A Field for Woman's Work in Astronomy," Fleming countered distrust of this new technology and advocated for astrophotography as an investigative tool. "And thus while the old time astronomer clings tenaciously to his telescope for visual observations, astronomical photography is leaving him far behind and almost out of the field in many investigations." Fleming provided an example of the revolution that astrophotography promised: "Zeta Ursae Majoris is a close binary star, the two components revolving around each other at a velocity of about a hundred miles a second, in a period of about fifty-two days. This discovery was made by Professor Edward C. Pickering, his attention being first attracted to it by the fact that in the photographs of the spectrum of this star, the lines appear sometimes double and at other times single." This was a new way to understand the stars, actualized by the insights of the observatory's female staff. As Pickering himself described, it was Harvard Computer Antonia Maury's "careful study" of seventy nights' worth of photographs that led to the published announcement of the star's status as a spectroscopic binary.

Cecilia Payne-Gaposchkin, known for the stunning conclusion of her 1925 doctoral thesis that stars are composed primarily of hydrogen and helium, which earned her the first doctorate in astronomy ever issued by Harvard University, arrived at the Harvard College Observatory in 1923, several years after Pickering's tenure ended. In her autobiography, Payne-Gaposchkin asserts that Pickering was at the center of a "new science" and acknowledges the lasting impact of "the great repository of data that was Edward C. Pickering's legacy." She wrote: "He saw the importance of observations, and set himself to supply those that were crucial to the astronomy of his day. Facts may seem like dry bones to the soaring imagination of the theorist. They are bones indeed, for they constitute the skeletal framework of the science, without which she could neither stand, nor walk, nor take the great leaps that have marked her progress in the last half century."

Pickering's own words, written just a year before his death, speak just as strongly to his original commitment. When publishing an updated version of the observatory's catalog of stellar spectra in the 1918 issue of the *Annals of the Astronomical Observatory of Harvard College*, Pickering wrote:

> In the development of any department of Astronomy, the first step is to accumulate the facts on which its progress will depend. This has been the special field of the Harvard Observatory. An attempt is made to plan each investigation on such a scale that it will not be necessary to repeat it shortly, for a larger number of stars. Speculations unsupported by fact have little value, and it is seldom necessary in such investigations as are carried on here, to form a theory

in order to learn what facts are needed. An observer is likely to be prejudiced if he has already formed a theory to which he thinks the facts should conform. The present work is a good example of collecting facts which it was known would be of value.

Why form a theory, when the facts can lead you there?

Pickering's efforts to map and catalog the night sky were ever expanding, culminating in the establishment of an observatory in Peru. The Harvard College Observatory was now able to capture the entire sky, both north and south of the equator. Solon Bailey would lead the expedition, temporarily placing equipment on a nameless mountain that Bailey, with local approval, christened Mount Harvard, outside Chosica, Peru, until the outpost was relocated to Arequipa, almost 8,000 feet above sea level, the volcano El Misti in the background.

This accomplishment was certainly significant to science—garnering the only fixed historical record from the Southern Hemisphere—but Harvard's methods were those of extraction, similar to any other imperial undertaking. The Peruvian government aided the establishment of the Arequipa station and offered duty-free import and export of all necessary materials; local residents staffed the observatory and assisted with the production of the plates. But in advance of the 1900 World's Fair, when the Peruvian government asked if the Harvard College Observatory would cohost an exhibition at the Paris event, the Harvard astronomers declined, choosing to display their gained knowledge with the North American contingent.

The carefully crated plates made their way from Arequipa to Boston Harbor, most taking a route that transported them across the Isthmus of Panama, though some journeyed several thousand additional miles around the tip of South America in an effort to reduce breakage, which was more likely to occur during transfers. They articulated the abundance of stars permeating what Ferdinand Magellan had described centuries earlier as luminous clouds when he circumnavigated the globe. Close enough to the southern celestial pole that they never set, the clouds had been used for millennia as navigational markers by seafaring peoples, including the ancestors of the Polynesians, First Nations Australians, and the Maori of New Zealand. Harvard's photographs of the Magellanic Clouds, some with exposures longer than six hours to allow fainter stars to register, were taken with the Bruce telescope (named after Catherine Wolfe Bruce, who had financially supported the enormous effort to point this most powerful telescope at the sky). Already impressive with its 24-inch aperture, the telescope's double lens—a "doublet doublet" made of two pairs of contoured glass—allowed the Bruce telescope to leapfrog over larger-aperture telescopes, such as those operated by the University of Chicago and Lick Observatory, its double array of lenses gathering light from more distant stars. These were the plates Leavitt studied to

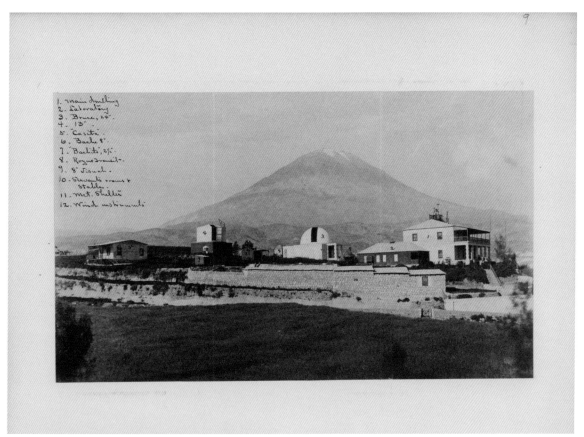

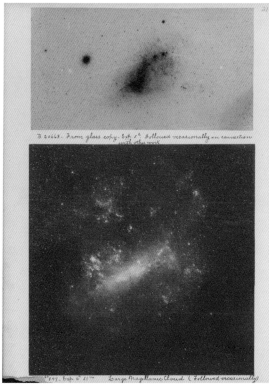

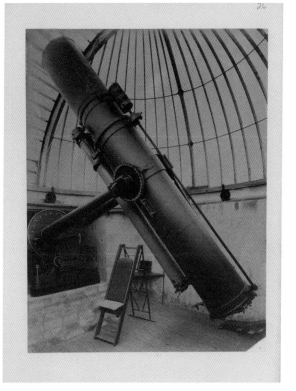

Pages from a photo album (likely assembled by Solon Bailey) about the Harvard Boyden Station in Arequipa, Peru.
Page 9 shows the observation station ca. 1897, page 26 shows the 24-inch Bruce telescope installed there, and page 21 includes contact prints of the Small and Large Magellanic Clouds created from glass plates made onsite.

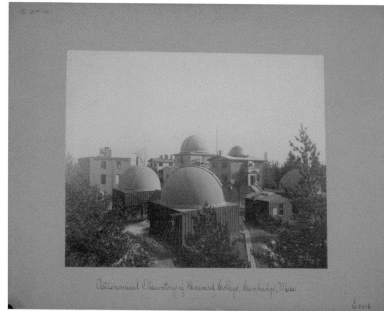

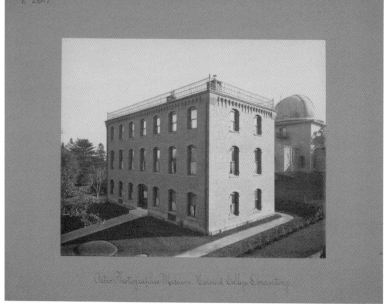

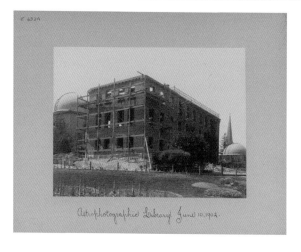

CLOCKWISE FROM TOP LEFT:

Williamina Fleming in front of the plate stacks in the Brick Building, Harvard College Observatory, ca. 1902.

UAV 630.271 (388), olvwork432040, Harvard University Archives.

The campus of the Harvard College Observatory with the Brick Building visible at left, ca. 1893.

UAV 630.271 (E2416), olvwork432380, Harvard University Archives.

The Brick Building, Harvard College Observatory, ca. 1893.

UAV 630.271 (E2547), olvwork432403. Harvard University Archives.

Construction of the Brick Building expansion, 1902.

UAV 630.271 (E6934), olvwork432424. Harvard University Archives.

Harvard College Observatory plate stacks, ca. 1891.

UAV 630.271 (E4097), olvwork432387, Harvard University Archives.

produce her groundbreaking period-luminosity relation correlating the length of a Cepheid variable star's cycle of pulsation to its intrinsic brightness. Eventually Leavitt's law would place the Magellanic Clouds at a known distance. For now, they remained indistinct lights, glowing in the southern sky.

When Leavitt's skill at discovering variable stars in these nebulous regions became apparent, sixteen new plates were commissioned from Peru in the fall of 1904 so that Leavitt could identify variables with shorter periods based on photographs taken within a narrower range of dates. On one visit to the observatory I requested several of these legendary plates be pulled from the plate stacks. Unsheathing each one from its protective envelope, I expected some sort of epiphany, some trace of Leavitt's discovery. They are, as Jennifer writes, remarkable objects, but there is nothing striking about these plates; they have no focal point. While they are no doubt miraculous—their arrest of wavelengths in silver, their transport across oceans, their fragile preservation, their scientific significance—nothing visually comes forward. Each plate is similar to the next: a cloudy apparition of an uncountable number of inverted black stars, each one so minute as to lack individuation. These plates were revelatory; they were the primary tool for building Leavitt's understanding. But they were not revelatory to me. Astonishing as objects, yes. But what is extraordinary to me about these plates is that Leavitt could understand them, that she could position herself within that space. Leavitt sat at her desk, looking. *This pinpoint field of specks and lines was Leavitt's world.*

The weighty repository of data continued to grow night after night, year after year. Pickering oversaw the construction, completed in 1893, of an all-brick building to protect this data bank from threat of fire. Not a single piece cracked when the collection of 30,000 plates—eight tons of glass—was moved into the new building. By the end of the nineteenth century, roughly 8,000 new plates were arriving on the doorstep of the Brick Building each year, adding to the existing 100,000 plates. By 1912 the collection had swelled to 200,000. Pickering knew this material wealth meant nothing unless the information on the plates was analyzed. He bemoaned the lack of initiative at other observatories to make their captured information useful for research. But the burden weighed most heavily on Harvard: with numerous telescope domes on the observatory's Cambridge hilltop and its outpost in Peru, Harvard was amassing the largest collection of astronomical glass plate photographs on Earth.

A larger workforce was needed to process the ever-increasing amount of material. As the place where the plates were both stored and examined, the Brick Building became, in Cecilia Payne-Gaposchkin's words, "a hive of industry." The women of the Harvard College Observatory were hired to "reduce" the plates: they

reduced the influx of information by translating each captured star's position to standard coordinates by applying a mathematical formula and organizing the plates according to regions of the sky. Their duties soon expanded to assessing magnitudes and classifying spectra, along with identifying new objects, such as variable stars, nebulae, and novae. These were not simple jobs. In more dramatic terms, Cecilia Payne-Gaposchkin wrote: "I need hardly emphasize the difficulties of photographic photometry. I heard it said when I came to Harvard that what really killed Miss Leavitt was Pickering's requirement that she devise a method by which the photographic magnitudes determined with all the Harvard instruments could be reduced to the same photometric system."

Despite the ambition and challenge of these endeavors, they were considered routine. Like the repeated tasks of a household—traditionally the essential yet invisible domestic labor of women—the reduction of data became defined as women's work. The job of building the empirical foundation of knowledge that Pickering wanted to offer the astronomical community would fall to the women who became known as the Harvard Computers. But just as the small, intimate actions of the home are unheralded even as they build society, astronomers—Pickering perhaps included—underestimated what an intimate understanding of the glass plates might produce. Leavitt and her colleagues were hired to make them legible, and they did. The Harvard College Observatory became a hub of international astronomical research, and answering investigative inquiries was quickly added to a computer's job description. But a specific kind of knowledge was gained by navigating this ocean of data, an exclusive understanding only accessible to the women immersed in it.

An association with embroidery, with its required precision and repetition, is especially strong in historical examples espousing women's "innate" ability for this kind of astronomical work. Maria Mitchell, who was world-renowned for her 1847 discovery of a comet and was the first female professor of astronomy at Vassar College, articulates that logic in a quote that straddles advocacy and the restrictive reasoning of the time: "A girl's eye is trained from early childhood to be keen. The first stitches of the sewing-work of a little child are about as good as those of the mature man. The taking of small stitches, involving minute and equable measurements of space, is a part of every girl's training; she becomes skilled, before she is aware of it, in one of the nicest peculiarities of astronomical observation."

Williamina Fleming was caught in the same confines, trying to make room for women in the sciences even if they were allowed only one entrance. In the same 1893 speech enumerating the promise of astrophotography to the Congress of Astronomy and Astro-Physics, Fleming ended her address with the following lines: "While we cannot maintain that in everything woman is man's equal, yet

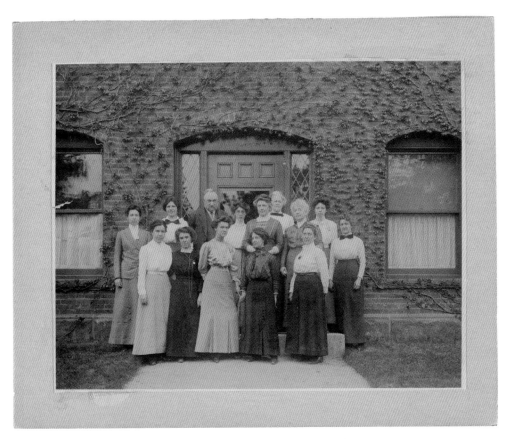

Staff portrait on the steps of the Brick Building, Harvard College Observatory, ca. 1911. Back row (left to right): Margaret Harwood, Mollie O'Reilly, Edward Pickering, Edith Gill, Annie Jump Cannon, Evelyn Leland, Florence Cushman, Marion Whyte, Grace Brooks. Front row (left to right): Arville Walker, Johanna Mackie, Alta Carpenter, Mabel Gill, Ida Woods. (Henrietta Leavitt was absent from the observatory at the time of this photo.)
HUPSF Observatory (14), olvwork360662, Harvard University Archives.

in many things her patience, perseverance and method make her his superior. Therefore, let us hope that in astronomy, which now affords a large field for woman's work and skills, she may, as has been the case in several other sciences, at least prove herself his equal!"

There is no doubt that the observatory's policy of hiring women was an exploitation of wage inequities. But Pickering was caught in his own confines: the observatory did not receive financial support from the university. Beyond interest from the observatory's endowment and income earned for exact-time services, there was no money for staffing, equipment, or publications. It was up to the director to fundraise for any and all of his ambitions. Pickering was remarkably resourceful. In his early years as director he sold grass clippings from the observatory's grounds, garnering thirty dollars a year. Not much, but considering the entry-level pay for a computer was twenty-five cents an hour, those grass clippings funded 120 hours of labor. I do not think it is a contradiction to say that the Harvard Computers were underpaid and highly valued.

Pickering was frugal, inventive, and determined. He launched a subscription campaign in 1878 and through small donations guaranteed the observatory an additional annual income of $5,000 for the next five years. His plea for funding to members of the Visiting Committee included this caution: "The income of the Observatory is not sufficient to keep its instruments at work, much less to prepare, and subsequently to publish, the observations made; which are thus gradually accumulating, remaining without value if not published, losing their value if not promptly published, to the very serious injury of the scientific reputation of the Observatory." The work of the Harvard Computers was vital, but only once their findings were broadcast did it become placed at the heart of the astronomical community. The pay was considered decent: the entry-level rate was better than in domestic service or cotton mills, though far below the wages of the men who operated the telescopes. But not to be dismissed is how Pickering helped normalize women being employed in the sciences or how he made their work visible.

The observatory's finances changed dramatically when Pickering secured generous and committed support from Anna Palmer Draper, the widow of Henry Draper, a physician and amateur astronomer who had been a pioneer of astro-photography. Anna shared her husband's fascination with the stars and wished to carry on her husband's legacy after his death at the age of forty-five. The couple had produced the first spectrum photograph to show distinct lines (of the star Vega in 1872) using a 28-inch reflector and a prism. The couple procured the piece of glass that would become that 28-inch mirror—by Henry and Anna grinding and polishing the glass themselves—the day after their wedding on a shopping expedition that they referred to afterward as "our wedding trip." With the establishment of the Henry Draper Memorial, which funded the shared ambition to catalog the spectra of thousands of stars, their work continued in the hands of the Harvard Computers.

The crescendo of Pickering's fundraising culminated with his successful five-year effort to secure the Boyden Fund, established by Uriah Boyden, an inventor, engineer, and eccentric, who upon his death allotted almost his entire fortune to the construction of an astronomical observatory at an elevation high enough that atmospheric interference would be minimized—the origin of the station in Arequipa. With Catherine Bruce's support of the 24-inch telescope housed there, Pickering's ambitions, now with global possibilities, could bring the A plates of the Magellanic Clouds to Leavitt's desk.

I like how the complexity and scope of these external efforts match the complexity and scope of Leavitt's internal measures. I like thinking about these two worlds meeting, these two worlds equaling.

Cecilia Payne-Gaposchkin had her own opinion, as she so often (and wonderfully) did, about the employment of the Harvard Computers: "In Pickering's days all this work had been done by women. It was respectable work at the end of the nineteenth century, work that conferred a certain distinction, and the old Director [Pickering] had taken full advantage of that fact. The college-trained scientists Henrietta Leavitt, Annie Jump Cannon and Antonia Maury were at the top of the hierarchy." The establishment of women's colleges throughout the Northeast and across the country, and Pickering's direct connections to faculty members at many of them, did open up some employment opportunities for female college graduates. But historian Margaret Rossiter argues that the prospect of women entering the workforce spurred the stratification of labor in the larger observatories. As the gentlemen scientists of yesteryear sought to professionalize the field of astronomy, women were given lower-level positions to bolster the status sought by male astronomers. There was a new willingness to educate women, but less of one to employ them. Rossiter elaborates: "Hardly anyone expected middle-class women to, or wanted them to, hold jobs outside the home—or to vote. Raising and teaching sons who would work and vote, however, were deemed to be such overwhelmingly important full-time tasks that it was felt that mothers must be educated through the secondary and, later, college levels." Keith Lafortune's research complements Rossiter's: "Because they were children's moral guardians and first teachers, women were encouraged to pursue formal education because they could pass the benefits onto the next generation." Middle- and upper-class white women were expected to stick to their roles as wives and mothers, lest they suffer overexertion from the demands of higher education. This was perhaps most succinctly stated by Harvard Medical School professor Edward Clarke in his 1873 book *Sex in Education*, summing up the issue in two words: "uterine disease." Receiving a college education was thought to jeopardize a woman's ability to have children. There is a tinge of this in Pickering's 1885 letter to Harvard president Charles Eliot when Pickering is describing his nighttime photometric observations: "the fatigue and the exposure to the cold in winter are too great for a lady to undergo." Dava Sobel summarizes the ramifications: "Astronomy was a day job for Henrietta Leavitt. She made all her discoveries without ever looking through a telescope."

Despite his susceptibility to the beliefs of the time about the fragility of a woman's constitution, Pickering was a committed advocate for women's higher education. In 1882, when he ran out of funding for additional staff positions, he issued a pamphlet to recruit volunteers for the time-consuming effort of tracking particular variables—work that could be done on an individual basis with a small telescope, comparing an assigned variable to nearby stars and tracking changes over time. Advertising the undertaking, Pickering wrote: "The criticism is often

made by the opponents of the higher education of women that, while they are capable of following others as far as men can, they originate almost nothing, so that human knowledge is not advanced by their work. This reproach would be well answered could we point to a long series of such observations as are detailed below, made by women observers." Limited as the option was, it gave some graduates an avenue of research.

Maria Mitchell posed the following question in her 1876 address to the American Association for the Advancement of Women: "Does anyone suppose that any woman in all the ages has had a fair chance to show what she could do in science?" Pickering's hiring of more than eighty women during the forty-two years of his directorship might be the beginning of a response. Other large observatories, such as Yerkes, Mount Wilson, and the Naval Observatory, also employed women to perform mathematical calculations and systematize photographic plates for use by male astronomers, but Harvard was the first institution to do so, and it employed the highest number. While at other observatories female employees supported research by men (which at times was also true at the Harvard College Observatory), the Harvard Computers possessed significant workplace autonomy. There was a certain expansiveness within the defined territory of Pickering's research aims; this work was their own. The conclusion of Mitchell's speech in many ways describes Leavitt's path: "The laws of nature are not discovered by accidents; theories do not come by chance, even to the greatest minds; they are not born of the hurry and worry of daily toil; they are diligently sought, they are patiently waited for, they are received with cautious reserve, they are accepted with reverence and awe. And until able women have given their lives to investigation, it is idle to discuss the question of their capacity for original work."

Despite the seeming relevance of women's higher education, Pamela Mack, whose 1977 Harvard thesis was one of the first pieces of scholarship on the Harvard Computers, told me that she believes it was the increase in girls' access to high school education that had the greatest bearing on women's employment at Harvard. Cited in her thesis is Radcliffe astronomy professor Arthur Searle's response to an applicant about a job at the observatory: "A knowledge of ordinary arithmetic and a legible handwriting are all the necessary qualifications of a computer, although, of course, the more that is known of languages and mathematics the better." Indeed, of the twenty-one women hired at the Harvard College Observatory between 1885 and 1900, only two—Antonia Maury and Annie Jump Cannon—had graduated from a women's college. (This statistic does not include Henrietta Leavitt, who originally volunteered for several years at the observatory and did not become a paid employee until 1902.) It is true that all three women Cecilia Payne-Gaposchkin describes as being "top of the hierarchy" earned college

degrees. Yet each Harvard Computer's story of arriving at the Brick Building
is distinctive.

Leavitt moved with her family from Massachusetts, where she was born,
to Ohio when her father became pastor of Cleveland's Plymouth Congregational
Church. She attended classes at Oberlin College for three years beginning in 1885,
taking a preparatory course followed by two years of undergraduate study. When
she returned to Cambridge in 1888, she entered the Society for the Collegiate
Instruction of Women, soon to become Radcliffe College, where the entrance
exams were comprehensive. George Johnson details the elaborate requirements
in *Miss Leavitt's Stars: The Untold Story of the Woman Who Discovered How to
Measure the Universe*:

> Every young woman was expected to prove her familiarity with a list of
> classics—Shakespeare's *Julius Caesar* and *As You Like It*; Samuel Johnson's
> *Lives of the Poets*, William Makepeace Thackeray's *English Humorists*;
> Swift's *Gulliver's Travels*; Thomas Gray's poem "Elegy Written in a Country
> Churchyard"; Jane Austen's *Pride and Prejudice*; and Sir Walter Scott's *Rob Roy*
> and "Marmion"—by writing, on the spot, a short composition. There were also
> tests on language ("Translation on sight of simple [in the case of Latin, Greek,
> and German] or ordinary [in the case of French] prose"), on history ("Either
> [1] History of Greece and Rome; or [2] History of the U.S. and of England"),
> mathematics (algebra through quadratic equations and plane geometry),
> and physics and astronomy. In addition to these examinations on "elementary
> studies," students had to demonstrate more advanced knowledge in two
> subjects—mathematics, for example, and Greek.

This was all required for Leavitt to *begin* her studies in Cambridge. By the
end of four years of classes she earned a certificate—the institution did not yet
confer degrees—for completing, as Johnson writes, "a curriculum equivalent to
what, had she been a man, would have earned her a bachelor of arts degree from
Harvard." It wasn't until Leavitt's final year that she took a course in astronomy.
Her photometry skills must have been evident during the subsequent four years
she volunteered at the observatory, because when she returned as a paid staff
member in 1902, Pickering offered Leavitt thirty cents per hour, 20 percent above
the standard rate.

Antonia Maury, who developed her own spectral classification system
parallel to Williamina Fleming's early efforts, came to the observatory in 1888 as
a Vassar graduate, having studied under the famed Maria Mitchell. Maury set to
work studying spectroscopic binaries and was the first person to calculate the
orbital speed of a revolving star using the varying redshift and blueshift in its
spectral lines. As young as four, Maury is reputed to have helped her uncle Henry
Draper with his chemistry experiments, handing him test tubes as he asked for

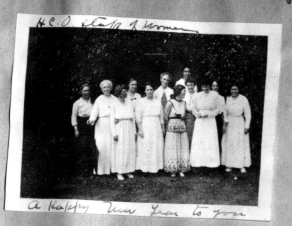

H.C.O. Staff of Women

A Happy New Year to you

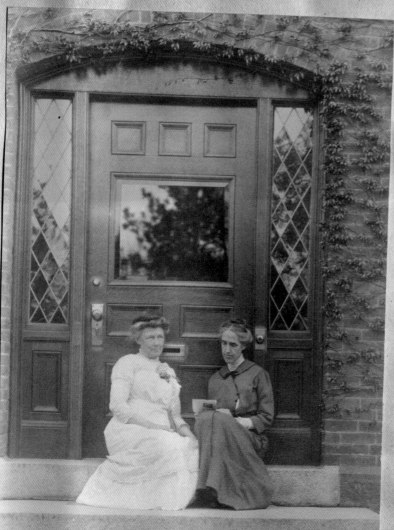

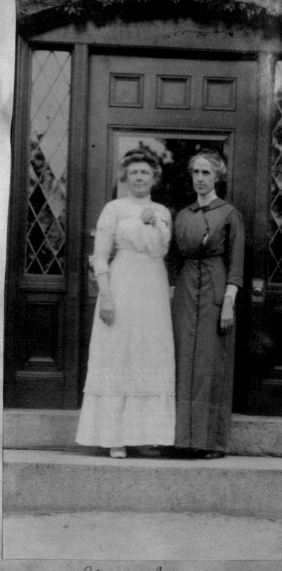

Page from one of Annie Jump Cannon's scrapbooks. The two photos of Annie Jump Cannon and Henrietta Leavitt on the steps of the Brick Building were taken May 14, 1913. The group photo labeled "H.C.O. Staff of Women" has Leavitt at the center.

Annie Jump Cannon Papers, HUGFP 125.36 (box 2), Harvard University Archives.

1913 A.J.C. H.S.L.

May, 1913

them. (One of the rare points of access to the sciences for girls and women was having a relative who was a scientist.) It was also said that Maury could read Virgil in the original Latin at the age of nine, having been tutored by her father. She graduated from Vassar with honors in astronomy, physics, and philosophy. Precocious and evidently brilliant, Maury arrived at the observatory prepared for insightful work.

Annie Jump Cannon, too, was encouraged in her studies by her family. Now sounding prescient, or simply formative, her mother set up a simple observatory in their attic that included a trapdoor to the roof and taught her daughter how to determine the positions of the stars using an astronomy textbook from her own youth. Both Cannon's mother and father supported her studies at Wellesley College, where Cannon took physics and astronomy classes from Sarah Frances Whiting, one of the founders and first director of the college's campus observatory. While still a young professor at MIT, Pickering invited Whiting to attend his lectures and observe experiments, providing a young female scientist access to an otherwise all-male realm. Pickering's approach was the basis for the physics courses Whiting taught at Wellesley, where she established the second undergraduate physics laboratory in the United States (MIT's being the first).

Despite Cannon's robust education and passion for spectroscopy, it wasn't until the age of thirty-four, after her mother's sudden death, that Cannon, grief-stricken and seeking purpose, turned back to astronomy. Using the connection between Pickering and Whiting, Cannon arranged for personal use of the telescopes at Harvard to further her postgraduate research at both Wellesley and Radcliffe. Pickering wrote in his introductory letter to her, "One or more telescopes will also be available for the observations on variable stars which you wish to make." (This letter is dated January 15, 1896. Apparently Cannon could handle the harsh winter nights of Cambridge.) Pickering supported her work and warmly welcomed her. He wrote, "I shall be glad to have you spend as much time at the Observatory as you wish, when you are at your leisure to do so. Mrs. Fleming will probably be too much occupied with her regular work to assist you much, but I have spoken to Miss Leavitt upon the subject, and she will doubtless be able to give you the information you need." Writing in her diary just before midnight on December 31, 1896, Cannon reflected on the three years since her mother passed: "The busy life I so longed for has been opened up to me. Friends have come to me from the great world and my heart, my life are _in_ the study of Astronomy. They little know what it means to me how it was the only thread holding my reason, almost my life." Just after her mother's death, Cannon had written in her diary, "May I be led into a useful, busy life. I am not afraid of work. I long for it. What can it be?" Cannon remained at the observatory for forty-five years.

Williamina Fleming came from entirely different circumstances. Her father

died when she was only seven, and Fleming dropped out of school in her native Scotland at the age of fourteen to become a pupil-teacher to help support her family. Later, as a young immigrant newly arrived to the United States, Fleming was abandoned by her husband while she was pregnant, leaving her in a financial emergency. She found employment as a maid for Edward and Elizabeth Pickering in their home on the observatory grounds. At Elizabeth's suggestion, Edward hired Fleming for part-time work at the observatory. Elizabeth Pickering's intuition was correct, and Fleming quickly moved beyond the ordinary tasks assigned to her. After a yearlong interruption during which Fleming returned to Scotland to give birth to her son, she became a permanent staff member at the observatory once back in Cambridge and remained there until her death at fifty-four. Edward Pickering notes Fleming's decades-long career in her obituary: "Mrs. Fleming began work at the Harvard Observatory in 1881. Her duties were at first of the simplest character, copying and ordinary computing. Later, as her powers developed, she was advanced until she occupied one of the most important positions in the Observatory."

Fleming classified the majority of the 10,351 stars indexed in the first edition of the *Draper Catalogue of Stellar Spectra*, published in 1890. This wasn't her only notable accomplishment. Dava Sobel elaborates: "In addition to the dedication she had shown in measuring and classifying the spectra of ten thousand stars, she had also expertly proofread the catalogue's four hundred pages. Most of the pages consisted of tables, twenty columns wide and fifty lines long, representing approximately one million digits in all." This doubled responsibility remained throughout Fleming's career. In Pickering's 1912 Annual Report, the year after Fleming's death, he appreciated this predicament: "Mrs. Fleming's record as a discoverer of new stars, of stars of the fifth type, and of other objects having peculiar spectra, was unequaled. Her gifts as an administrative officer, especially in the preparation of the *Annals*, although seriously interfering with her scientific work, were of the greatest value to the Observatory." Possibility and limitation seemed to be ever-present companions for a Harvard Computer.

In this gathering of stories I return to Fleming's 1893 Chicago speech: "A great many women of today must have a similar aptitude and taste for Astronomy and if granted similar opportunities would undoubtedly devote themselves to the work with the same untiring zeal, and thus greatly increase our knowledge of the constitution and distribution of the stars." Fleming was speaking about astronomy pioneers Maria Mitchell and Caroline Herschel, who had access to the field through their father's teaching and brother's research, respectively. But Fleming could have been talking about herself. There is an apocryphal anecdote about her hiring, in which Pickering, disappointed by the work of one of his male assistants, cries, "My Scottish maid could do better!" and

hires Fleming on the spot. But Pickering did not simply turn and hire the nearest woman. Or perhaps he did: turn and hire the brilliant woman already close at hand. So often throughout history women have done science elbow to elbow with men. Anna Palmer Draper, in Wyoming with her husband on an 1878 expedition to view a solar eclipse, volunteered to call out the resulting 165 seconds of totality from inside a tent so as not to be distracted by the awe-inducing sight and therefore be able to provide a more accurate count. *That* is dedication to science. I am struck by the idea that the closest woman could do better than a chosen man. And struck by just how many women *were* close at hand, some seen, some unseen.

Pickering's file in the Harvard University Archives is full of courteous replies to applicants seeking work at the observatory. Despite offering unequal mobility—some of the men, such as Arthur Searle, began as a computer but then quickly rose up the ranks to assistant and then professor, but for women there was only one job title available—the position was a coveted opportunity. Everyone employed at the observatory supported Pickering's goal: to calculate the position, brightness, and spectrum for every star in the sky, and to share that information with anyone who wished to know it. In describing the work of the observatory in his 1902 Annual Report, Pickering wrote, "in many cases this involves a repetition of the work many hundreds, or even thousands, of times, and renders it necessary that the observers and computers shall continue for years upon work of the same character." Mapping the sky required long-term study from both men (observers) and women (computers), but the roles were fully segregated: in Pickering's era, only women occupied the Brick Building. With that structure in place, this work became women's work not just because this type of meticulous, repetitive labor was defined as such by society, but because at the observatory, women were the only ones who did it. This also means that the expansiveness found in that limited sphere was theirs. This was their own territory of research, and they were, therefore, able to define it, shape it, and make the discoveries latent within it. They loved the work, they chose it, and so they stayed.

Their longevity proved rewarding. One of the reasons Annie Jump Cannon's classification system, built on the work of Fleming and Maury, has such value (it was adopted as the international standard and is still in use today) is its utter consistency, due to her single-minded persistence. For the nine updated volumes of the *Henry Draper Catalogue* she classified the spectra of 225,300 stars; in her lifetime she classified the spectra for over 358,000. Sustained engagement leads to knowing something intimately—perhaps the only way to truly know anything.

Sometimes discovery shows itself as a comprehensive understanding, and sometimes discovery flares up out of that understanding. Surveying a photographic plate from Arequipa taken on July 10, 1893, Fleming spied a star with

a peculiar spectrum that contained a dozen bright hydrogen lines. Looking at the same region on previous plates in the collection, no prior indication of the star could be found. Fleming had discovered the first nova detected by spectral photography. It was essentially identical when she compared it to the spectrum of Nova Aurigae, a nova discovered in the sky in February 1892. Fleming had both made a discovery and discovered a new way to make one.

Still, at times the limitations of the work seemed to feel more pressing than the possibilities. Fleming participated in Harvard University's Chest of 1900 time capsule project, which aimed to document everyday life at Harvard for the month of March 1900 as a way to mark the end of the nineteenth century and the beginning of the twentieth. Fleming's journal entry for the project on March 3 reads, "Looking after the numerous pieces of routine work which have to be kept progressing, searching for confirmation of objects discovered elsewhere, attending to scientific correspondence, getting material in form for publication, etc., has consumed so much of my time during the past few years that little is left for the particular investigations in which I am especially interested." She continues in her March 5 entry: "If one could only go on and on with original work, looking for new stars, variables, classifying spectra and studying their peculiarities and changes, life would be a most beautiful dream; but you come down to its realities when you have to put all that is most interesting to you aside, in order to use most of your available time preparing the work of others for publication. However, 'Whatsoever thou puttest thy hand to, do it well.' I am more than contented to have such excellent opportunities for work in so many directions, and proud to be considered of any assistance to such a thoroughly capable Scientific man as our Director."

Perhaps Pickering could be seen as a tyrant, mandating drudgery. But an entry from Pickering's own Chest of 1900 journal displays Pickering's level of commitment to this work: "Although the work is the most acute and absolutely monotonous, I find it very fascinating, and always watch the next morning for the progress made in the completion of the work." Pickering's million measurements with his meridian telescopes were just a subset of his astronomical work; the man was an observer at heart. Pickering let facts be his guide, trusting they would lead somewhere interesting.

Even when busy with external demands, the women found themselves at the center of things. In a prologue to his 1944 paper on white dwarfs, Henry Norris Russell writes about the very first identification of one of these small yet incredibly dense objects. At the moment of discovery in 1910, he had been discussing with Pickering the spectra of stars with large parallax, all of which were turning out to be from the G class of stars or cooler. By contrast, a faint companion star in a multiple-star system in the constellation Eridanus was white in color, implying

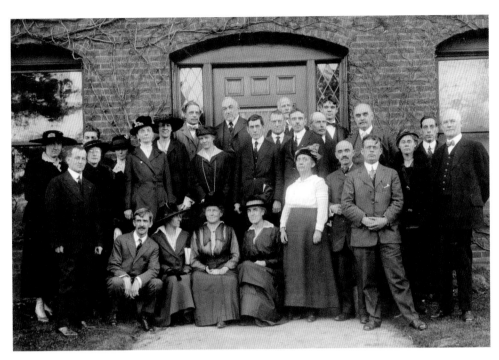

Attendees of the annual meeting of the American Association of Variable Star Observers (founded in 1911, with close ties to Harvard) on the steps of the Brick Building, Harvard College Observatory, November 10, 1917. Standing (left to right): Mary Vann, Forrest Spinney, William Delmhorst, Dorothy Block, Mrs. E. T. Brewster, Anne Young, Susan Raymond, John Crane, Dorothy Reed, Edward Pickering, E. S. McColl, Edwin Brewster, Solon Bailey, William Olcott, Ida Woods, T. C. H. Bouton, David Wilson, Henry Schulmaier, Michael Jordan, Alan Burbeck, I. F. Conant, Francis Ducharme, W. H. Reardon. Seated (left to right): Leon Campbell, Leah Allen, Annie Jump Cannon, Henrietta Leavitt.

American Association of Variable Star Observers.

it was hotter despite its small size. As Russell explains, it was from an entirely different spectral class:

> The first person who knew of the existence of white dwarfs was Mrs. Fleming; the next two, an hour or two later, Professor E. C. Pickering and I. With characteristic generosity, Pickering had volunteered to have the spectra of the stars which I had observed for parallax looked up on the Harvard plates. All those of faint absolute magnitude turned out to be of class G or later. Moved with curiosity I asked him about the companion of 40 Eridani. Characteristically, again, he telephoned to Mrs. Fleming who reported within an hour or so, that it was of class A. I saw enough of the physical implications of this to be puzzled, and expressed some concern. Pickering smiled and said, "It is just such discrepancies which lead to the increase of our knowledge." Never was the soundness of his judgment better illustrated.

I love all that this story demonstrates: Fleming, stuck in an administrative position limited in scope, yet standing as witness—as seeker and finder—to

new wonders; Pickering, justified in his belief in facts as a pathway to scientific truth; and Russell, confirming these truths about Pickering and Fleming, both conceding the strength of Pickering's methodology and acknowledging Fleming's centrality. (I've never quite forgiven Russell for not only refusing to accept Cecilia Payne-Gaposchkin's revelation that hydrogen and helium are far more abundant in the atmospheres of stars than here on Earth, but also making her include the following concession in her doctoral thesis: "The enormous abundance derived for these elements in the stellar atmospheres is almost certainly not real." That "enormous abundance" *was* real, and Payne-Gaposchkin, recognizing the ground-breaking implications of her results, had checked and rechecked her work. She found no mistakes. But Russell's own work hinged on the principle of uniformity—that all planets and stars are made of the same elements as Earth, in about the same proportions—and so he had initially rejected her research. Within a few years Payne-Gaposchkin's results were widely accepted—including by Russell—as correct and fundamental.)

Pickering's approach did suit some women, and it seems to have suited Leavitt. She left scant correspondence and no diary, so portraits of her often come from others. Solon Bailey, acting director of the Harvard Observatory at the time of Leavitt's death, writes in Leavitt's obituary: "She took life seriously. Her sense of duty, justice, and loyalty was strong. For light amusements she appeared to care little." I like thinking she didn't mess around. But it wasn't a lonely life, simply one of focus. Bailey continues, "She was a devoted member of her intimate family circle, unselfishly considerate in her friendships, steadfastly loyal to her principles, and deeply conscientious and sincere in her attachment to her religion and church." This commitment and loyalty she showed to her work as well, reflected once more in Bailey's words, this time from *The History and Work of Harvard Observatory, 1839–1927*, describing Leavitt as being "deeply absorbed in her astronomical work, dedicating herself to it with an almost religious zeal."

The few words we get directly from Leavitt are often in her absence from the observatory. When Pickering and Leavitt exchanged letters in 1902 to discuss her possible full-time employment, Leavitt referenced the astronomical research she had undertaken as a volunteer several years prior. "I am more sorry than I can tell you that the work I undertook with such delight, and carried to a certain point with such keen pleasure, should be left uncompleted." Notice the words *delight* and *pleasure.*

Leavitt's time at the observatory was often interrupted for extended periods by family obligations such as tending to her mother after her father's death, caring for other relatives, and some unexplained travel, but most significantly by her own health problems. Her 1909 convalescence at her parent's home lasted

the entire year. Letters between Pickering and Leavitt continually anticipate her return, and their correspondence brims with a shared concern for their research. Pickering writes, "It may however relieve your mind if we can dispose of two or three questions." Leavitt, in response, admits, "The thought of incomplete work, particularly of the Standard Magnitudes is one I have had to avoid as much as possible, as it has had a bad effect nervously. At last, however, progress seems to be establishing itself on a sound basis." Pickering, equally eager for her to resume her investigations, made a rare exception and shipped equipment and photographic plates to where she was recuperating in Wisconsin. In all of the letters, Leavitt's mind steers back toward the work, her own true north.

For Antonia Maury, however, Pickering's philosophy of obtaining the widest, most certain reaches of knowledge was not a good match. The spectral classification categories she developed were much more nuanced than Fleming's. Within the scope of Pickering's assignment, each researcher had the freedom to develop their own system. Fleming had been cataloging spectral patterns on plates made with Pickering's invention of placing a prism at the objective end of the telescope, which crowded hundreds of spectra together; Maury had been assigned the brightest stars in the Northern Hemisphere and examined each individually under higher dispersion—one plate often displayed a single spectrum several inches in length, which she then enlarged under a microscope for even richer detail. Her uncle, Henry Draper, had been able to produce a photograph of Vega's spectrum showing ten lines. Maury could now look at Vega's spectrum and study more than a hundred. She considered not just the presence of certain lines but also their quality, strength, and clarity, and added subclassifications to her system based on attributes that she trusted held significance.

Annie Jump Cannon, arriving at the observatory fifteen years after Fleming and nearly a decade after Maury, chose to adapt Fleming's classifications based on the strength of a star's hydrogen lines. Cannon merged some of Fleming's categories while reordering others to prioritize the helium lines, as Maury had done. Cannon's decisive ordering was later shown to directly correspond with a ranking of stars from hottest to coolest, proving her intuition to be astonishingly perceptive. Hers was the classification system Pickering selected to put forward to the international community, which would become the basis of Ejnar Hertzsprung and Henry Norris Russell's independent work on the relationship between a star's spectra and its luminosity, founding the modern theory of stellar evolution. Yet Hertzsprung (not yet of Hertzsprung-Russell diagram fame) discovered that some of the brightest but most distant red stars he was calculating through parallax were aligned with one of Maury's subcategories. This produced in a class of red stars the distinction between giant and dwarf stars—a distinction

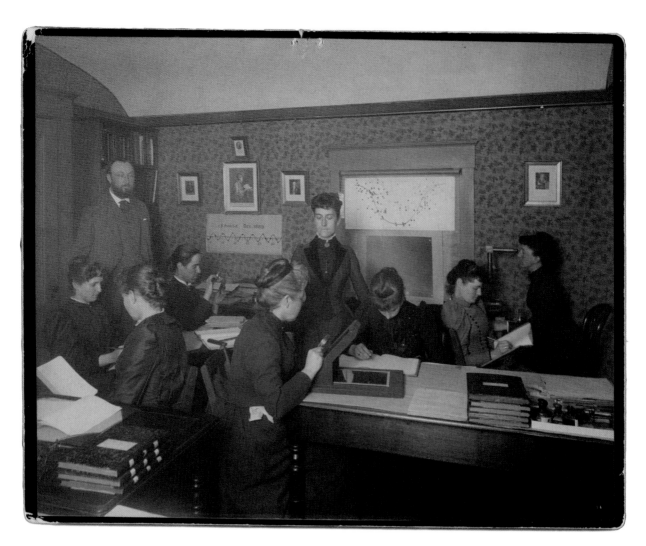

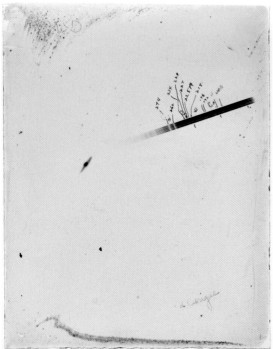

Staged photograph of observatory staff in the computing room of the original observatory building, 1891. Left to right: Mabel Stevens, Edward Pickering (standing), Imogen Eddy, Antonia Maury, Evelyn Leland, Williamina Fleming (standing), Louisa Wells, Louisa Winlock (possibly), Florence Cushman. The graphed light curve for Beta Aurigae sits on the wall above Antonia Maury's left shoulder. To anatomize the peculiar spectral patterns of this spectroscopic binary, which she discovered, Maury writes in her 1898 *Astrophysical Journal* article "The K Lines of Beta Aurigae" that she studied two hundred glass plate photographs spanning a period of nine years.

HUPSF Observatory (45), olvwork360664, Harvard University Archives.

Negative spectrum glass plate C191 of Beta Aurigae, 4 × 5 inches. Exposure of 43 minutes made with the 11-inch Draper telescope on November 4, 1886, Harvard College Observatory, Cambridge, Massachusetts. This plate was used for Antonia Maury's spectral analysis work and, decades later, for Cecilia Payne-Gaposchkin's.

Astronomical Photographic Glass Plate Collection, Harvard College Observatory.

Cannon's system did not make. To ignore this difference was like grouping
together "a whale and a fish," as Hertzsprung put it to Pickering. When Maury's
subdivisions were absent year after year in the spectral types published in the
Annals, Hertzsprung protested their exclusion in a series of letters to Pickering.
Despite Hertzsprung's urging, Pickering was not confident in the science Maury's
research stood on: the bright stars she had been assigned were a much smaller
sample, and Pickering was worried the differences in line structure that Maury
saw might be instrumentational, not actual. Prior to Hertzsrpung's sustained
defense of her work, Maury had articulated her own objections to Pickering in a
letter dated December 21, 1893: "You also, not having examined minutely into all
the details, did not see that the natural relations I was in search of could not easily
be arrived at by any cast iron system." She saw complexity and investigated it, but
that didn't fit within Pickering's program. He wanted a system that was encom-
passing, simple, and flexible, and therefore powerful enough to be chosen as the
international standard (there wasn't one at the time). Maury's system was too
labor-intensive and subtle, slowing the progress Pickering sought.

By this time Maury, agitated, had already left the observatory. When
Pickering wrote to Maury hoping she would return and complete her work—or,
if need be, give her findings thus far to others to complete, Maury responded, in
a letter dated May 7, 1892, "I do not think it is fair that I should pass the work into
other hands until it can stand as work done by me. I worked out the theory at the
cost of much thought and elaborate comparison and I think that I should have full
credit for my theory of the relations of the star spectra and also for my theories
in regard to Beta Lyrae." In reply, Pickering reassured Maury, "It is the regular
practice of this observatory to make full acknowledgment in its publications of
the credit due to authors of particular portions of them." She did return to the
observatory in 1893 and again in 1895 to complete her focused study. Her propri-
etary sense of her own research ultimately reaped a reward. When her spectral
analysis of bright stars of the Northern Hemisphere was finally published as
part of the Henry Draper Memorial in the 1897 *Annals*, her name appeared on
the author page—*above* Pickering's, a first. She returned to the observatory as an
associate researcher in 1908 to continue the work on spectroscopic binaries that
began her career and to pursue her curiosity about Beta Lyrae, a strange variable
about which Maury quotes Leavitt as saying, "We shall never understand it until
we find a way to send up a net and *fetch the thing down!*" Maury studied nearly
three hundred spectra of the complex spectroscopic binary Beta Lyrae, trying to
understand its weirdness. She returned and worked under Pickering's successor,
Harlow Shapley. She couldn't quite leave the place; she cared too much about
what she saw.

Annie Jump Cannon was said to be able to categorize spectra as fast as the person she was dictating them to could write them down. Cecilia Payne-Gaposchkin, who studied spectra alongside Cannon, describes numerous times coming across a vague smudge on one of the glass plates with an ink notation from Cannon and asking Cannon to verify its spectral class; Cannon's new identification never strayed from her original. Payne-Gaposchkin also shares this story: "In the last years of Miss Cannon's life, Henry Norris Russell used to say: 'Somebody ought to find out from Miss Cannon exactly how she classifies each spectral type.' I argued with him that she would not be able to tell them because *she did not know*. She was like a person with a phenomenal memory for faces. She had amazing visual recall, but it was not based on reasoning. She did not think about the spectra as she classified them—she simply recognized them."

This mental capacity of Cannon's was beyond even the exceptional bounds of extraordinary. Harlow Shapley recounts in his autobiography mentioning to Cannon, on his first day as director of the observatory, that he was curious to see the spectrum of SW Andromedae (a faint variable star he "had a hunch about"). Shapley remembers, "She called to her assistant: 'Will you get Plate I37311?' She just sang out that five-figure number. The girl went to the stacks and got the plate and SW Andromedae was on it!" Cannon was the authority. Shapley concludes, "As far as the spectra went, I was her assistant." Despite this note of respect, Shapley coined the dismissive term "girl-hours." In his own words: "I invented the term 'girl-hour' for the time spent by the assistants. Some jobs even took several kilo-girl-hours. Luckily Harvard College was swarming with cheap assistants; that was how we got things done."

In her autobiography, Payne-Gaposchkin wrestles with the different scientific approaches each woman took, juxtaposed against her self-image as a theorist. Referring to Cannon, Payne-Gaposchkin admits: "I had even permitted myself to wonder how anyone who had worked with stellar spectra for so long could have refrained from drawing any conclusions from them. She was a pure observer, she did not attempt to interpret. As I look back I see how her work has outlasted my early efforts at interpretation. The *Henry Draper Catalogue* is a permanent monument." Here, once more, are Pickering's words in his introduction to that very monument: *Speculations unsupported by fact have little value, and it is seldom necessary in such investigations as are carried on here, to form a theory in order to learn what facts are needed.* Cannon was an observational purist, a perfect executor of Pickering's mission. But is observation unthinking? Cannon's innate knowledge was cultivated, her intelligence responsive. Her practiced knowledge, as Payne-Gaposchkin said, outlasted theories of the day. Payne-Gaposchkin's own theories were based on repeated calculations, repeated observations. It is hard—is it necessary?—to parse one from the other.

ANNIE JUMP CANNON, 1863–1941

ANNALS
OF
THE ASTRONOMICAL OBSERVATORY

HARLOW SHAPLEY, I

VOLUM

THE ANNIE J. CANN

THE HENRY D

MAR

The Annie J. Cannon Memorial Volume of the Henry Draper Extension, which cataloged the spectra of the faintest known stars, published in the 1949 *Annals of the Astronomical Observatory of Harvard College.* Harlow Shapley writes in the introduction to this volume:

> For her first spectrum classifications Miss Cannon used plate B9431, which was made with an exposure of 140 minutes in 1893. It is reproduced as the frontispiece of the ninth and concluding volume of the Henry Draper Catalogue. A glance at the remarkable early photograph will suggest why Miss Cannon was captivated by stellar spectra and was led to devote a long and happy career to the classification of faint stars…. It is an interesting coincidence that Miss Cannon's work on spectra ended near where it began. In March, 1941, after 45 years of work on photographic plates, she was again classifying stars in the Carina region for Dr. Bok's studies of the structure of that interesting part of the Milky Way. She died the following month.

Photo by Anna Von Mertens.

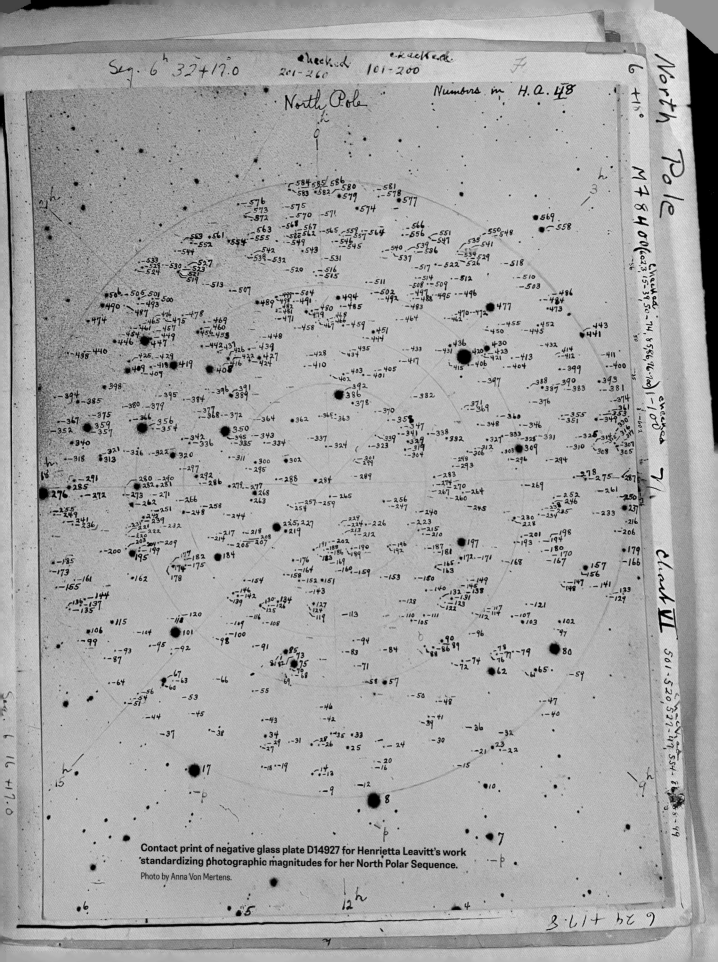

Contact print of negative glass plate D14927 for Henrietta Leavitt's work standardizing photographic magnitudes for her North Polar Sequence.

Photo by Anna Von Mertens.

I discussed with historian Pamela Mack what it means to be a scientist, a concept continually shifting, and defined differently then and now. She drifted into a definition: "Science is systematic, it's systematic … it's trying to reduce things to some kind of simpler principles, and it's in a community where results are shared." That word, *reduce*, had surfaced: the job the Harvard Computers were hired to do. They made the information held on the glass plates comprehensible by reducing the amount of data present. In that work, the women themselves took up the act of understanding; to distill something, one must determine what is there.

Their knowledge was formed through repeated actions. The discipline of science requires perseverance and patience, and yet patience tends to be doled out to women, whereas the patient male scientist "perseveres." In this parsing, women are labeled assistants; men are astronomers. Sometimes an achievement is not defined as science simply because a woman did it. But theories begin with observations, necessarily repeated. Theories begin with noticing. Mack continued to refine her definition of science, emphasizing the action of it: "Taking the complexities of the world and finding underlying principles." What an excellent description of the work of the Harvard Computers.

After publishing her groundbreaking work on variables, Leavitt was assigned to stellar magnitudes, a line of research she and Pickering pursued as doggedly as the study of variables. Pickering's nighttime observations with his meridian photometers were the foundation of his visual magnitude work, bringing Polaris into view for direct comparison with each star to standardize his results. To create standardized *photographic* magnitudes—to understand how the technology mediated the starlight it captured—Leavitt needed to identify the inconsistencies latent in each plate, calibrate between telescopes, and then check her measurements against previous, published estimations, both visual and photographic. Leavitt obviously excelled at this complex task; in her time at the observatory she was quickly promoted to head the department of photographic stellar photometry. While a systematic survey of stars had been done in Germany, estimating the brightness of several hundred thousand stars, nothing had been established uniformly. Pickering wanted it done right. From *Harvard Circular* no. 150: "As it is not probable that a similar research of equal extent will be undertaken elsewhere, it is essential that it should be based upon a correct scale." Leavitt set about determining absolute photographic magnitudes for a selected sequence of stars near the North Pole representing the widest possible range of brightness. Solon Bailey writes in his history of the observatory, "The precise determination of the Polar Sequence was of primary importance. Its value in the progress of photometry

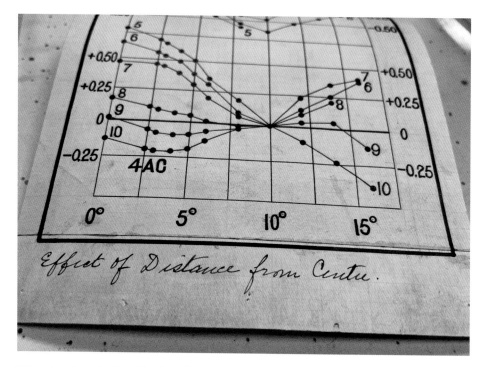

This series of graphs, found in a box of sequence charts and captioned in Henrietta Leavitt's recognizable cursive, presumably specifies distortion corrections for various telescopes to be applied to stars according to their position on a plate.

Photo by Anna Von Mertens.

could hardly be overestimated, for as soon as this sequence should be definitely established and accepted by astronomers, its scale of magnitudes could be transferred by photographic methods to any region of the sky." A photograph could be taken of the North Pole encompassing Leavitt's standardized sequence, and then a second exposure could be superimposed on the same plate of a different region of the sky (taken under similar clear conditions, at the same altitude, for equal duration) to bring other stars into direct comparison with Leavitt's known photographic magnitudes. The stars in Leavitt's North Polar Sequence could become standardized reference points for stars halfway across the heavens.

But those standards had to be established first. From Solon Bailey again: "The determination of photographic magnitudes would be simple except for the great number of variants which occur in photographic processes." Nothing could be counted on. Even within the confines of one rectangular plane of glass, a true relationship did not hold; it shifted from the center of a plate to its edge. And not uniformly. I was confounded by this sentence from Pickering in *Harvard Circular* no. 160 addressing these difficulties: "As we recede from the centre, bright stars appear brighter, and faint stars fainter, owing to the increased size of the images." The gap between certainty and doubt only widened. Leavitt estimated the size,

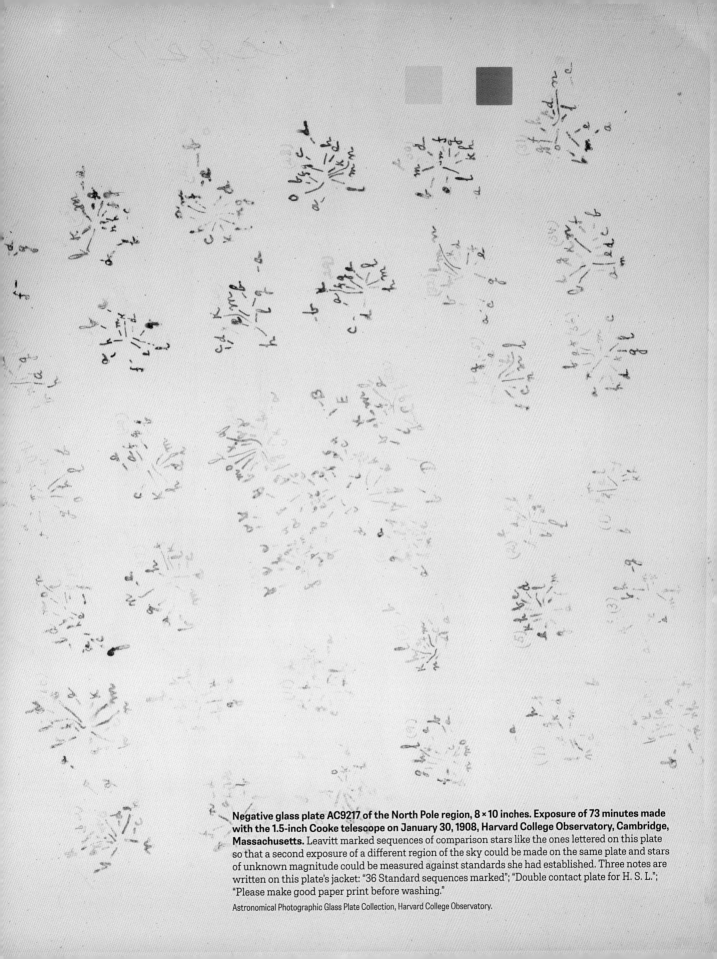

Negative glass plate AC9217 of the North Pole region, 8 × 10 inches. Exposure of 73 minutes made with the 1.5-inch Cooke telescope on January 30, 1908, Harvard College Observatory, Cambridge, Massachusetts. Leavitt marked sequences of comparison stars like the ones lettered on this plate so that a second exposure of a different region of the sky could be made on the same plate and stars of unknown magnitude could be measured against standards she had established. Three notes are written on this plate's jacket: "36 Standard sequences marked"; "Double contact plate for H. S. L."; "Please make good paper print before washing."

Astronomical Photographic Glass Plate Collection, Harvard College Observatory.

Friday, November 17, 1905.

New Variables in Virg. (Jupiter plates)

No.	Bz.		H					
1	3554 [14] 3556		3657 [15] 3667 3655	3654				
2	3669 [13.] (3670)		3657 [13.7] 3554 3667	3655 [14.] 3654 355				
3	Ad Virginis							
4	3669 [18.] 3670		3657 [14.] 3554 3667 3666 3654 3556					

No. 1

No. 2

No. 4

Pages 26 and 27 of Henrietta Leavitt's logbook *Miscellaneous Observations, H. S. L.* (volume 13, both pages dated November 17, 1905). Page 27 heading: "Measurements to determine Correction to Photographic Magnitudes as the Edge of the Plate is approached."

John G. Wolbach Library, Harvard College Observatory.

Friday, November 17, 1905

Measurements to determine Correction to Photographic
Magnitudes as the Edge of the Plate is approached.

Plate A 3307. M. Mag Cloud 0² ᵐ −7 Exp. 60ᵐ

#7 Tucanæ

x	y					x	y			
−8	+21	d'	4.0		·43	−124	−10	d^4	4.9	4.3²
12	+21	e'	5.7		5.9	115	−15	e^4		5.9²
16	+23	f'			7.2	116	−19	f^4		7.8
8	+25	g'			7.9	120	−20	g^4		9.1
9	+25	h'			9.7	119	−17	h^4		9.8
−41	+12	d^2	4.6		4.4	−156	−11	d^5	5.2²	4.9²
41	9	e^2	5.2		5.1	156	−14	e^5		7.0²
46	13	f^2	6.7		6.6	158	−14	f^5	5.2²	8.2²
44	15	g^2		8.1	7.2	158	−12	g^5		9.2?
47	15	h^2			9.4	158	−13	h^5		10.1
77	+6	d^3	4.8		4.4	−18	+21	k'		8.2
73	−3	e^3	5.4		5.0	29	+15	k^2		8.0
75	−2	f^3			7.1	56	+8	k^3		8.3
71	−6	g^3			8.1	67	+4	k^4		8.7
73	−1	h^3			9.7	76	−9	k^5		8.7
						89	−9	k^6		8.8
						101	−19	k^7		8.8
						127	−19	k^8		7.8
						139	−18	k^9		8.9
						146	−16	k^{10}		9.1

Photograph by Jennifer L. Roberts of the bright star Polaris on multiple-exposure negative glass plate I36786, 8 × 10 inches. Made with the 8-inch Draper telescope on August 12, 1910, Harvard College Observatory, Cambridge, Massachusetts. The first exposure was 6 minutes, made without perforated tin; the second exposure was 5 minutes without perforated tin; the third exposure was 60 minutes without perforated tin; the fourth exposure was 5 minutes with perforated tin placed over the telescope's objective; the fifth exposure (not shown) was 5 minutes without perforated tin.

or diameter, of each small circle of emulsion as the primary indicator of a star's magnitude. Yet even those circles were mutable. The shapes of the stars on the plates could be aberrant due to a slight tilt in the setting of the photographic plate or to atmospheric refraction. Pickering noted that at times the images were not circular even at the center of the plate. There was no true, fixed origin from which Leavitt could begin her work.

But the most considerable challenge was accommodating the fact that different telescopes produced divergent results. Leavitt assembled photographs taken by thirteen instruments, including contributions from the Yerkes, Lick, and Mount Wilson observatories. Their three large reflectors made it possible to determine stars as faint as twenty-first magnitude, way beyond sixth-magnitude stars, which are near the limit of visibility with the naked eye, and even further still from, say, the bright pole star Polaris. Four-hour exposures taken to register the faintest stars would need to be in conversation with, for example, ten-minute exposures from a different telescope that more effectively registered stars from the sixth to the fourteenth magnitudes.

To establish a standard sequence, Leavitt needed to bring bright, inter-mediate, and faint stars into relationship with one another. Because the action of light on a photographic plate is not linear, simply taking a longer exposure wouldn't accurately capture these three categories of stars. With the first contact of starlight, silver deposits begin to build on a plate; with more light, they accumu-late at an increasing rate. Eventually that rate holds steady, and for a window of time it is directly proportional to the light received. But past a certain threshold, the rate of accumulation of silver particles slows and then comes to a standstill, even as light continues to contact the plate. Bright stars can pass all the way through the curve of this relationship by the time enough light is collected from faint stars to create a silver dusting. Sometimes the bright stars simply went off the rails. Leavitt wrote in her logbook about the long-exposure plate B18383, "The images of the faint stars are good. The images of bright stars have trails and are peculiarly shaped."

The light from the brightest stars in Leavitt's polar sequence needed to be brought down to the level of her sequence's midrange stars, whose magnitudes were the best established, for direct comparison. This was often attempted by taking multiple-exposure plates, which Leavitt helped procure. American astronomer Frederick Seares worked at Mount Wilson Observatory, but he often referred to Harvard's techniques for standardization, and his 1913 *Astrophysical Journal* article "The Photographic Magnitude Scale of the North Polar Sequence" delves into some of Leavitt's methodologies. Addressing the strategy of multiple exposures—which might result in three, four, or five consecutive images for every star on a plate—Seares describes how, in one of the exposures, the light of

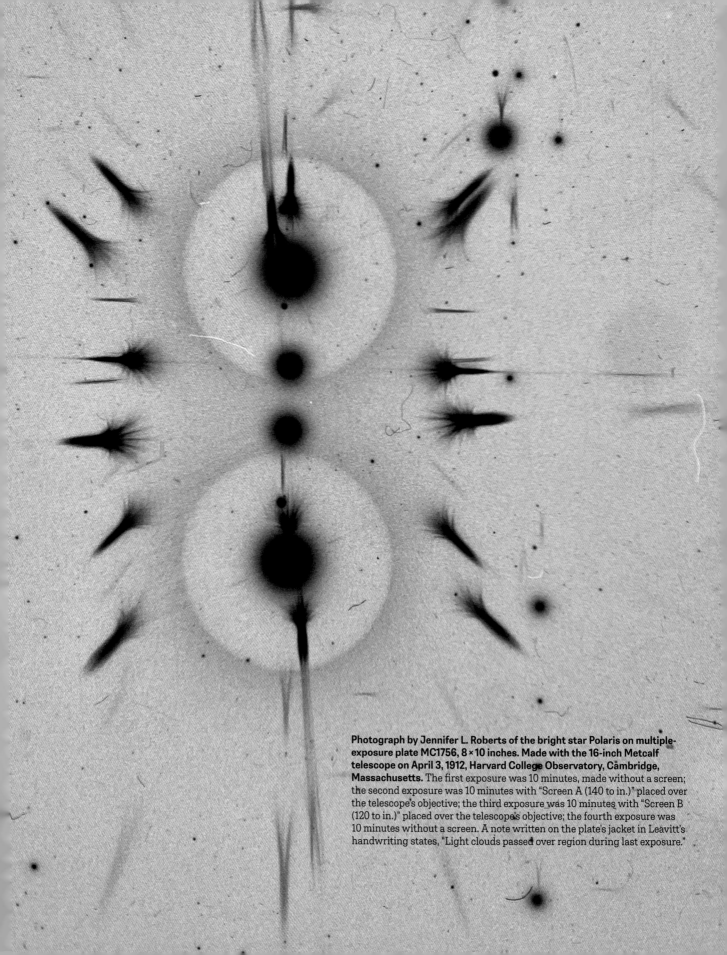

Photograph by Jennifer L. Roberts of the bright star Polaris on multiple-exposure plate MC1756, 8 × 10 inches. Made with the 16-inch Metcalf telescope on April 3, 1912, Harvard College Observatory, Cambridge, Massachusetts. The first exposure was 10 minutes, made without a screen; the second exposure was 10 minutes with "Screen A (140 to in.)" placed over the telescope's objective; the third exposure was 10 minutes with "Screen B (120 to in.)" placed over the telescope's objective; the fourth exposure was 10 minutes without a screen. A note written on the plate's jacket in Leavitt's handwriting states, "Light clouds passed over region during last exposure."

brighter stars was dampened before chemically reacting with the photographic plate by using diaphragms and wire screens to reduce the brightness of a given star. "The apparent magnitudes were then determined by comparison with the stars of known brightness photographed on the same plate, with the same exposure as the brighter stars, but with the full aperture of the telescope. The subtraction of the reduction constant of the diaphragms and screens from the apparent magnitudes gave the real magnitudes of the bright stars." The phrase *reduction constant* repeatedly appears in Seares's writing. Perforated sheet metal, closed-down apertures, and out-of-focus images were used in addition to diaphragms and wire screens to create images of the brightest stars with their light reduced by a set amount so that they could be compared on a multiple-exposure plate to intermediate stars of established brightness. Once a visual match was found between an image of a dampened bright star and a conventional image of a midrange star, the reduction constant could be subtracted (brighter stars are *lower* in number on the magnitude scale) from this temporarily shared magnitude to produce a brighter star's actual magnitude. Diffracting and siphoning starlight, doubling and diminishing stars: these esoteric photographic techniques became a way to bring one star into conversation with another. However, each method had an inherent weakness: some were more affected by passing clouds, others by dust on the lens or temperature aberrations. The strategy seemed to be to throw everything but the kitchen sink at the problem of standardized magnitudes and then average the outcomes for each star so that systematic errors would reveal themselves. From all of this, a reliable magnitude would emerge.

Leavitt's published findings ("Adopted Photographic Magnitudes of 96 Polar Stars," *Harvard Circular* no. 170) provide a comprehensive list of her methods used to wrangle an absolute photographic magnitude from these separate domains. This includes photographs taken out of focus to spread the light of bright stars onto the surface of the plate. This idea of a plate's "surface" comes from Edward Skinner King's comprehensive 1931 *Manual of Celestial Photography: Principles and Practice for Those Interested in Photographing the Heavens.* (King was known for his fastidious work of more than forty years managing the production of photographic images at the Harvard College Observatory.) In-focus images were best to allow faint stars to precisely burn their starlight into the emulsion, but for bright stars it was better to use extra-focal images that diffused their light, photographing them, King writes, "as surfaces." When analyzing the resultant forms, "the photometric law governing their size and density are well established," allowing them to be computed into magnitude.

While the size of each circle of emulsion remained the best criterion for brightness, King mentions a second informative quality: density, or "the blackness of the silver deposit." The density of a star's image depended on the

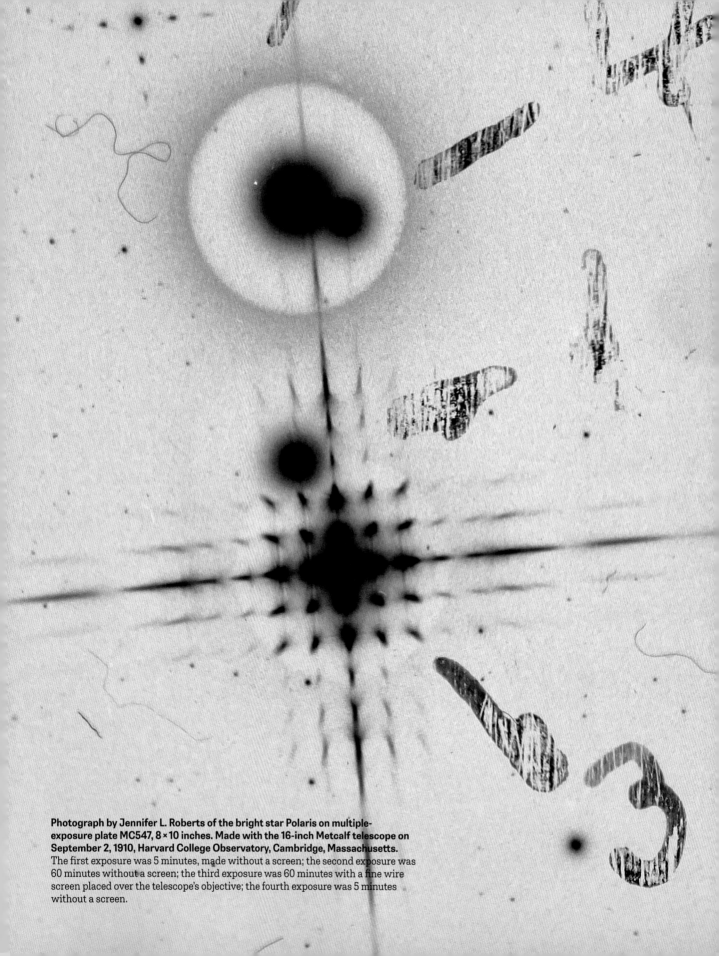

Photograph by Jennifer L. Roberts of the bright star Polaris on multiple-exposure plate MC547, 8 × 10 inches. Made with the 16-inch Metcalf telescope on September 2, 1910, Harvard College Observatory, Cambridge, Massachusetts. The first exposure was 5 minutes, made without a screen; the second exposure was 60 minutes without a screen; the third exposure was 60 minutes with a fine wire screen placed over the telescope's objective; the fourth exposure was 5 minutes without a screen.

"penetration of light and photographic action to the lower strata of the emulsion." There were subtle layers in this two-dimensional world. Brighter stars and longer exposures allowed light to pass "clear through the back of the emulsion," producing a deeper black. An out-of-focus image could pull that bright star back to the surface, pooling its light. At times, for the faintest stars, "the light has not penetrated deeply into the emulsion, and the images are to some extent transparent." What an eloquent, complex visual language these stars of emulsion possessed.

Diffracting starlight is another approach Leavitt cites in *Harvard Circular* no. 170, achieved with "two exposures of equal length, on the same plate, taken with and without a wire screen placed over the objective." When a grating of equal spacing interrupted the starlight hitting a sensitized plate, the diffracted light produced a pattern dependent on the thickness of the wire and openness of the screen's weave. Of this exploded light, King clarifies, "These diffraction images are really little spectra, but those nearest to the central image can be made so short that they look like star points and can be measured in similar fashion." These offshoot "stars" could be measured as a known percentage of that star's overall light.

This is my favorite of Leavitt's methods, though it took me a while to muddle through: "Secondary images formed by an auxiliary prism of very small angle, which is attached to the objective of the 8-inch Draper Doublet, and deflects about a hundredth part of the light." A circular prism would be attached to the center of a telescope's objective, which diverted a small portion of each star's light. Adjusted to a specified angle, it was known to deflect one-hundredth of a star's light, producing a second image on the plate of a star one-hundredth as bright. Because the stellar magnitude scale is exponential, not linear, this fraction of light produces a star five magnitudes fainter than the original star's brightness.

With these techniques stars ascend and descend the magnitude scale, coming into agreement on multiple-exposure plates with stars of known brightness. Solon Bailey wrote of Leavitt's efforts, "This work was carried out with unusual originality, skill, and patience." In a separate instance, Bailey described Leavitt's "unusual ability, originality, and enthusiasm" in regard to this work. I like that patience and enthusiasm are intermixed.

Leavitt's reassignment to magnitude work after her revelations about variables stung Payne-Gaposchkin. (She never met Leavitt or Pickering, having arrived at the observatory two years after Leavitt's death and four years after Pickering's, but in her autobiography, the presence of both is palpable. The fact that Payne-Gaposchkin writes about them as much as she does about the women she worked adjacent to is a testament to both of their legacies.) "It may have been a wise decision to assign the problems of photographic photometry to Miss

Leavitt, the ablest of the many women who have played their part in the work of Harvard College Observatory. But it was also a harsh decision, which condemned a brilliant scientist to uncongenial work, and probably set back the study of variable stars for several decades. I speak feelingly." She writes that it was cruel to relegate Leavitt to the drudgery of magnitude calibration when her excellence at variable work was so vitally apparent. Yet Payne-Gaposchkin acknowledges that "the study of variable stars can lead to precise and significant results only when it is based on accurate photometry." Validating this reality, when Leavitt's ninety-six standard magnitudes were published in *Harvard Circular* no. 170, the paper directly following Leavitt's states: "Systematic observations of the majority of the variables recently discovered on photographs belonging to the Harvard Map of the Sky have been delayed, on account of the difficulty of determining their magnitudes on an absolute scale. The adoption of magnitudes for the stars in the Polar Sequence, as described above, is an important step toward the solution of this problem."

Perhaps Pickering's assignment was not a relegation but a promotion. After Leavitt's germinal discovery of the period-luminosity relation, her continuation of variable work could have served the reputation of the institution. Pickering could have seized her breakthrough finding as a demonstration of what the observatory had accomplished under his watch. But Pickering deemed Leavitt's North Polar Sequence to have the utmost importance. While Leavitt needed to recuperate at her parents' home—just after publishing her paper identifying 1,777 variables in the Magellanic Clouds, in which she first noted the meaningful relationship between the brightness of a variable and the length of its period—Pickering sent a wooden viewing mount, magnifying eyepiece, ledger, contact prints, and glass plates to Leavitt in Wisconsin. The plates he chose to send her were for work on the North Polar Sequence. Leavitt wrote to thank Pickering, in a letter dated February 1, 1910: "My dear Professor Pickering, It is very gratifying to me to have an opportunity to do even a little work on the magnitudes of Polar stars. The interruption of this has been my greatest trial in connection with my present illness."

After those two sentences, it's all about the work. The next line from Leavitt reads, "The enlargements from Plate MC 81, and from the photograph taken with the 60-inch Mount Wilson reflector, show that we shall have the material for a better determination of the magnitudes of faint stars than I had thought probable." This eight-page letter (written on paper that is eight by ten inches, the same dimensions as so many of the plates Leavitt studied) goes on to explain, point by point, the reasoning behind her determinations listed in the columns of the table included with her letter. From page four: "The discordances of magnitudes given in the fifth, sixth, and seventh columns are due principally to the differences in appearance between star images and prismatic comparisons but partly to the fact

641 Church Street,
Beloit, Wisconsin, February 1, 1910.

My dear Professor Pickering,-

It is very gratifying to me to have an opportunity to do even a little work on the magnitudes of Polar stars. The interruption of this has been my greatest trial in connection with my present illness.

The enlargements from Plate MC 91, and from the photograph taken with the 60-inch Mount Wilson reflector, show that we shall have the material for a better determination of the magnitudes of faint stars than I had thought probable. I am glad to know that Professor Hale expects to have a 6-inch auxiliary prism attached to the 60-inch reflector, as some device for determining absolute magnitudes of the faint stars is so important. Although the images on the photographic print in my possession are poor, as you say, stars which are probably more than two magnitudes fainter than No. 47 of the sequence are clearly seen.

I have made some observations of the

that several of the brighter stars do not appear on the print." And from page five: "The large systematic differences given in the last column of the table are largely due to the sharper definition of prismatic comparisons when compared with star images. This has been the greatest difficulty in all determinations of absolute magnitudes by means of different apertures. Would it not be possible to place the auxiliary prism on the 16-inch doublet at some distance from the centre, at a point to be determined by experiment? When the small aperture is placed halfway between centre and edge on the 8-inch doublet, the corresponding images are too poor for safe measurement, but at some intermediate point they would probably be satisfactory." And at the bottom of page seven: "Would it not be worthwhile to take two or three photographs with the 16-inch Metcalf telescope for the purpose of determining the relative absorption in different parts of the objective?" She adds a suggestion at the top of page eight: "Five exposures of equal length might be made, the first and last with the full aperture, and the other three with a 2½-inch diaphragm placed successively over the centre, midway between centre and edge, and tangent to the edge." You get my point. Leavitt may not have been permitted to operate the telescopes, but she knew their inner workings.

Payne-Gaposchkin wasn't the only one with objections to Leavitt's photometry assignment. After her profound discovery, Harlow Shapley and others sent letters encouraging Pickering to have Leavitt continue her variable work, often asking for any updates on her research. Shapley's persistent campaign culminated in a letter dated July 20, 1918:

> I believe the most important photometric work that can be done on Cepheid variables at the present time is a study of the Harvard plates of the Magellanic Clouds. Probably Miss Leavitt's many other problems have interrupted and delayed her work on the variables of the clouds for the interval of six or seven years since her preliminary work was published. I wrote last year something about the importance of these variables in my investigations of cluster parallax. The theory of stellar variation, the laws of stellar luminosities, the arrangement of objects throughout the whole galactic system, the structure of the clouds—all these problems will benefit directly or indirectly from a further knowledge of the Cepheid variables.

When Gösta Mittag-Leffler, a member of the Swedish Academy of Sciences, sent a letter to Leavitt in 1925 (unaware of her death from stomach cancer in 1921) to congratulate Leavitt on her "admirable discovery of the empirical law touching the connection between magnitude and period-length for the S. Cephei-variables of the Little Magellan's cloud," he aired the possibility of nominating her for a Nobel Prize. Shapley, who was by then director of the observatory, was the one to reply, informing Mittag-Leffler of Leavitt's death and expressing regret that she had not been able to take her work further. "Much of the time she was engaged

at the Harvard Observatory, her efforts had to be devoted to the heavy routine of establishing standard magnitudes upon which later we can base our studies of the galactic system. If she had been free from those necessary chores, I feel sure that Miss Leavitt's scientific contributions would have been even more brilliant than they were."

Those necessary chores. In the years following Leavitt's announcement of the light curves for twenty-five Cepheid variables and the graphed relationship between their luminosities and repeating fluctuations—during which time Shapley was developing his work on cluster variables and so eager to have Pickering direct Leavitt's research back to the Magellanic Clouds—a tiny sampling of the tasks Leavitt was working on included studying a class of eclipsing binary stars at the request of Henry Norris Russell; creating color indices based on photographic experiments that tested the sensitivity of plates by using colored screens to filter the range of starlight hitting the emulsion; estimating comparison stars; noting the spectra of stars near the edge of indiscernibility; and devising methods of transforming photographic magnitudes into visual ones. In other words, she was trying to encompass the whole. There is a sense of loss that the direction of her research was not in her own hands. And I, in part, feel that, too. But the relative nature of the work is evident: the eye, the emulsion, the heavens, the individual, and the community are all interdependent. An example: Leavitt used her colleague's spectral classifications to account for a star's color, trying to accommodate the unique way each instrument read the color of starlight. Regarding the numerous telescopes Leavitt was attempting to integrate, Payne-Gaposchkin writes, "I myself attempted to reduce their magnitude systems to some sort of order, and was defeated by the variety of their color curves and the consequent intractability of their color equations." Maybe Pickering prioritized magnitude work for Leavitt over her variable studies because she was the only one who could do it.

Pickering was ambitious and purposeful, clever and tactical. His aspiration to map the sky had been incredibly successful, and he wished to unite the international astronomical community under those heavens. He scheduled a meeting of the Astronomical and Astrophysical Society of America to be held in Cambridge just prior to the 1910 meeting of the International Union for Cooperation in Solar Research at Mount Wilson Observatory, hoping to entice European astronomers to attend both sessions. Adding to the enticement, Pickering arranged for shared travel across the country by train. "After long and friendly discussions" on the journey west—as characterized by Pickering in the 1917 *Annals*—by the time the train reached Flagstaff, Arizona, Pickering had convinced the committee on photographic magnitudes to accept the Harvard system, making Leavitt's North

Attendees of the eleventh meeting of the Astronomical and Astrophysical Society of America (later named the American Astronomical Society) held at the Harvard College Observatory, Cambridge, Massachusetts, August 17–19, 1910. The back of this photo is signed by Williamina Fleming, with these instructions: "This photo must be returned to Mrs. Williamina Fleming, Harvard Observatory, Boston, Mass (Cambridge)." In the same handwriting are descriptions of some of the people shown on the front of the photograph:

Miss Cannon who discovered one new sun in 1910 and another in a previous year

Prof. Edward C. Pickering, Father of the stellar photograph system at Harvard

Miss Florence Cushman one of the star seekers at Harvard Observatory

Miss Leavitt who has discovered one new sun

Mrs. Fleming who discovered two new suns in 1910 and has discovered 10 during her life

Photographic views of the Harvard College Observatory, 1860–1964. HUV 1210 (box 2, folder 26), Harvard University Archives.

Polar Sequence the basis of an international reference standard. In his diary Pickering wrote, "My part in this will be regarded as one of the most important things I have ever done." Once the train arrived, the Solar Union's committee on spectral classification endorsed Cannon's system (agreed on in 1910 and formally adopted by vote at the 1913 Solar Union meeting in Bonn, Germany). The magnitude and stellar classification systems devised by the Harvard Computers had officially established Pickering's desired foundation of knowledge. *Taking the complexities of the world and finding underlying principles.* The women of the Harvard College Observatory were at the center of a collective global effort to understand our observable universe.

I don't want to overly romanticize this work. While at times effusive about her research, at others Williamina Fleming grew weary (like all of us who engage

in repetitive work). In her Chest of 1900 journal entry for March 1 Fleming wrote, "From day to day my duties at the Observatory are so nearly alike that there will be but little to describe outside ordinary routine work of measurement, examination of photographs, and work involved in the reduction of these observations." Yet all scientific discoveries require an appetite for a certain kind of tedium: experiments must be replicated; data needs processing. It reminds me of the early days of parenthood and how small domestic acts done by mothers and fathers—changing a diaper, washing a dish—are the foundations of relationships. They are mundane and repetitious, but also revolutionary. It's where the action is.

T HE GLASS PLATES brought Leavitt to her desk, and they brought her story to me, carrying it through time. That is what quilts, too, have often done: they bring history forward, connect generations, and allow silent voices to be heard. The act of hand stitching—holding layers together, holding ideas together—solidifies my work, making it sturdy enough to carry an idea. Just as the glass plates held Leavitt's presence for me to encounter, I hope my art can help carry Leavitt's story.

At the center of my exhibition at Radcliffe, and remaining at the heart of this body of work wherever the show travels, is a diptych of two hand-sewn quilts I made as a tribute to Henrietta Leavitt's life: her devotion to looking and seeing, the understanding her discoveries facilitated, and the fact that she died before that meaning was fully revealed. In one panel I stitched the stars visible during the first hours of dawn on the morning of her birth; in the other I stitched the stars as dusk settled on the evening of her death. These star trails arc away from each other—one looks east, toward the rising sun, and the other turns west as the sun sets—forming a reverse bracket of light. The strong presence of these two large, black rectangles is a handcrafted monument to Leavitt's achievements, but the space between them holds a very specific amount of time: her life, and the engaging repetition she enacted in that span of time, which built something astonishing—both a profound discovery and a meaningful life.

To translate the heavens into stitches I used software to calculate the stars of the past and projected the stars framing Leavitt's birth and death onto fabric. Playing time forward required choreography. Walking back and forth between my computer and the projection, I traced the trajectory of each star with chalk, a wobbly white line. I reset the time and started again—another star trail, another arc. I assigned each star a value based on its brightness and linked that value to a thread color of white, numerous shades of gray, or black. Then, making them disappear by changing thread colors every few inches as I sewed, I faded each star trail through the gray scale into the black background of fabric.

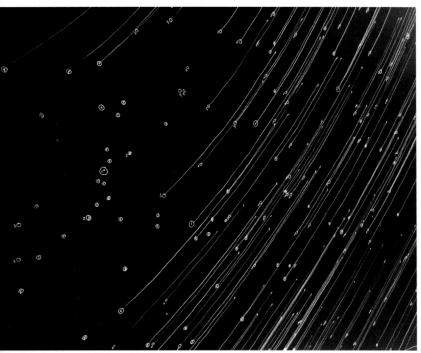

CLOCKWISE FROM TOP:

Diptych installed in Anna Von Mertens's studio (2018) in preparation for her exhibition at the Harvard Radcliffe Institute.

Photo by Gary Arruda, Studio 141 Photography.

Threads in grayscale.

Photo by Anna Von Mertens.

Chalk notations of calculated star magnitudes and trails in preparation for stitching.

Photo by Anna Von Mertens.

Jennifer Roberts has her own words to describe my movements in creating this piece, written for *Measure*, published in conjunction with the 2018 exhibition of these works:

Crouching and stretching as she chased the digital light points across the cloth with her fabric chalk, she drew the data back into a relationship with the span of the human body, back into its original position as something to be pursued, something always just out of reach. And stitching the data into a quilt, she returns it to what I can only think to call its behindness, its emergence from a negotiation between layers and planes, front and back, presence and inscrutability. Half of each thread remains behind the surface, invisible and ineffable as the stitch moves in and out of the plane. (It is precisely in order to achieve this single-stitch dotted line that Von Mertens sews her quilts by hand.) The pattern of the stitches, the image they form, depends on this disappearance and reappearance, this shuttling play between front and back.

The inconstancy of the dotted line created by my hand stitching (whereas a sewing machine produces a solid line of two interlocking threads) interrupts the data it represents. The eye bridges these small leaps of distance, but those small uncertainties remain. As the thread passes through the three layers that construct a quilt (the top, batting, and backing), reemerging and then disappearing once more, it forms a single unit, discrete and isolated, yet connected to the accumulated movement of the strand. This diptych has a presence in its dramatic sweep of birth and death and in its visual rhythm of positive and negative space, but in its humble, straightforward construction it retains a quality of its becoming, of sitting with what is right in front of you and seeing what you can make of it.

Henrietta Leavitt sat and calculated; I sat and stitched. We devised systems for seeing, and in the end, our systems receded. What remained was the brightness of stars. What remained were sewn trails of stars curving against the memory of the domed sky. An echo of our small actions, taken with deliberation, in hope of their significance, the best we could do.

When Jennifer and I installed this diptych at Radcliffe, with the help of Meg Rotzel and Joe Zane, we began by spacing the two panels one hundred inches apart. With each panel one hundred inches wide, this created three equal parts. But it didn't look right. We tried moving the two panels farther apart to give more room for Leavitt's life, but they became visually disconnected. So we slowly brought them back toward each other, until they seemed to click into place. Out of curiosity, I measured the span: ninety-nine inches. Closer together by a single inch, that magnetic pull had been needed to draw the two quilts together, activating that space, and in that space, Leavitt's life.

LEAVITT WORKED INDEPENDENTLY, and she depended on the relationships surrounding her. There were individual lines of research, and research that was built from shared findings. There was brilliance and the everydayness of things. There were personalities, egos, affections.

Cecilia Payne-Gaposchkin was a direct woman, and her descriptions of her colleagues are delightfully so. She describes Lillian Hodgdon as "a voluble strutting hen." Her job was to replace the envelopes for the glass plates once they were overworn. "In her own mind she kept the whole enterprise in motion." Hodgdon worked at the Harvard College Observatory for forty-eight years. Maybe she *did* run the place.

There was Evelyn Leland, who worked at the observatory from 1889 to 1925 and hunted for variables with Cannon and Leavitt when Pickering divided up the sky into fifty-five sections and assigned a third to each of them. Pickering parceled out each woman's assignment irrespective of location in seemingly random bundles, or as Dava Sobel describes it, "as though dealing a hand of rummy." From *Harvard Circular* no. 127:

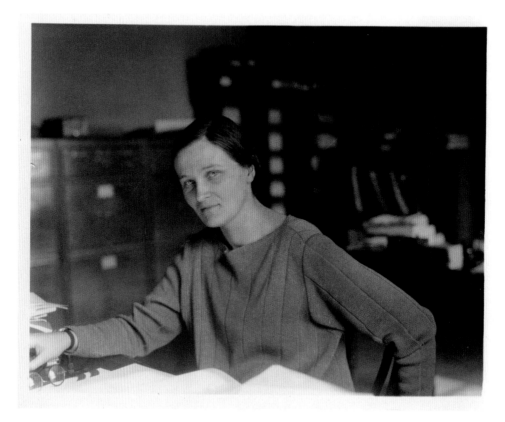

Cecilia Payne-Gaposchkin at the Harvard College Observatory.
Smithsonian Institution Archives. Image # SIA2009-1326.

The sky has accordingly been divided into three parts, that covered by Nos. 1, 4, 7, 10 etc., being assigned to Miss Cannon, Nos. 2, 5, 8, 11 etc., to assigned to Miss Leland, and Nos. 3, 6, 9, 12, etc., to Miss Leavitt. For each region, five plates are selected and a contact print made from one of them. The other four are then superposed on this print in turn, and the stars showing evidence of variability marked. Some of these prove to be known variables, some to be new variables, some are still suspected of variability, and the others are not confirmed and seem to be due to photographic defects or other causes of error.

These three women scoured the sky for variables—for *all* variables, everywhere.

With Harvard's deep reservoir of data and Pickering's willingness, even eagerness, to share this resource (it was his explicit intention for the observatory to be at the center of international astronomical research), research requests came by letter and telegram. The Harvard Computers sent informed responses, including annotated prints made from the plates. A logbook of Ida Woods's shows that she spent two weeks looking through the plate stacks in regard to a 1925 request from B. Asphind of Sweden for any plates taken in 1901 that might show a particular asteroid of his interest. Woods's reply, identifying and illustrating numerous potential asteroids, began a correspondence between Asphind and the observatory that continued for many years.

Ida Woods worked at the observatory for thirty-seven years, and Mabel Gill, who assisted Woods with the research request, worked at the observatory for thirty-five years. When Mabel Gill entered the workforce in 1892, she joined her sister, Edith Gill, who began working at the observatory in 1889. Both sisters worked at the observatory until 1927. Of the two, Payne-Gaposchkin writes, "The Gill sisters, Mabel and Edith, hover in the background, quiet, self-effacing, always busy."

Leavitt is commonly referred to as having been deaf, but there is little record of this beyond Leavitt mentioning, in a 1902 letter to Pickering, that she was seeking the help of an aurist. "I am having some trouble with my hearing, worrying, a little oddly, that stargazing might make it worse. My friends say, and I recognize the truth of it, that my hearing is not nearly as good when absorbed in astronomical work." It appears to have been a progressive loss of hearing (Shapley, who arrived at the observatory as director just a year before Leavitt's death, states plainly in his autobiography that Leavitt was deaf) but one that affected her personal and working relationships not at all. Leavitt's hearing is not a detail Solon Bailey mentions in her obituary. Annie Jump Cannon, too, has been described as deaf, although Shapley writes that Cannon "had some kind of infection while she was in college, and as a result her hearing was pretty much lost"—likely a bout of scarlet fever during her years at Wellesley. Cannon was known to remove her hearing aid when she wished to increase focus on her work.

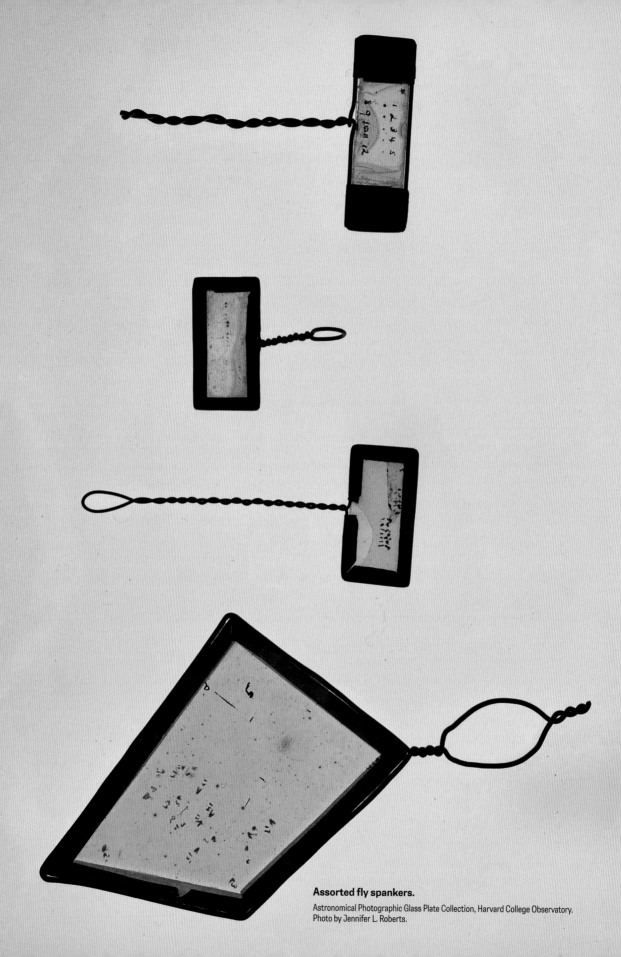

Assorted fly spankers.

Astronomical Photographic Glass Plate Collection, Harvard College Observatory.
Photo by Jennifer L. Roberts.

Amid collaborative work, there was room for the individual within the walls of the Brick Building. I couldn't verify a theory that the women sat in the round to facilitate lip reading, but one of its implications seems sound: Cannon's and Leavitt's loss of hearing wasn't a big deal. What needed to be accommodated was accommodated without fuss. The women supported each other in their work and workaday lives.

While the individual legacies of the Harvard Computers are often merged into a collective one, their jobs were varied, and the skills each woman excelled at varied as well. Pickering wrote in the preface to the 1918 update to the *Draper Catalogue*, "Miss Cannon was aided by several assistants, the average number being five. It was evidently best that she should restrict her own work to those portions which could not readily be undertaken by the others. This included the classification, the revision, and the supervision of the whole." Pickering goes on to list those who helped: "Among the assistants who have participated in this work at different times may be mentioned Misses Grace R. Brooks, Alta M. Carpenter, Florence Cushman, Edith F. Gill, Mabel A. Gill, Marian A. Hawes, Hannah S. Locke, Joan C. Mackie, Louisa D. Wells, and Marion A. White. The excellent progress made is largely due to the interest and skill shown by all who have taken part in the work."

Leavitt, whose prowess in photometry was as exceptional as Cannon's in spectroscopy, was also aided in her research. In the very back of Leavitt's Record of Progress (a leather-bound notebook that provides narrative documentation of the projects she was working on between 1912 and 1919), several pages have the same header in Leavitt's handwriting: "Routine Work for Assistants." This is often how the work of the Harvard Computers was and is described. Here is evidence that the roles of each woman at the observatory were not the same, nor equivalent.

One of my favorite descriptions from Payne-Gaposchkin is of Louisa Wells: "She was tiny and vehement, and she seemed to me very, very old. Years before she had discovered SS Cygni on Harvard plates, and it had been known as 'the Wells variable.' Today SS Cygni is such a classic star that it is hard to believe that I knew the person who discovered it. I have a memory (or is it just a legend?) of her sitting at her desk marking stars on a plate, and then falling asleep and rubbing off all the marks with her nose." Louisa Wells worked at the Harvard College Observatory from 1887 until 1930.

One of the tools the women created to aid their study of the glass plates— particularly to distinguish tenths of magnitude, the subtlest of shifts—was called a fly spanker. These were small pieces of cut glass attached to a wire handle, edges wrapped. They were not dissimilar in appearance to miniature fly swatters, so Leavitt called them fly spankers because they were "too small to do a fly much damage." I underestimated fly spankers as merely a funny story, and then realized

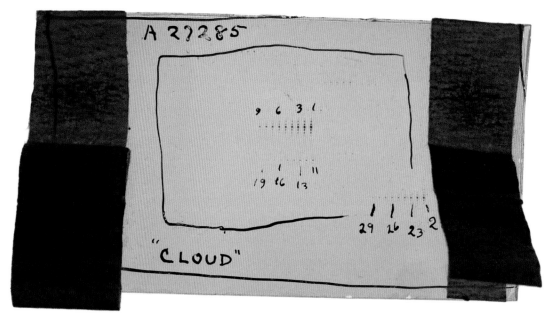

While early versions of fly spankers had twisted wire handles, these objects evolved into being simply pieces of cut photographic glass that could be slid across plates to facilitate comparison. These fly spankers were given names such as "Blue Haze" and "Cloud."

Astronomical Photographic Glass Plate Collection, Harvard College Observatory. Photo by Jennifer L. Roberts.

that was in and of itself significant—these women had a sense of humor. They had their own world, their own language, their own jokes. I am confident nothing else in this world has ever been called a fly spanker.

I had also underestimated the power of this compact tool. These fly spankers were their own remarkable objects. They were made by taking repeated exposures of the same star, with each exposure increasing in length: five seconds, eight seconds, fifteen seconds, all the way up to a minute, then two minutes, four minutes, and so on. This produced an incremental string of dots, like an elongated ellipsis growing in intensity, to which the women would ascribe numbered magnitudes, marked in ink directly on the glass. Cut from one of these multiple-exposure glass plates into small rectangles and made handheld with twisted wire, these portable guides helped reveal discrepancies associated with the technology. The women would examine a reference star on a plate to see if its registration of light had been shifted from its standard magnitude by a long list of subtleties: a thin veil of clouds unnoticed by the telescope technician, temperature fluctuations expanding or contracting the equipment, a layer of dust obscuring the lens, or developing chemicals varying batch to batch. If the standard deviated, that reference star, and all of the other stars on the plate, could be calibrated accordingly. Fly spankers could also help couple sequences of stars from plate to plate. A star captured on one plate could more easily be compared

to its own likeness on a second plate using a fly spanker as a gauge. Not only did they help the women readily assign magnitudes; fly spankers established correlations, linking plates, sewing together patches of the sky. From parts they created a whole. The Harvard Computers constantly needed reference points, and they made their own.

Like almost all of the Harvard Computers, Leavitt never married and had no children. Perhaps this was her choice, or perhaps it was a choice society pressed upon her—it was expected, demanded even, that middle- and upper-class white women leave their jobs once married. Regardless, as Dava Sobel writes in *The Glass Universe*, "no newcomers need apply." There were no positions available; nobody was leaving. This group of women chose to be wedded to their work.

There may have been other circumstances behind this dedication, financial necessity being one of them. Anna Winlock grew up assisting her father, Joseph Winlock, who was the third director of the observatory, preceding Pickering. Winlock sought work to help support her mother and younger siblings after her father's unexpected death. She was one of the first computers hired, and stayed as part of the observatory staff for the remainder of her life. Louisa Winlock began working at the observatory several years after her sister, yet another Harvard Computer with a lengthy tenure: twenty-nine years.

A single mother, Williamina Fleming was dependent on her lone income, though she occasionally noted in her diary her frustrations with Pickering. After eighteen years of working at the observatory, Fleming was promoted to be the curator of astronomical photographs, becoming the first woman to hold a Harvard University title. When she wrote this journal entry on March 12, 1900, she was supervising a staff of twelve women: "Sometimes I feel tempted to give up and let him try someone else, or some of the men to do my work, in order to have him find out what he is getting for $1,500 a year from me, compared with $2,500 from some of the other assistants. Does he ever think that I have a home to keep and family to take care of as well as the men?"

As outliers, the Harvard Computers created their own community outside the bounds of traditional expectations. While there is no written evidence of intimate feelings between any of the women, there is no doubt they were family. They worked together and sometimes lived together. Many resided at a nearby boardinghouse, including Leavitt, who lived there for several years starting in 1916. When Annie Jump Cannon lived with Fleming during Cannon's early time at the observatory, Fleming wrote in her journal about a visit from their mutual friend:

> Miss Anderson spent the evening with us. She is so bright and happy, we
> always enjoy seeing her. We played a game of "India." Then we went down to
> the kitchen to make "fudge" but found that the fire had gone out. We were not

Photograph of a group of Harvard Computers from one of Annie Jump Cannon's scrapbooks. Left to right: Molly O'Reilly, Florence Cushman, Mabel Gill, Evelyn Leland, Annie Jump Cannon, Henrietta Leavitt, Grace Brooks, Alta Carpenter, Edith Gill, Ida Woods, Johanna Mackie.

Annie Jump Cannon Papers, HUGFP 125.36 (box 2), Harvard University Archives.

to be beaten, however, so we got the chafing dish, collected in it the ingredients for one "spree" and carried all upstairs to the sitting room. We played a second game of "India" while the "fudge" was cooking, but as our attention was necessarily divided between the game and the "fudge," the first was most amusing, while the second was not quite so good as usual. We ate it, however, and promised to give more attention to our cooking next time.

The fondness that infuses these relationships is evident in Cannon's writing as well. During the year after Leavitt's death, Cannon spent six months in Arequipa, yet again behind the eye of a telescope, producing photographic plates like the ones she had studied for so long. Almost sixty years old, Cannon seemed to relish the physicality of manning the telescopes. "I expect to be an athlete when I return to Old Cambridge," she wrote in a letter to Shapley, "for the running of the 13-inch requires turning a heavy dome, mounting ladders big and little, and all sorts of things, which Mr. Muñiz declared I could not do, for it was not 'woman's work.' I can do it all, however, except get good plates of faint spectra." (Again, a sense of humor shines through.) Cannon's April 20, 1922, journal entry from her time in Peru includes these three bittersweet sentences: "Magellanic Cloud (Great) so bright. It always makes me think of poor Henrietta. How she loved the 'Clouds.'" How strange to think that Leavitt never set eyes on their luminescence herself.

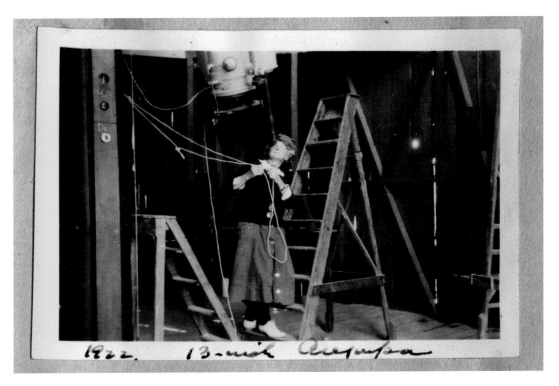

Photograph of Annie Jump Cannon looking through the 13-inch Boyden telescope at Harvard Boyden Station, Arequipa, Peru, 1922, from one of her scrapbooks.

Annie Jump Cannon Papers, HUGFP 125.36 (box 2), Harvard University Archives.

Leavitt knew the Magellanic Clouds so well, their patterns probably as familiar as the features of a loved one.

In Cecilia Payne-Gaposchkin's obituary for Cannon, published in *Science* in 1941, she recognizes the enormity of the loss for the astronomical world—not just the loss of Cannon's vivacity, but the loss of Cannon as "an institution." Yet Payne-Gaposchkin's last sentence feels the most resounding: "Perhaps the greatest tribute that I can pay to her memory is to say that she was the happiest person I have ever known." Their jobs built affection for the work, and for one another.

The final paragraph in the chapter in Payne-Gaposchkin's autobiography about her early days at the Harvard College Observatory begins, "I heard tell that Miss Leavitt's lamp was still to be seen burning in the night, that her spirit still haunted the plate stacks." True to her thorough methodologies, Payne-Gaposchkin offered the probable facts: she liked to work at night, as did Antonia Maury, who insisted on keeping the windows open. Succumbing to mosquito bites became a workplace hazard. Harlow Shapley had given Payne-Gaposchkin the desk at which Leavitt used to work. Payne-Gaposchkin's lamp would have been seen in the window: Leavitt's ghost. I am not surprised that Leavitt's presence was felt, and missed. She was a legend. She was astonishing; she was a marvel.

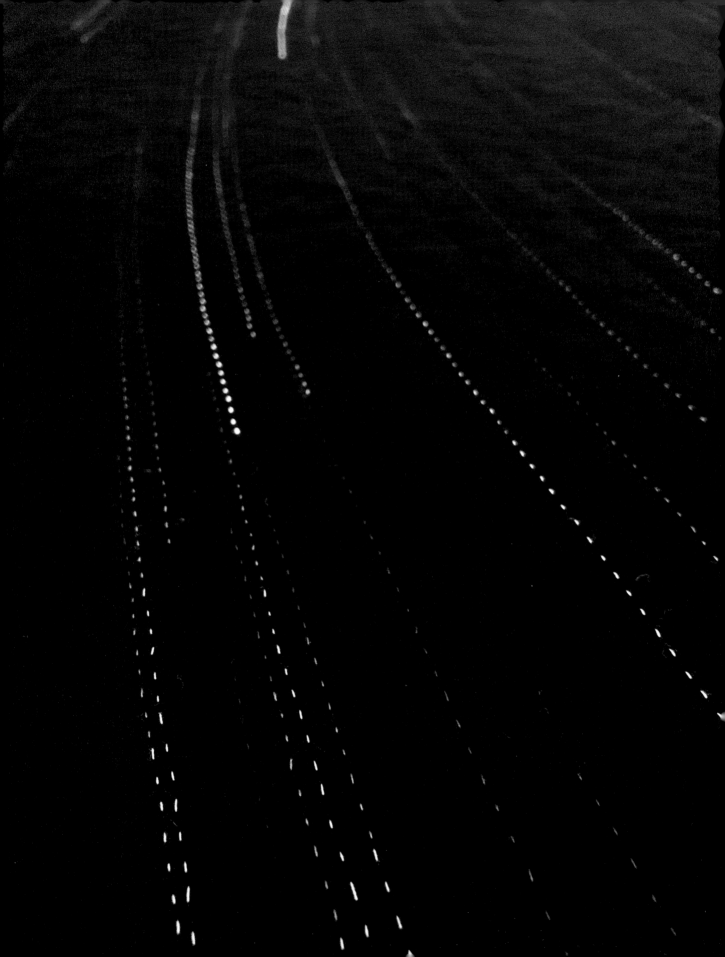

IN THINKING ABOUT Leavitt's life and her choices held within it, I return to Jennifer's writing from 2018 about the two hand-stitched quilts I made commemorating Leavitt:

> With her stitches, Von Mertens introduces opacity and uncertainty to data, interrupting its apparent omnipresence, its relentless apparency. She devisualizes it. In this sense, her stitching is an act of closure. But at the same time it is an act of opening—and holding open—the spaces in which that data is formed. In terms of Henrietta Leavitt's work, this seems to me to be an urgent operation. Without it, we sentence Leavitt (and all of the Harvard Computers) to a plodding and plotting reputation; we imagine them working drearily in a flat world of rote calculation. To restore to Leavitt the rooms and days and glasses through which she worked is to give her back the scope in which to be restless, the space in which to conceive of vast scales. A space shared by dreamers, scientists, and poets. It is to hold open the space of searching that led to the finding.

There is a document in the Oberlin College Archives, an alumni survey that Leavitt completed in 1908. For the question "Books or articles written or edited?" Leavitt has a sizable answer. She lists her publications to date: "*Harvard Observatory Circular* 78, 79, 82, 86, 90, 91 (1904), 105 (1905), 107, 115, 120, 121, 122 (1906), 127, 130, 133, 135 (1907). 1,777 Variables in the Magellanic Clouds. Ten Variable Stars of the Algol Type (1907), etc." (Yes, Leavitt actually wrote "etc." Her list was just a start.) But Leavitt had made an error—she had listed *Harvard Circular* no. 79 as her first publication, forgetting for a moment that her published findings actually began with *Harvard Circular* no. 78. To correct this, Leavitt made a mark similar to one she often made in her logbooks. Protocol asserted that she never erase—part of the scientific process is leaving all documentation of the path taken—so if an estimation of magnitude required adjusting, Leavitt would draw a diagonal line through the digit to be modified and write the updated value just to the right above the original. On the Oberlin survey, Leavitt draws a diagonal slash across the digit nine and writes above it the number eight. Her published findings now began with *Harvard Circular* no. 78. Leavitt's presence is asserted both in her long list of published papers and this careful mark. In written summaries of Leavitt's life, I am accustomed to seeing the year of Leavitt's death (1921) accompany the year of her birth (1868). In this archival document, of course, just her birth year appears. Here she is, at her desk, sitting and looking. Here she is, paying attention, repeating small actions that build meaning. Here she is, in the middle of things, in the middle of the finding.

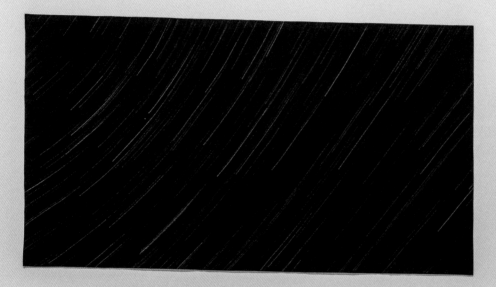

Installation view of Anna Von Mertens's quilt diptych as part of her 2023
exhibition at University Galleries of Illinois State University. Left: *The stars fading
from view on the morning of Henrietta Leavitt's birth, July 4, 1868, Lancaster,
Massachusetts.* Right: *The stars returning into view on the evening of Henrietta
Leavitt's death, December 12, 1921, Cambridge, Massachusetts.* Hand-stitched
cotton, 2018.

University Galleries of Illinois State University. Photo by Jade (Minh Hà) Nguyễn.

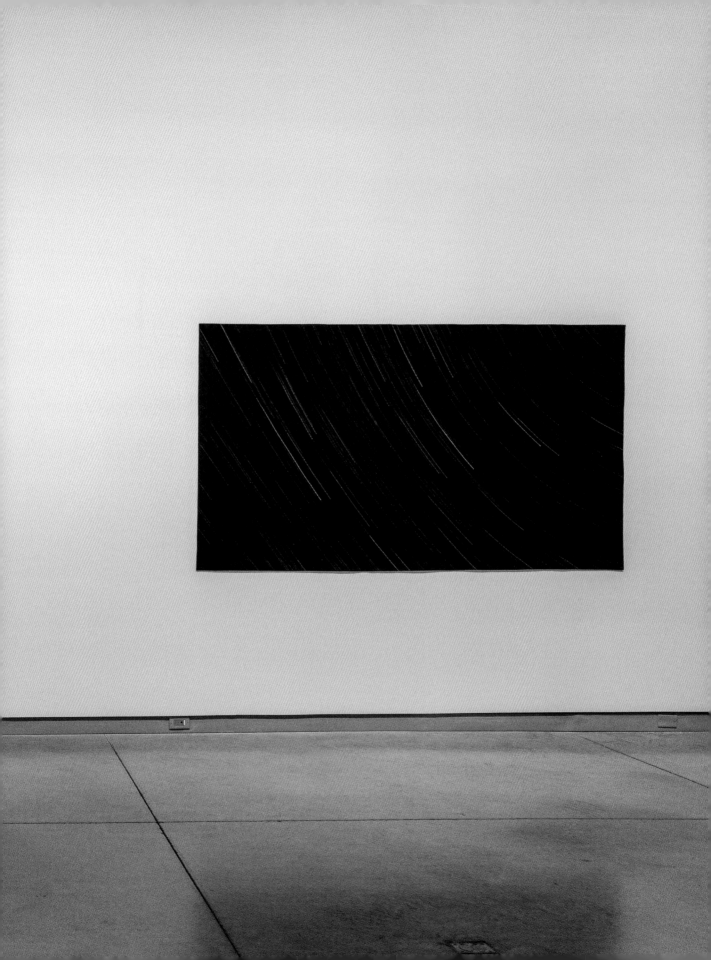

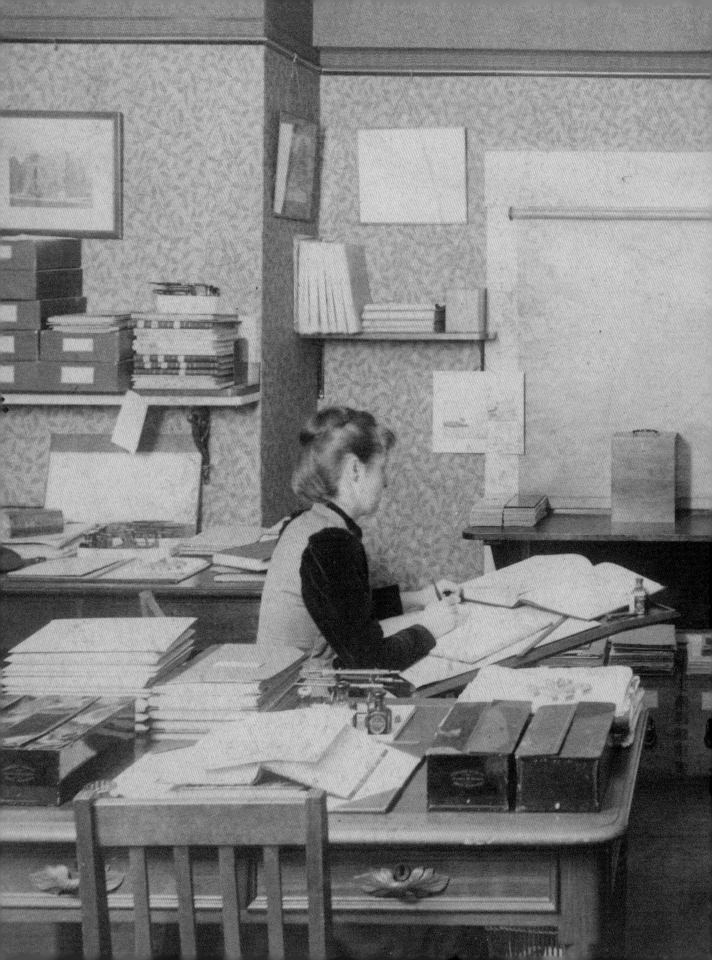

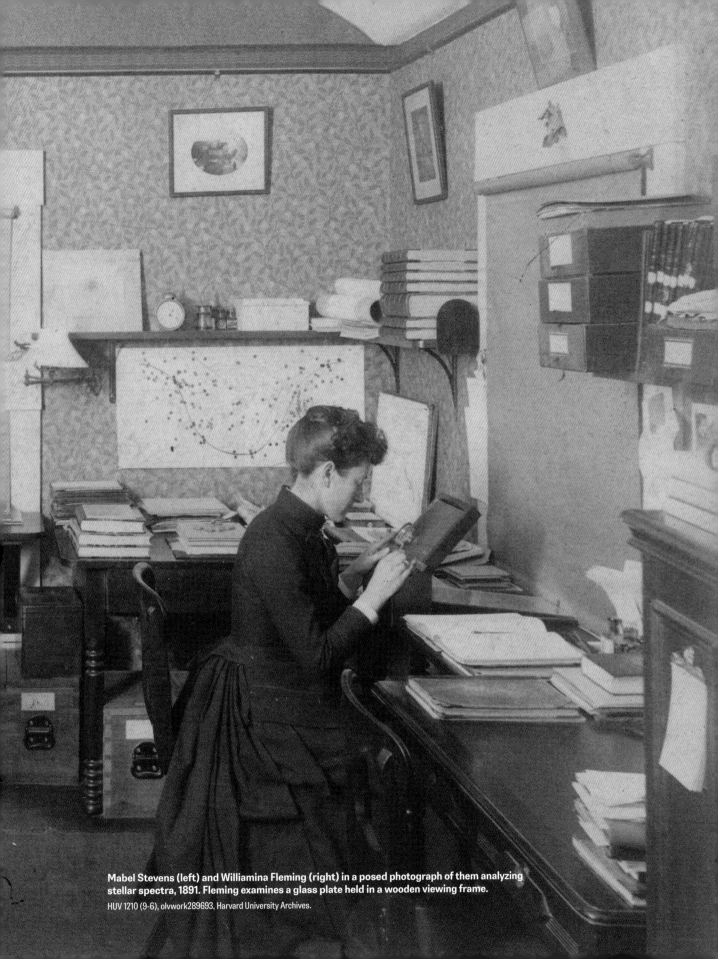

Mabel Stevens (left) and Williamina Fleming (right) in a posed photograph of them analyzing stellar spectra, 1891. Fleming examines a glass plate held in a wooden viewing frame.

HUV 1210 (9-6), olvwork289693, Harvard University Archives.

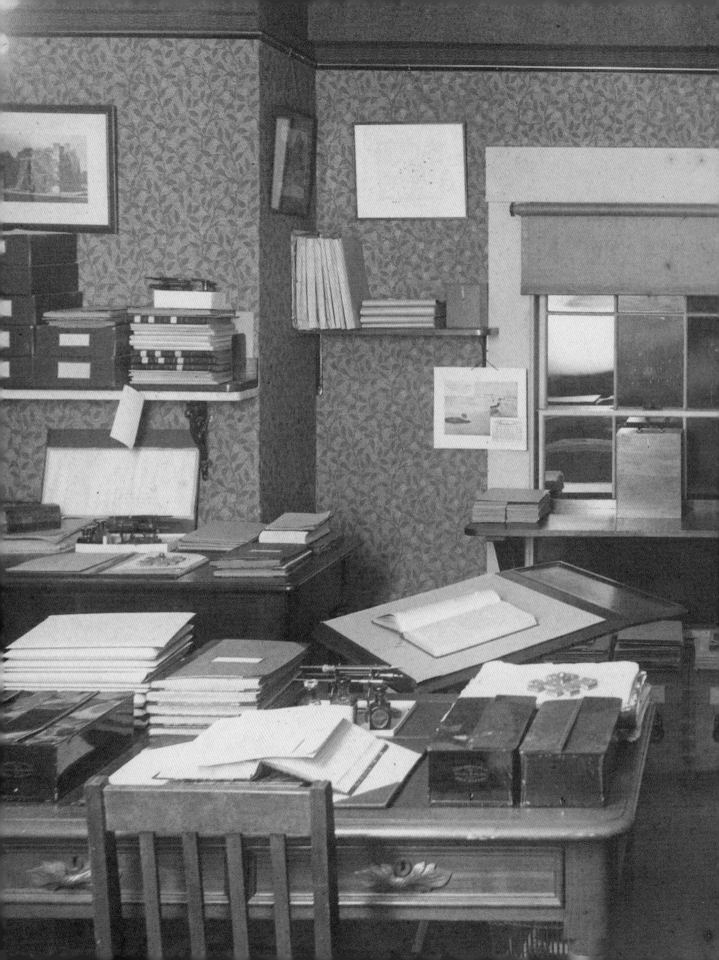

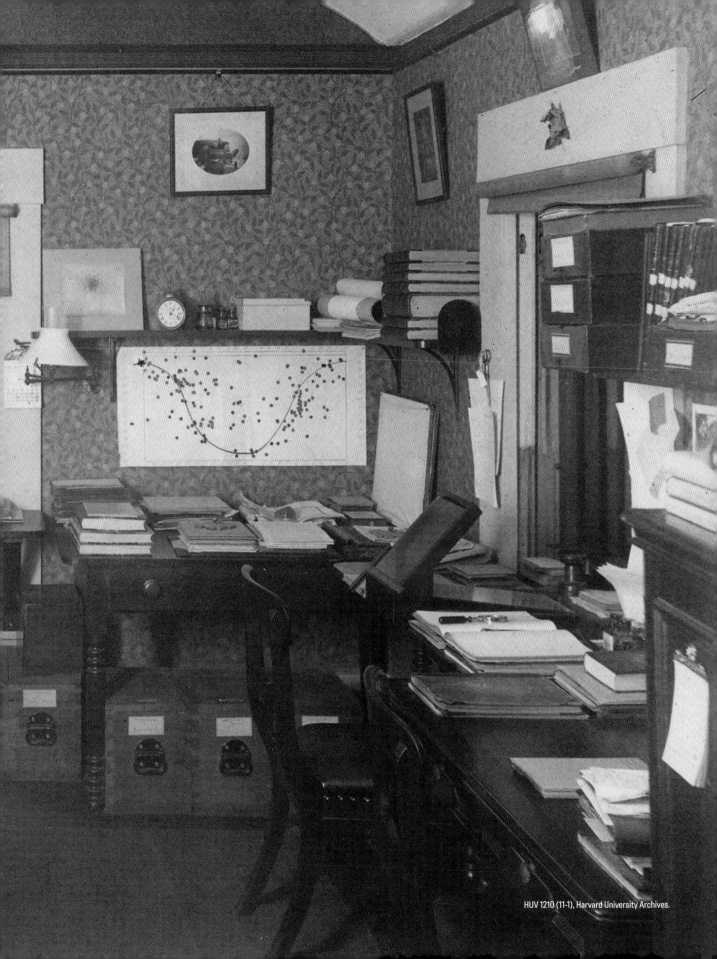

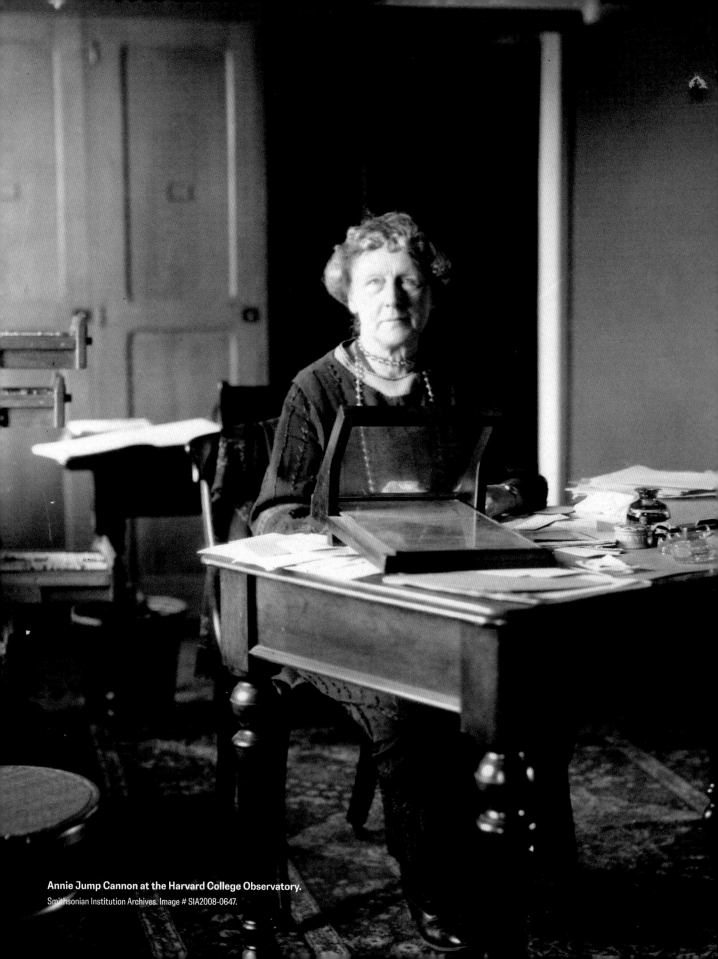

Annie Jump Cannon at the Harvard College Observatory.

Colleagues and Characters

LEAVITT, FLEMING, CANNON, AND MAURY

Rebecca Dinerstein Knight

Between 1877 and 1919 Edward Pickering hired over eighty female computers. In a small room of nearly identically clad women—women whose high-buttoned, long-sleeved black dresses stood out only against the room's floral wallpaper, whose bangs curled uniformly to cover only the top inch of their foreheads, whose buns were coils of jailed braids, whose tidy American names were Mabel and Edith and Louisa and Louise and Lillian, whose comportment proved so orderly they occasionally wore bowties—Williamina Fleming, Annie Jump Cannon, Antonia Maury, and Henrietta Leavitt have been singled out again and again as the ones to watch.

It could be the sameness that emphasized the exceptional. It's easiest to distinguish players' ability when everyone's playing the same game. And one virtuosity illuminates, and delineates, the next. Each figure on an NBA court, for instance, is working to win by the same rules, but it's often a solo attraction (Jordan), or a seamless duet (Jordan and Pippen), or a geometrically unflappable triangle (James, Bosh, and Wade) that comes to define the sport. The talents of individual players are grouped into shapes and relationships that become as recognizable as constellations and acquire their own myths. Popular television writing, too, has made use of this configurative device—in which the charm of a single character is enhanced and differentiated by her position within a cohort—famously and fruitfully in the HBO television series *Sex and the City*, which ran from 1998 to 2004. The show's protagonist, Carrie, is as savvy as a heroine need be to function as a standalone lead, but what allowed viewers to identify her, to see her facets in better detail, was in fact her contradistinction from, say, Charlotte, whose pearls and neuroses helped to demonstrate what Carrie was and wasn't. Viewers of the show

know, in archetypal terms, what a "Samantha" is (a siren), just as they understand a "Miranda" (a snail: soft-bellied, hard-shelled). The writers of this series unwittingly proved an astronomical point: stars require comparison with one another to measure their individual brightness.

We might then interpret the Harvard College Observatory's leading figures as a quartet. Their sensibilities and scientific practices functioned alongside and against each other. And in the case of Leavitt, who did not share the habits of diary keeping and scrapbooking held by Fleming and Cannon, nor the squeaky-wheel outspokenness of Maury, this kind of comparative approach may be the best (and only) technique available for unraveling her reticence.

Williamina Fleming knew how to showcase her strengths. We don't know what she did to distinguish herself while employed as a maid in the Pickering home, what conversational brio or unconventional linen care caught the homeowners' eyes. But she made herself clear. Where many maids might choose to vanish, Fleming allowed herself self-expression (or perhaps refused to repress herself) and drew

notice. Once transferred out of the home and into the observatory, Fleming kept up a markedly domestic affection in her communications with the observatory director, beginning the office minutes during his absences with such endearments as "Dear Sir, Everything here seems to be going on very well, except that everyone misses you."

Unlike so many who buckled under the weight of propriety, Fleming seemed to experience no conflict between personality and professionalism. She carried herself with the kind of unaffected confidence that comes from an innately sturdy disposition or an underdog's indefatigable pluck. When she decided to have lunch she "got Miss Cannon interested." When the telephone at Littlefield's market was out of order, she got the clerk at Norton's fish market to run over her household grocery list. In explaining a delayed return to work, she wrote, "Hallie was so glad to get me here that she has made me promise to stay with her over Friday night for some special function. So I shall not reach Cambridge before sometime Saturday afternoon" — her own slightly more self-congratulatory version of Jane Eyre's "There is no happiness like that of being loved by your fellow creatures, and feeling that your presence is an addition to their comfort" — and signed off a pre-event letter with "I am sure you would wish me 'good luck' in my interview."

Fleming's inclination to document herself in diaries and letters and logs, itself a personality trait, preserves her entry in the history of science. In her monthlong journal of daily activities (a contribution to Harvard University's Chest of 1900 time capsule project) we get a glimpse of her industry. Her observatory duties from March 10 alone include reviewing plates for suspected variables with Evelyn Leland, discussing calibration of atmospheric absorption with "the Director," working with Ida Woods on "out of focus" plates, analyzing variable magnitudes with Solon Bailey, and untangling Miss Cannon's "remarks" (quotation marks are hers, and somewhat derogatory, as she grew increasingly frustrated with the sinkhole that editing these "remarks" had become), only to come home to a computer applicant waiting at her door and a fourteen-person dinner party to host. She and the last two lingering guests discussed an upcoming solar eclipse expedition until one o'clock in the morning, when "sheer exhaustion forced us to seek rest."

Fleming concluded her workdays with these nightly notations until she conceded: "March 14 to March 20. My daily duties at the Observatory exhausted all my strength each day and at night I was unable to make any record of the day's work and events." A doctor's house call the following day confirmed that she had been working through a severe case of influenza. Her next five days were spent recovering. Fleming broke only when she broke down.

As a teenager in her native Scotland she had worked as a teacher; still her handwriting across these records proved sloppier and speedier than her colleagues' schoolgirl cursive. In place of uniform loops of equal height and width, Fleming scrawled with pointed strokes and crossed her *t*s with frantic dashes as long as the words themselves. This was someone who valued completeness over convention, and who wanted most of all to get her message across. She enjoyed running ship (and Pickering trusted her to do so in his absence), while also running a perpetually demanding household (among the Harvard Computers, Fleming was the only single mother), even when both home and office required what she perceived as the endless cleaning up of other people's messes. At her own desk she cataloged more than 10,000 spectra and

discovered 10 novae, 59 gaseous nebulae—the Horsehead Nebula among them—and 310 variable stars. She would have liked to discover far more. The first woman to receive a Corporation appointment at Harvard, Fleming died of pneumonia at fifty-four, after wrestling with chronic fatigue.

Annie Jump Cannon took things, in some respects, a bit slower. She could classify the spectra of 300 stars an hour (a 1912 volume of *Popular Astronomy* described her as "the one person in the world who can do this work quickly and accurately"), but she also liked to glue cardboard puppies into gilt-edged scrapbooks. Cannon classified a total of 350,000 stars with an average error margin of less than one-tenth of a unit and received worldwide recognition as "the greatest living expert in this area of investigation," yet her attitude toward the work remained curiously level, devoid of compulsion, anxiety, or pride. "Miss Cannon was extraordinarily kind to me," recalled Cannon's colleague Cecilia Payne-Gaposchkin. "She might well have resented a young and inexperienced student who was presumptuous enough to attempt to interpret the spectra that had been her own preserve for many years." In recommending Cannon for university recognition (previously denied by Harvard president Lowell and not awarded until 1938, under new university leadership, three years before her death), the chairman of the Visiting Committee noted, "She has acquired such a perfect mental picture not only of the general types, but of their minute subdivisions, that she is able to classify the stars from a spectrum plate instantly upon inspection without any comparison with photographs of the typical stars."

Cannon seemed to find solace in her own expertise. Her encyclopedic efforts did not agitate or drain her. When she wasn't at work, she led a prolific social life, seeking out the pleasures and restorations of good company, fine weather, travel, games. When the observatory hired Shapley as Pickering's successor, Cannon took the new director to the symphony. Her brand of ebullient equanimity—Shapley called her "famous and jolly"—was her own, an example of excellence without vanity.

In her own corner worked Antonia Maury, vinegar to Cannon's salt of the earth, described by her own aunt (the Mrs. Draper behind the observatory's Draper Memorial) as "the annoyance." Maury's mixture of aptitude and attitude has been described by Bessie Jones and Lyle Boyd in their history of the observatory as "the most elusive personality among the women astronomers at Harvard." They generously, and insultingly, equivocate: "Miss Maury was by temperament not entirely suited to the day-by-day tedium that was accepted as a matter of course by the less creative members of the staff."

If Cannon chose identification over interpretation, Maury demanded interpretation above all. And if Fleming prized completeness over convention, Maury preferred credit over completeness. She wanted her name, and her name only, listed on her work (fair enough), yet her projects remained long unfinished. "[Pickering] valued her skill highly," Jones and Boyd acknowledge, "but by leaving an important piece of investigation in midair yet being unwilling to relinquish it to others she had placed him in a quandary." Finally, Aunt Draper comes out with it: "Between ourselves," Draper wrote to Pickering, "if Antonia would write up the work she has done,—it seems as if for the future we might supply her place more satisfactorily—she is not a valuable member of the corps."

This judgment is severe on one who developed a spectra classification system so complex it sorted across twenty-two groups and three divisions of

As We Were.

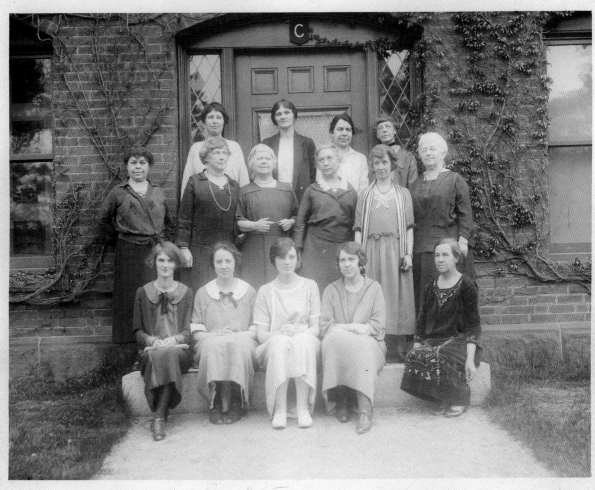

1925

The copy of this 1925 photograph in the Harvard University Archives is inscribed with the caption "As We Were." The same image appears, with the women identified, in Cecilia Payne-Gaposchkin's autobiography. Back row (left to right): Margaret Harwood, Cecilia Payne, Arville Walker, Edith Gill. Middle row (left to right): Lillian Hodgdon, Annie Jump Cannon, Evelyn Leland, Ida Woods, Mabel Gill, Florence Cushman. Front row (left to right): Agnes Hoovens, Mary Howe, Harvia Wilson, Margaret Walton Mayall, Antonia Maury.

HUV 1210 (23-1), olvwork360658, Harvard University Archives.

stars, as Maury did over a course of nine years. But such a granular standard proved far too slow to generate and apply. "Miss Maury had a passion for understanding, a genius for analysis that led her to anticipate by several decades the discovery of luminosity criteria," grants Cecilia Payne-Gaposchkin. "Her eye for detail was as keen as Miss Cannon's, but she was always slowing things up by asking what it meant." Maury came and went from the observatory repeatedly, restlessly, and begrudgingly,

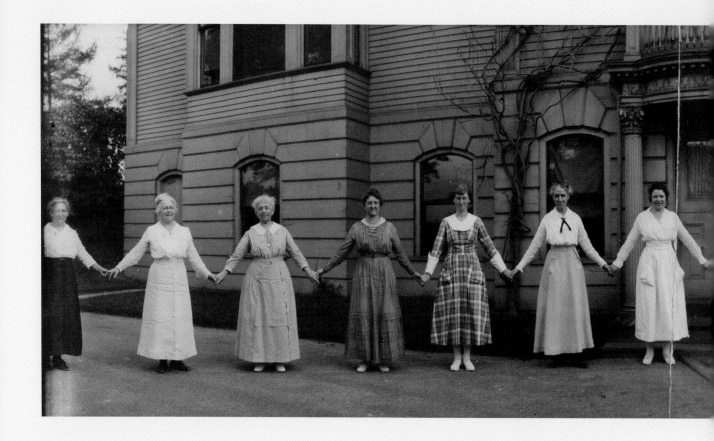

never able to fully distance herself from this work. Payne-Gaposchkin recalls: "I was very fond of her, but she just talked and talked and talked and talked. You couldn't do any work because she wanted to talk so much. It was just that she needed an outlet; she needed to discuss. Nobody had ever listened to her, nobody had ever responded to her scientific questionings, I think."

This tension between discovery and recognition, adamance and arrogance, plagued the men and women of nineteenth-century astronomy—a particularly competitive set of scientists vying for dibs on an uncharted domain. But naturally it had shown up in all kinds of cohorts before them. The outline of one's ego is always visible on the floor—the shadow cast by every ambition. Some crave distinction among peers; others draw strength from self-possession. Michelangelo could not bear the company of rivals and refused to encourage young talent; not so with Leonardo, who, after achieving his own standard of technical or theoretical satisfaction, handed his work off to others, sometimes forgetting even to sign it. An aging Wordsworth is known to have cut down an emerging Keats in a fit of perceived threat and envy; Auden considered himself, even after receiving the Pulitzer Prize, the youngest poet in any room. Individual advancement can spring only from a collective effort, yet these communities of likeminded strivers furthered and thwarted themselves in turn.

Within twentieth-century astronomy, Edwin Hubble sported a cape, knickers, and an affected

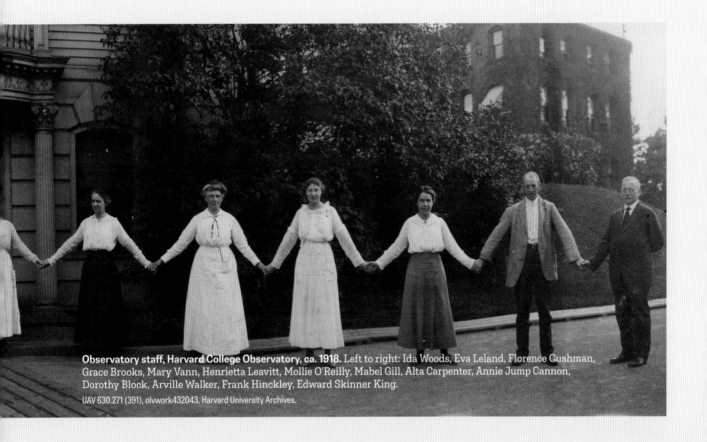

Observatory staff, Harvard College Observatory, ca. 1918. Left to right: Ida Woods, Eva Leland, Florence Cushman, Grace Brooks, Mary Vann, Henrietta Leavitt, Mollie O'Reilly, Mabel Gill, Alta Carpenter, Annie Jump Cannon, Dorothy Block, Arville Walker, Frank Hinckley, Edward Skinner King.
UAV 630.271 (391), olvwork432043, Harvard University Archives.

British accent, yet in his later years shied away from the hullabaloo around his own discoveries. Harlow Shapley's expression of bravado, on the other hand, involved masking insecurity with stubbornness. Shapley erroneously argued (based on eleven "miserable" Cepheids—his own admission of small sample size) that the Milky Way comprised the entire universe. He was proven wrong, but went on to win the observatory directorship and to map 76,000 galaxies. When asked to support a posthumous Nobel Prize nomination for Henrietta Leavitt, Shapley tilted her achievements toward his own, replying, "It was my privilege to interpret the observation by Miss Leavitt, place it on a basis of absolute brightness, and extending it to the variables of the globular clusters, use it in my measures of the Milky Way." "It is clear whom Shapley would like to nominate for the prize," biographer George Johnson concludes, incriminating a remarkable self-regard.

There she is, sneaking in from the side of someone else's example: Henrietta Leavitt. She has not appeared in any of these logs or notations—she did not boil fudge with Fleming or go caroling with Cannon or spar with Maury. She appears more often in endnotes and indices than in the body of the text. It's as if a casting director denied Leavitt the leading role in her own story. Her name appears in the credits, but she wasn't given many lines.

So what do we know about her, after all? We know that she came from a scholarly family that

liked to name its sons and grandsons Erasmus Darwin. We know that as a student she received a C in German and a B in physics, but an A in differential calculus. We know that before taking her staff position at the observatory she traveled to Europe several times, sometimes alone, but there is no record of which countries she visited, how she chose, or what she enjoyed. She was not the heroine of a James or Forster novel in which the brilliant young American unfolds herself abroad and returns home more richly defined.

Leavitt sent letters only when health concerns kept her away from the observatory. She did not write to explore or expand her persona. She would update Pickering on the timing of her return and lament the interruption of her progress: "The delay in publication must be annoying to astronomers who desire to use the magnitudes, as it is distressing to me." Discussions of reductions, sequences, apertures, and color screens resolve into apologies for her absence: "I am especially sorry to be so long away"; "I am sorry that I cannot attend the meeting"; "I was disappointed by unexpected cares at home"; "The illness of a relation with whom I stopped to visit on my way to Cambridge is likely to detain me for some time in Ohio." She doesn't bother with niceties or the weather; in fact, her one mention of fog in Nantucket, in the single remaining letter sent while she was apparently on vacation, reads as startlingly subjective and personal.

Leavitt came from a fairly well-established and privileged New England background. She did not bear the scrappy urgency of Fleming's heartrending emigration from Scotland. She did not receive the extrovert's boost from socializing that Cannon did, nor was she propelled by Maury's alert sense of injustice. It is evident that through whatever meeting of nature and nurture, Leavitt defined herself more by service than by show. Her devoted care for relatives, willingness to forego friendship circles beyond the Brick Building (inside it she was beloved), and ambivalence about representing herself at professional events distinguishes her brand of ambition from those of her colleagues. Where they clamored to be present and included, Leavitt hurried home to observe family Christmases. She took her work immensely seriously (Solon Bailey describes her as having "an especially quiet and retiring nature, and absorbed in her work to an unusual degree"), but asked others to read her conference papers aloud for her. She was never a proudly fatigued mother and full-time worker (Fleming), a self-designed teacher and researcher (Maury), or a holder of honorary titles from Oxford and Harvard (Cannon). Even more so than her colleagues, nearly all of whom lived unconventionally, Leavitt operated outside the known trajectories.

If the record of Henrietta Leavitt exists primarily in her measurements—her immaculate, right-angled, revelatory logbook tables—does that make her less of a character, less human, or has her old schoolgirl's preference for calculus over language helped her transcend caricature and achieve some more lasting, rarified essence? Was her relative modesty a genuine aversion to the trappings of personal success, or was she embittered by a sense of obligation? Does the absence of a revealing diary mean that we lose out on a secret interior life, or, as David Foster Wallace put it in accounting for the oddly banal memoirs of star athletes, was Leavitt's interior life in fact "exhaustively" absorbed into her external accomplishments?

Leavitt's example fractures the facile correlations between merit and fame. Some people are built to do one thing. If that thing takes place in a stadium or on a stage, it is seen; if the talent manifests more

privately, the driving force can be harder to parse. Leavitt leaves one wondering where ambition and vanity diverge and where achievement and vanity overlap. Our aspirations are not merely byproducts of self-centeredness—a certain sense of dignity and self-worth drives our personal exertions. Leavitt was a scholar of vast capacity and application; she was also very sick, very quiet, and at the end of the day, perhaps more sure of herself than all the others combined.

When examining the efforts and choices of past personalities, perhaps all one can ask is: What did they want? And, as a derivation: To what extent did they get it? Leavitt wanted to discover variable stars. She discovered more than 2,400 of them. She would have done more, gone further, made even greater connections, had her workload been her own to assign, and had her health extended her life's workday. Yet in the center of her industry and exactitude sat a woman engaged in what compelled her most. No sounder or finer coherence can be attributed to any pursuit, domestic or cosmic, traditional or groundbreaking, athletic, artistic, or scientific. The Harvard Computers funneled individuality into the standardizing uniform of their time and emerged from the specificity of their task, as out of a prism, with their particular spectral colors both dispersed and intact.

Staff of the Harvard College Observatory aboard the CS *Minia*, ca. 1900.
Left to right: Captain William DeCarteret, unknown man, Louisa Wells,
Mabel Gill, Edith Gill, unknown man, Williamina Fleming (holding Mabel
Gill's hand), Florence Cushman (partly obscured behind Fleming), Mabel
Stevens, Imogen Eddy, Chief Officer James Adams, Evelyn Leland, Ida Woods.

UAV 630.271 (173), olvwork431825, Harvard University Archives.

Independent researcher Paul A. Haley helped identify individuals in this
photo and postulates that this group of observatory staff was part of the
expedition to Georgia to witness the 1900 solar eclipse. (Paul bases this on the
date the photograph was made, two passages in Fleming's Chest of 1900 diary
describing the excited anticipation among some of the hopeful viewing party,
and a mention of a letter from "Captain Adams" that references the CS *Minia*.)
It is also possible that this photograph simply documents an excursion to visit
the ship while in port. I know which explanation I prefer.

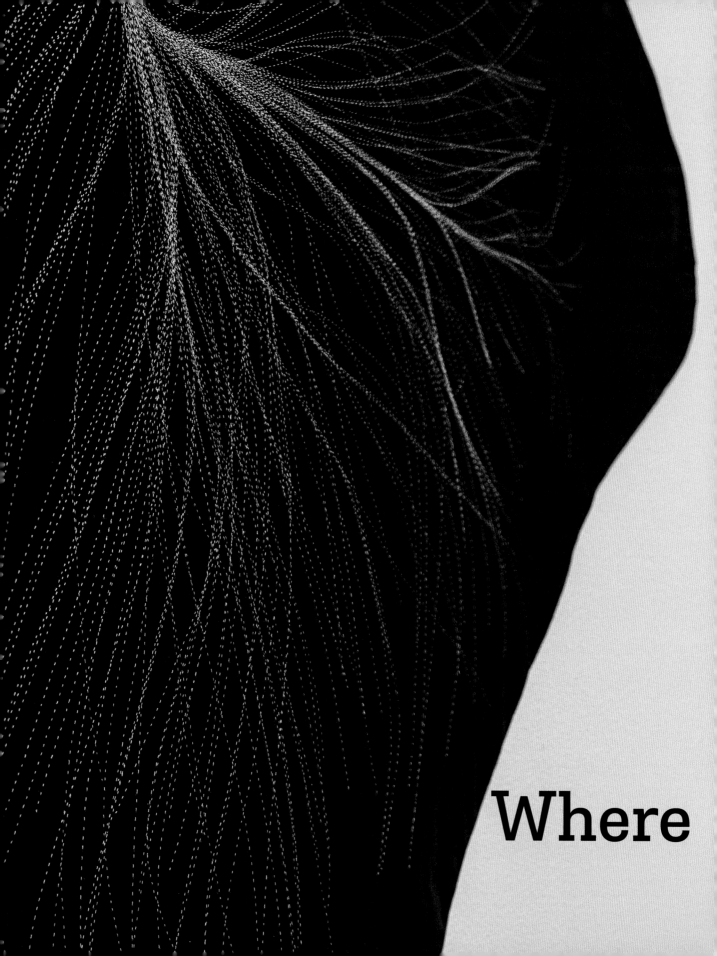

Where

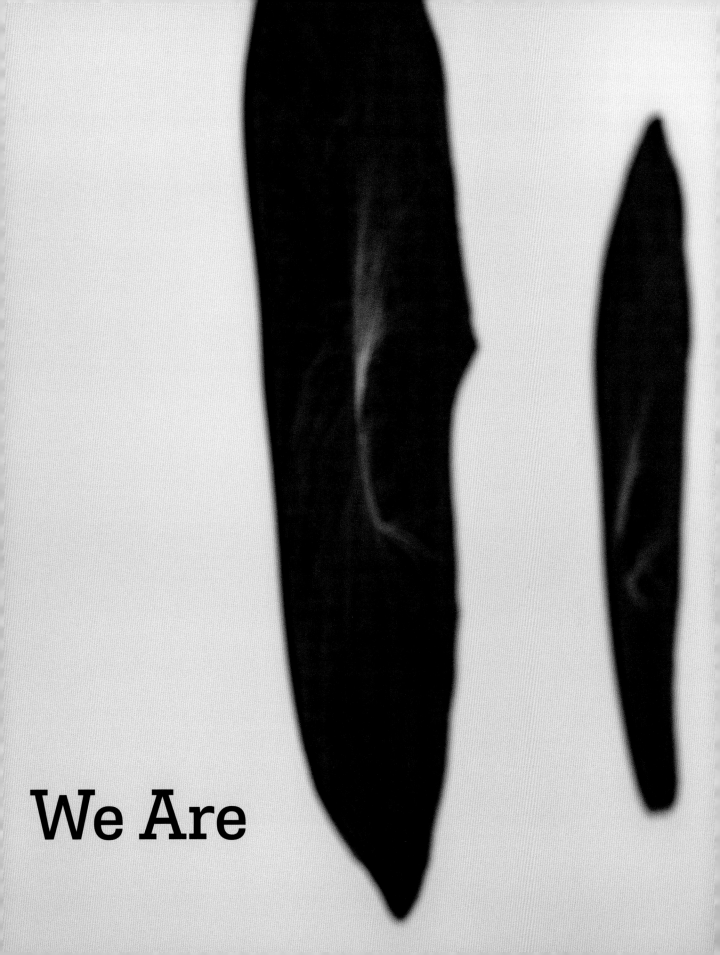

We Are

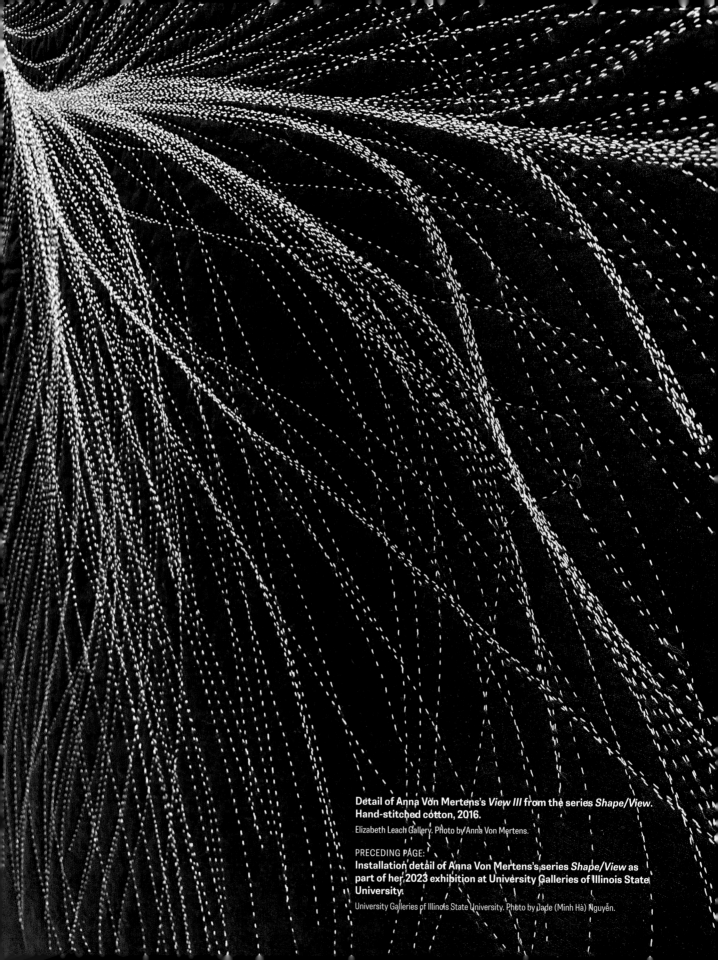

Detail of Anna Von Mertens's *View III* from the series *Shape/View*.
Hand-stitched cotton, 2016.

Elizabeth Leach Gallery. Photo by Anna Von Mertens.

PRECEDING PAGE:
Installation detail of Anna Von Mertens's series *Shape/View* as
part of her 2023 exhibition at University Galleries of Illinois State
University.

University Galleries of Illinois State University. Photo by Jade (Minh Hà) Nguyễn.

ANNIE JUMP CANNON traveled to Virginia Beach, Virginia, in May 1900 to witness a solar eclipse. She wrote in her diary shortly after the experience: "The rolling darkness was unlike anything I have ever seen. It didn't seem like the coming of night in the least, it was more like the gathering of a mighty storm." As the shadow approached, Cannon recognized two qualities meeting: the fundamental nature of things and our capacity to comprehend that nature. "One other thought came suddenly just before totality—that the human mind had after all learned to predict this phenomenon." Looking up at the Milky Way, or encountering an eclipse, we appreciate that our cosmos has an intrinsic, awe-inspiring structure; our ability to ascertain that structure is its own dazzling, creative act.

Mapping is thematically central to my work, reflecting a long-felt desire to know where I am. A map provides a fuller sense of where I might go. When I moved to San Francisco after college, I moved sight unseen. I had never been to the city until I arrived with a pickup truck full of my belongings. That first night, as I lay in bed in my friend's apartment, I couldn't imagine my surroundings. I could only picture a few blocks' radius; the rest was simply blank. Slowly, over the years, I built a relationship to that space and made a life within it. Physical orientation led to an internal one. Looking to the heavens is an age-old way of finding one's bearings; it offers that same quality of perspective.

My artworks embody systems of mapping. Observing patterns, recognizing patterns, creating patterns, I try to build a sense of home, a place to step forward from. Before the glass plates led me to Leavitt's story—before I knew the origins of how we learned to map and understand our three-dimensional universe—I made a body of work titled *Shape/View* based on a piece of this carefully formed knowledge: a newly recognized way galaxies organize as part of our universe's underlying structure. To reveal this implicit principle, cosmologists first discounted the expansion rate of our universe to determine an object's "peculiar velocity." From the 2014 *Nature* article announcing their results comes the exquisite language of science: "The peculiar velocity is the line-of-sight departure from the cosmic expansion and arises from gravitational perturbations." A galaxy's peculiar velocity can be calculated by establishing its distance, multiplying that by the Hubble constant, then subtracting the result from the observed velocity of the galaxy to quantify the influence from a deep well of gravity. The published study maps which galaxies are moving with us, toward a shared so-called basin of attraction, and which galaxies are being pulled away, toward a different gravitational center. The boundary where that galactic flow diverges becomes a cosmic watershed, determining a new astrophysical form: the galactic supercluster, one of the largest known structures in the universe.

Each stitched artwork in *Shape/View* depicts the same "thing"—an organization of galaxies drawn toward a common center so massive it is almost beyond comprehension—but because each work represents this structural entity from a different vantage point, there is dramatic variation in the resulting black silhouettes. That shapeshifting perimeter represents the gravitational boundary of this structure, and the iterations of its shape are determined by rotating a computer model diagramming our home supercluster, Laniakea, which encompasses 100,000 galaxies and spans 500 million light-years across. To distill this overwhelming volume of data, I first made loose gesture drawings in chalk to translate onto fabric the subconscious movements of these galaxies over time, bringing this unimaginable expanse of space back to a human scale and the physical body. I then built the information back up, stitch by stitch. The pull of needle and thread binds the intimate and the vast, embedding in these works a fundamental understanding that Leavitt's work began. I folded this completed series into the larger body of work I was making in response to Leavitt's life, as here was the farthest reach of her work—an answer before a question was even formed.

Cannon continues in her diary entry from May 28, 1900, "Never before had the human intellect seemed so majestic as when standing before this rapidly vanishing sun and there flashed before the myriad eye the long line of searchers after truth who had made it possible for us today to be certain of this eclipse." The same long line of searchers in which Henrietta Leavitt and the Harvard Computers stood and still stand. Such searchers simultaneously reveal and construct our relationship to the cosmos, and it is on their knowledge that we build our own.

Page 3 of Annie Jump Cannon's five-page account of the 1900 eclipse. Cannon's handwriting requires its own kind of pattern recognition. As an example, she writes the word *the* (appearing seven times on this page) with the initial stroke for her lowercase *t* never very tall, and when crossing that *t*, her horizontal line rarely makes contact with its vertical counterpart—it tends to float in space, lingering someplace after. Recognizing that visual unit of Cannon's *th* is the only way I could decipher the words *there* and *other*, also on this page. Full transcription of page 3:

Under the falls of Niagara, and on top of Vesuvius, had before seemed to me to be the times of my life when I was nearest to the forces of nature. But those experiences were nothing to this. One other thought came suddenly just before totality—that the human mind had after all learned to predict this phenomenon. Never before had the human intellect seemed so majestic as when standing before this rapidly vanishing sun and there flashed before the myriad eye the long line of searchers after truth who had made it possible for us today to be certain of this eclipse.

Annie Jump Cannon Papers, HUGFP 125.45 (box 1, folder "Eclipse Papers"), Harvard University Archives. Photo by Anna Von Mertens.

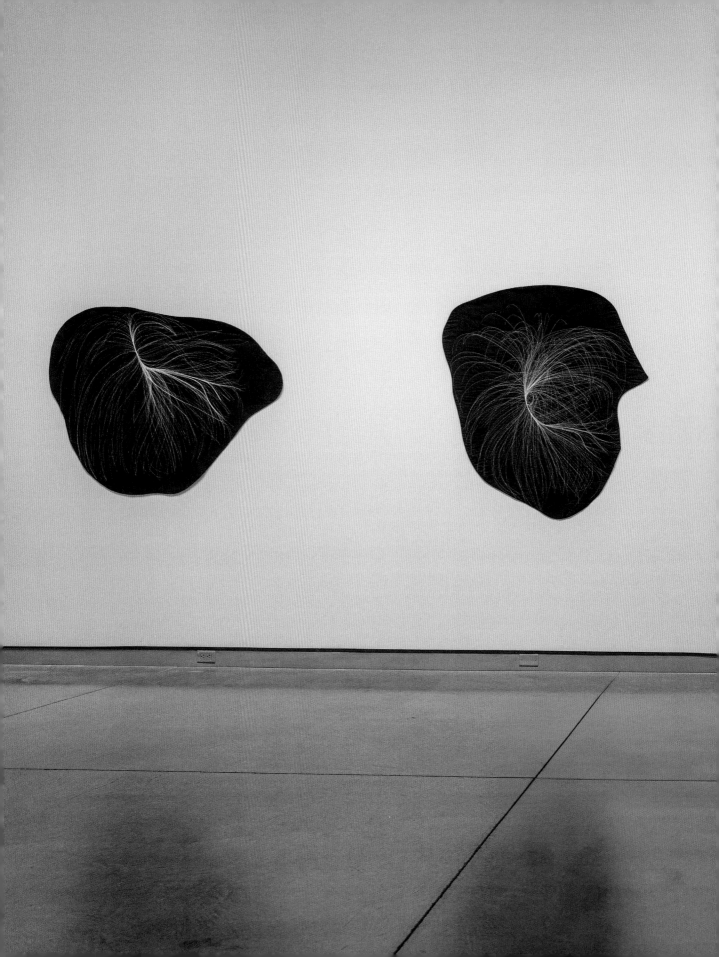

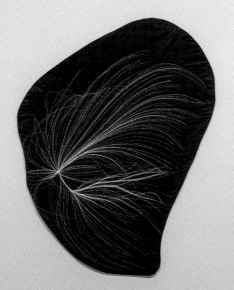
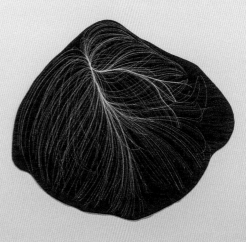

**Installation detail of Anna Von Mertens's series *Shape/View* as part of her
2023 exhibition at University Galleries of Illinois State University.**
University Galleries of Illinois State University. Photo by Jade (Minh Hà) Nguyễn.

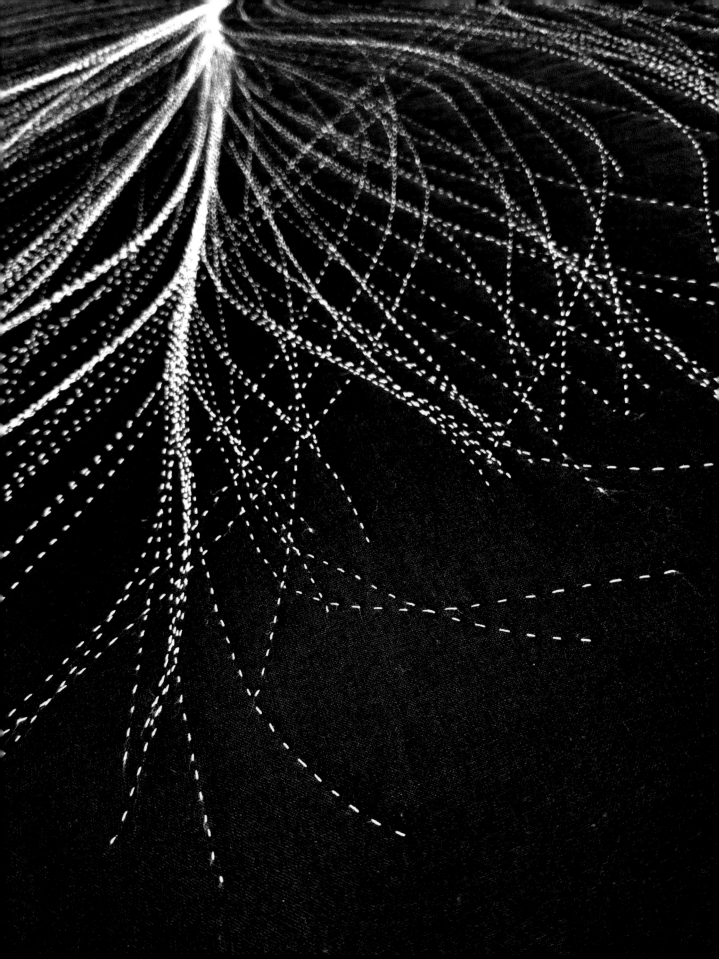

Seeing Things

THE DISCOVERY OF
THE RADCLIFFE WAVE

João Alves

I first learned of Henrietta Leavitt at a secondhand bookstore in Harvard Square. It was the spring of 1995, and I had just moved from Lisbon to Cambridge, Massachusetts, to start my PhD at the Center for Astrophysics. I came across a general astronomy book on one of the shelves, an edition of Harlow Shapley's *Galaxies* from 1943, and browsing briefly, I noticed a portrait of a young woman. The photograph was remarkable because it was the only portrait of a woman in the book and because this woman had enormous, piercing eyes. The caption read, "Miss Henrietta S. Leavitt, explorer of the Magellanic Clouds." In the paragraph above the photo, Shapley explains, "The Clouds were first being seen by a young woman sitting at a desk in Cambridge, Massachusetts, in her hand an eyepiece, with which she could examine a confusion of little black specks on a glass plate." And just below, this cryptic line (italics mine): "Leavitt … had the gift of *seeing things* and of making useful records of her measures."

During my years in Cambridge I was fortunate to work with the brilliant Charles Lada. Charlie is a legend in star formation research and has established many of the canons of the field. My thesis was focused on a new mapping technique to study the structure of dark clouds (the places where stars are born), a technique Charlie had developed the year before I arrived. Dark clouds are hard to study because they are dark at optical wavelengths. Astronomers have avoided them since the early 1900s, when they were finally recognized as actual objects. Astronomers love light. They love signals they can measure. And dark clouds, well, dark clouds extinguish light. But dark clouds become transparent at longer wavelengths because of the size of the dust particles in them. Charlie's idea was to use an infrared reading of stars toward the farthest edge of a cloud—stars otherwise invisible to the human eye—to trace the distribution (the range of density) of interstellar dust in these clouds. I remember flying from glacial Boston to balmy Mount Hopkins in Arizona several times during my thesis to observe stars toward the background of dark clouds, stars no one had ever seen, with a new infrared camera mounted on the 48-inch telescope. I worked for months after converting noisy, fragile images into calibrated photometry and grayscale maps of the mass distribution inside the dark clouds. I was mapping by starlight.

With every new map I produced, I would rush up the stairs to Charlie's office—in the old Brick Building, the very same where Henrietta Leavitt had worked—to show him my results. Over time, I noticed that Charlie often had my latest cloud map on his desk. It would remain there for weeks and always be the first thing he saw when he arrived in the morning. I was flattered but intrigued, because these maps were not much to look at; they were full of artifacts, most of them not obvious. Meeting after meeting, Charlie kept asking questions. From the dreaded "Something is not right, João," which would trigger me to run through a spree of checks

This photo, which João first saw in the 1943 edition of Harlow Shapley's *Galaxies*, also appears in the April 1922 issue of *Popular Astronomy* alongside Solon Bailey's obituary for Leavitt, with the caption "Henrietta Swan Leavitt / At about 30 years of age."

(he was often right), to the "Interesting. Didn't we see this relation before?" Charlie's questions were insightful and guided me to make better maps, better relations, and eventually led me to the results of my thesis. It would only later dawn on me that looking at an image over a long period is far from an exercise in boredom: it's a *technique*. Repeated looking, day after day, gazing, contemplating. Looking for a sign, no matter how small.

Fast-forward twenty-three years since first encountering Henrietta's eyes in Shapley's book. It's September 2018 and I'm back in Cambridge, this time as a fellow at the Harvard Radcliffe Institute. My research project aimed to map "the local neighborhood" (defined by a 3,000-light-year radius) using the European Space Agency's Gaia data, released earlier that year, documenting the positions and motions of about 1.8 billion stars in our Milky Way. I wanted to create a 3D map to disentangle the local dark clouds and find connections between them. There was a 150-year-old model for the distribution of the local clouds, known as Gould's Belt, but I had found problems with it years earlier. The newly available data was ideal for a closer look at this well-established structure. Having studied these clouds for over twenty years I knew them by heart, but, like Leavitt measuring the stars on her glass plates, I only had access to data in two dimensions. It was impossible to know where one cloud stopped and another one started. I had spent countless hours looking at ways to represent these clouds, from the dust maps I was making to gas maps from radio telescopes and optical photographic plates, which revealed the intricate complexity and beauty of these objects. Some clouds appeared compressed and windblown. Others had mesmerizing filigree structures, not unlike Earth's clouds. Some were

star-forming. I had ideas about which cloud was in front of which and how a particular arrangement might hint at how interstellar clouds evolve. But these ideas were only hunches based on subtle gradations of darkness on photographic plates, the way cloud filaments appear to weave with one another, and probably some imagination. I couldn't prove them.

Why study these dark clouds? Because local clouds are the only clouds in the universe close enough for our telescopes to reveal exactly how nature performs the miracle of converting extremely diffuse gas into hydrogen-burning stars with rocky planets around them and, eventually, life. But in reality, I just love clouds, and have forged a complicity with them over the years. Knowing their three-dimensional shapes and distribution in space would be a wonderful step toward understanding these silent giants that are overlaid on each other against the cluttered, two-dimensional night sky. The origin of stars and planets is one of nature's fundamental mysteries we still haven't cracked, and these clouds are our best chance to do so.

Launched in 2013 by the European Space Agency, the Gaia satellite performs one simple task: it measures nearby stars with astonishing precision — both their position and velocity — by tracking a star's continuously shifting position as the satellite (and Earth) travels around the Sun. By the end of the mission Gaia will have observed each star extensively, allowing astronomers to derive the most accurate distances to and motions of nearly two billion stars. This number represents over 10,000 times more stars than the previous astrometric survey, and Gaia is about a hundred times more accurate. It's hard to comprehend the significance of this, but here's a try: One arcsec (a unit of angular measurement) is the angular size of

a five-cent coin at one kilometer. Gaia can measure the positions of stars in the sky with an accuracy of 0.000024 arcsec—equivalent to measuring the width of a human hair from a distance of 1,000 kilometers. This level of accuracy, added to the sheer volume of data, is absurd. It's transformational.

To disentangle the dark clouds, we must determine the distances to each cloud and construct a 3D map of the local galactic neighborhood. Easier said than done. Gaia was *not* designed to study dark clouds. Gaia is sensitive to optically visible light, and dark clouds are invisible at such wavelengths. How to measure the distance to clouds with Gaia? The simplest way was developed by Max Wolf, a pioneer of astrophotography and the first astronomer to prove that dark clouds were not holes in the sky but things, clouds between the stars. Wolf's method relied on measuring the effect of dark-cloud dust on starlight: if a star is in front of a cloud it will not be reddened by dust, but if a star is toward the back of a cloud, it will be. Just as sunsets are redder than midday sunlight because of how light scatters in the atmosphere, stars behind dark clouds are redder than stars in front of them. The distance to a cloud consists of finding the farthest unreddened star near a cloud and the closest reddened one; these two distances bracket the distance to the cloud. The more stars you have, the more accurate the measurement will be. The most challenging step in this approach is, by far, determining the distances to random, unstudied stars. This has remained an impossible task until Gaia; distances to an unfathomably large number of random stars are Gaia's gift to astronomers. Wolf's century-old method has been given new life.

One month into my Radcliffe sojourn, I flew to Paris to present the first results of my project at a workshop on the interstellar medium. My wife and three children were still adjusting to life in Cambridge, and aside from looking into Orion, I had little done researchwise. During my sabbatical I was still advising a great PhD student, Josefa Großschedl, who was finishing her thesis on Orion, so it was fresh in my mind. Because of Josefa's work, I knew that the Orion A cloud, containing the Orion Nebula, was hiding a surprise. Its straight, filamentary appearance—a model for the 2D shape of similar massive star-forming regions—is an illusion. The Orion filament is actually L-shaped, but appears straight because of Earth's point of view. Nice one. While preparing my talk on the plane, I was emboldened by Josefa's research; we were right to have pursued a hunch with early Gaia data. But could I present on a hunch?

It is known that Orion and its neighbor the Monoceros R2 cloud are off the plane of the Milky Way and, because of that, are likely to be related. The leading explanation is that the two clouds were associated with the long-ago impact of a high-velocity cloud coming from the halo of the Galaxy or beyond and colliding with gas on the plane of the Galaxy, forming and pushing Orion and Monoceros R2 to their current locations below the plane. My hunch was that a third massive cloud, Canis Major, at a greater distance and sitting on the galactic plane, was connected to Orion and Monoceros R2. If true, the implications were clear: the high-velocity cloud theory was probably wrong, and there is an unknown order in the distribution of stellar nurseries. Reception to the talk was, understandably, lukewarm. "It could make a nice story," I imagined the audience saying, "but can you prove it?"

The best thing about that workshop in Paris was getting to know Catherine Zucker, who is the definition of an outstanding researcher and has become one of my closest collaborators. At that

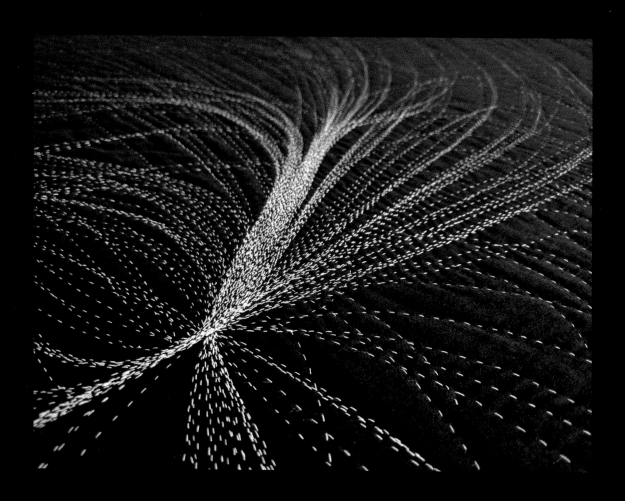

Seeing things that have been there along: two of the photographs
(this page and page 124) created in 2018 by João Alves and only
recently shared with Anna Von Mertens of works in her Harvard
Radcliffe Institute exhibition *Measure*.

meeting Catherine was particularly popular because she had developed an application of Wolf's method combining the recent Gaia and ground-based data. Thanks to Gaia, she could determine accurate distances to clouds with about six times greater accuracy than previously possible. Her implementation was based on the Bayesian framework of Douglas Finkbeiner's group at Harvard, and it ran on a supercomputer Catherine could access from Paris. Many, including me, asked her to calculate the distance to objects they had spent decades studying and writing papers about. Receiving her results was thrilling and solemn, like being presented with a letter from a faraway loved one. My letter's decree? My three clouds aligned perfectly in three-dimensional space, forming a curve I was referring to as a "ramp" from Orion sitting below the galactic plane leading to Canis Major above it. But three points on a curve is hardly a result, so to confirm it, I asked (begged?) Catherine to estimate the distances to a couple of poorly studied, diffuse clouds lying between the three major ones. She calculated a few more points—quite a feat for her technique given that these were barely visible clouds. One by one, they all fell into place, further delineating the ramp. I was ecstatic. Objects that align along a curve in space over 3,000 light-years are a very rare sight. There was no sign of the established ring of stars that had defined the Gould's Belt for a hundred and fifty years. I returned to Cambridge with a promising new project in hand.

Late October and November brought many doughnut-fueled working sessions with Catherine and more distance measurements to diffuse clouds. Making such measurements is no trivial task; the clouds were barely visible, but Catherine was fully committed, now convinced this project was not a waste of time. All new measurements continued to fit the ramp; the occasional outlier was the exception. The idea of these apparently random clouds in the sky aligning along an arc connecting Orion to the galactic plane started to settle in, and the feeling was electrifying. Three enormous clouds are connected by an umbilical-cord-like distribution of diffuse clouds. But why? Was this how nature created large, star-forming nursery clouds like Orion? Were giant molecular clouds (astronomer speak for large arrangements of star-forming clouds, such as Orion) like beads on Galaxy-long strings of interstellar gas? Why had this giant gas structure not been noticed before? More doughnuts and work sessions followed. We started to be systematic and ambitious. Alyssa Goodman, my colleague and friend at Harvard, had established a "red team" to test our results. We passed, and her insights and data visualization magic made it clearer that we had something important in hand even if we were unsure of what it was. We now wanted all measurements possible. Meeting at Alyssa's office (and upgrading to Indian takeaway), we started a guessing game about which random clouds in the direction of the ramp would fit.

The same November, Anna Von Mertens's exhibition *Measure* opened at Radcliffe. Alyssa warned me not to miss it. "It's about Henrietta Leavitt," she said; "You'll like it." It was part of the promise of the Radcliffe fellowship experience: with a broad view of scholarship, the program brings together individuals intensely focused on their own research—be it in the arts, humanities, or sciences—to form a unique and interdisciplinary community. But is the total greater than the sum of its parts? Exchanging ideas with colleagues from orthogonal backgrounds is a worthy goal. However, most of us barely have the time or energy to make sense of the immeasurable

complexity of whatever specific universe we are studying. I was not expecting more than an enjoyable event.

Navigating the packed crowd surrounding the artist, I stared at the diptych central to the exhibition, each panel showing star trails against a dark background: one from the place and time of Henrietta Leavitt's birth, the other from her death. Intriguing. As I got closer I realized the star trails were stitches: white to gray to dark gray stitches on black cloth charted the extinction of starlight as it crosses more and more atmosphere toward the horizon—just like reddening, but in grayscale. Handmade stitches laid one after the other, nothing else. The star trails' arcs looked accurate. This was not an impressionist view. But how did they relate to Henrietta? The precision of these cotton stitches reminded me of "a young woman sitting at a desk in Cambridge," spending her life doing photometry by eye, star by star, on glass plates. But I was unsure whether I understood Anna's message or even if there was a message for me to decipher.

In the following weeks, when I went for lunch, I would spend some time in the gallery, not far from my office. I was intrigued by Anna's stitches; they were straightforward and stunning. You could almost hear the thread being pulled by the needle in Anna's hands as it porpoised along the fabric. I started taking pictures of the stitches, admiring how the line sometimes frayed a little and how that made them perfect. It dawned on me that Leavitt's star by star was Anna's stitch by stitch: a deeply empirical process of collecting tiny fragments of our shared reality while "sitting at a desk" over long periods of time. I was mesmerized.

On the wall to the right of these two pieces was another surprise: Anna's pencil drawing of a glass plate containing the Orion Nebula, the nearest major stellar nursery and a familiar sight. It

is a region I have spent countless hours observing, measuring, analyzing—even flying through in my imagination as I fall asleep. A pencil drawing that looked exactly, startlingly, like the original plate, imperfections and artifacts included. Why? It took Anna months to make such a thing. It took Anna months to make any piece in this exhibition. Her hands, cotton threads, and long months of stitching tell the story of an astronomer she must deeply admire. I started seeing Anna's handsewn sky as an attempt to record and hold something as precious as Leavitt's lived life, her actions large and small. The most humane representation of life on Earth. The universe observed and recorded from a spinning planet, for a limited time.

Cloud by cloud, the Orion ramp grew into a beautiful result none of us expected. Eventually we ran out of clouds and it was time to stop measuring and start writing. We were enjoying that ephemeral feeling scientists have when they have found something. It was not a straight ramp but an arc-like structure that stretched from Orion to the galactic plane. Why such a well-defined, 3,000-light-year-long trail of gas? And why would this arc be so perfectly straight when viewed from above?

Then it hit me. I had seen that arc before, in Anna's stitches. A ramp is just a quarter of a stitch. The ramp could be a relatively small part of a much larger structure, a sort of giant galactic stitch. Maybe we were not done measuring after all. Now we had a blueprint: we knew to keep looking, in particular toward the treacherous galactic plane where cloud confusion was at a maximum. Like domino pieces falling one after the other, cloud complexes we never imagined would connect to the ramp aligned, mysteriously, to form a narrow gas structure extending for more than 10,000 light-years: Taurus, Perseus, then a series of nearby

Installation view of Anna Von Mertens's 2018–2019 exhibition *Measure* at the Harvard Radcliffe Institute.
Harvard Radcliffe Institute. Photo by Stewart Clements.

clouds crossing the plane Catherine named Big Linky, followed by Cepheus (near L988, where I spent my PhD years making dark cloud maps), the great North American Nebula, and ending in the star formation powerhouse Cygnus-X. Within weeks we had quadrupled the size of the ramp. We named the structure the Radcliffe Wave as a tiny homage to the many famous female astronomers from Radcliffe's past, and for one in particular that had connected astronomers and artists in true Radcliffe spirit: Henrietta Leavitt.

The Radcliffe Wave is now part of our known solar neighborhood. It has been occupying half of our sky for tens of millions of years, yet we didn't see it. We can easily recognize evidence of the Radcliffe Wave in archival data, but that is because we learned how to look. Scientists are loaded with opinions and preexisting models, often for many good reasons. Leavitt's gift is the contemplation of things as they are, not as what we wish them to be. A profound respect for reality, engaged through repetition to see anew. Looking, looking, and looking, until finally seeing things.

Aquppipos buch
time.
Eve. Anselin clea
yeady to start
English in west. 8
elanie Clound (She
makes me think M
How she loved th

The

Friends We Find

Negative glass plate X2925 of the Orion Nebula, 8 × 10 inches. Exposure of 166 minutes made with the 13-inch Boyden telescope on March 15, 1890, Harvard Mount Wilson Station, California (temporary observation site from 1889 to 1890).

Astronomical Photographic Glass Plate Collection, Harvard College Observatory.

PRECEDING PAGE:
Annie Jump Cannon's diary entry from April 20, 1922.

Annie Jump Cannon Papers, HUGFP 125.2 (box 1), Harvard University Archives. Photo by Anna Von Mertens.

Magellanic Cloud (Great) so bright.
It always makes me think of poor Henrietta.
How she loved the "Clouds."

WHEN I READ Annie Jump Cannon's journal entry from Peru (written just four months after Leavitt's death), in which she writes about how, in the presence of the Magellanic Clouds, she is reminded of Henrietta and her love of the clouds, I think of how Leavitt must have felt at home in that pattern of stars. Cannon was acknowledging two old friends. This reminds me of João and his familiarity with Orion. One night in Cambridge, after attending his lecture on the Radcliffe Wave, a group of us went out to dinner. As we left the restaurant and rounded a corner, we encountered Orion in the night sky. The constellation's lights were some of the few stars visible above the city. João stopped in his tracks, arrested by one of the night sky's most accustomed sights. As an astrophysicist, João knows these stars very, very well; he is a foremost expert on Orion. And yet he was amazed. On a sidewalk in Cambridge, João stood in the presence of an old friend.

Last summer Jennifer and I were looking at a photographic plate of Orion, observing how the pattern of its nebula's swirl of gas and dust had landed on the glass. As Jennifer pointed her camera at the image she said, "The light of Orion *made* this." A simple truth, easily forgotten. There is the miracle of the glass plate—its technology, creation, and preservation—but at the heart of that miracle is the light from the Orion Nebula traveling more than a thousand light-years and touching emulsion-coated glass more than a hundred years ago. I associate rendering with drawing—I myself have rendered the Orion Nebula in graphite—but light itself rendered those shapes and shadows. This reminder of light's correspondence sends my mind reaching. There, in another world, in contact with ours, is Orion.

Antonia Maury studied the puzzling spectra of Beta Lyrae well beyond her official retirement in 1935 from Harvard. (Beta Lyrae is forever tied for me to that rare quote from Leavitt: "We shall never understand it until we find a way to send up a net and *fetch the thing down!*") Maury had been fascinated with binary stars since her arrival at the observatory; she made her own discovery of a spectro-scopic binary, Beta Aurigae, in 1889. It was her theories on Beta Lyrae that Maury had defended so passionately as her own in her letters to Pickering. Absurd in its complexity, Beta Lyrae (located in the constellation Lyra) is now known to be

a multiple-star system, and the brightest component of that grouping is its own triple-star system composed of a single star and an eclipsing binary. I can only imagine Beta Lyrae's irregular spectral pattern, but can easily envision Maury's and Leavitt's steadfast determination to make sense of it. It is no wonder that for Maury, Beta Lyrae was a lifelong companion.

Negotiating the space between here and there is something we do all our lives. Between self and other, near and far, the limits of our understanding and the expansiveness of the unknown. These encounters, these relationships, our astonishment—stopping in our tracks—all come up against the familiar and the unfamiliar, opposites that neatly overlap and agreeably coexist. I find great comfort in this, in the clouds on the glass plates and in the cosmos, their nearness and farness, and the friends we find in them.

Annie Jump Cannon's 1922 diary (Daily Reminder) in a box of Cannon's collected diaries.

April 1922
Thur 20

Lovely warm clear day. Developed plates and worked all day. Intended to go to Arequipa, but did not have time.

Eve. Another clear one. We were ready to start at 6.30. Venus bright in west. 8 P.M. Sky very clear. Magellanic Cloud (Great) so bright. It always makes me think of poor Henrietta. How she loved the "Clouds".

Annie Jump Cannon's diary entry from April 20, 1922:

Lovely warm clear day. Developed plates and worked all day. Intended to go to Arequipa, but did not have time.

Eve. Another clear one. We were ready to start at 6.30. Venus bright in west. 8 P.M. Sky very clear. Magellanic Cloud (Great) so bright. It always makes me think of poor Henrietta. How she loved the "Clouds."

1922　　　　　　　　　　**April**
　　　　　　　　　　　　　　　Fri
　　　　　　　　　　　　　　　21

Cannon's entry from April 21, 1922:

Lovely day and another perfect night. Worked the Cooke and the 10-inch until 11 P.M. Mr. B. & I walked to Arequipa, starting at 2.15, getting back about 6. Had tea with Mrs. Bates, who has a bad cold. I did some shopping alone and got along well right. In the evening, between plates, I used 5-inch to look. Saw Neb. Orion, Jupiter, Saturn, Large Cloud, 30 Doradus lovely, Alpha Centauri widely double, Alpha Crucis not certain of doubling, Kappa Crucis, Coal Sack, Omega Centauri, Eta Circini. Quite a haul! Was so excited I did not sleep well.

One Hundred Years of

Cepheid Variables

COSMOLOGIST WENDY FREEDMAN'S research has centered around Cepheid variables since her time in graduate school. As she says, they are "the best yardstick astronomers have had for over a century to measure the distances to galaxies." For much of her scientific career Wendy has focused on measuring the expansion rate of our universe. To do this precisely, one must know the precise distance to things around us. Distances are significant to Wendy: "The idea that you could know the age and size of the universe by making accurate measurements." Measuring the expansion rate reveals how our universe has evolved, telling us not only what will happen, but what has happened; it speaks to both future and origin.

Images from the Hubble Space Telescope unveiled the splendor and pyrotechnics of our cosmos. While images such as the Pillars of Creation, with light-years-tall columns of gas and dust condensing to forge new stars, inspire and inform, one of the telescope's primary missions—what the telescope was designed to do, points out Wendy, who led the Hubble Space Telescope Key Project—was to measure the expansion rate of our universe as accurately as possible. And to make those measurements, she needed Cepheids.

In the 1980s light received from the universe was still being measured with photographic plates, an updated version of the same technology Henrietta Leavitt used. Wendy herself analyzed glass plates as a graduate student studying Cepheids in nearby galaxies (although by then the plates were able to be read and calibrated by machine—no fly spankers needed). Glass plates had the problem that they were primarily sensitive to blue light. This was a reality that Leavitt and other Harvard College Observatory astronomers knew well. Leavitt identified this problem, for example, when describing the variable S Cephei—a tricky star that seemed impossible to locate on any of Harvard's photographic plates. There it was in the sky (in a visual range of the eighth to thirteenth magnitude), yet it remained absent from Leavitt's two-dimensional glass world. Of this star, Leavitt wrote in her 1918 report for the American Astronomical Society: "The variable S Cephei was looked for in 1896, without success. Several suspected objects proved to be defects. The difficulty was easily explained by the extreme redness of this object." It took a specially treated plate that was chemically sensitized to a broader range of wavelengths, then exposed to starlight through a yellow screen to dampen the amount of blue light it received, to finally bring S Cephei into photographic view.

As Wendy continued her work, trying to refine the distances to Cepheids in neighboring galaxies, telescopes were beginning to be equipped with a new mechanism for measuring starlight: charged-coupled devices (CCDs), which converted incoming photons into electron charges that could be counted. CCDs *relayed* information instead of trying to capture it. The precise quantification of how many photons landed on the sensors made this new technology's

relationship to light linear. Recall Leavitt determining standards for her North Polar Sequence: the amount of light hitting the photographic plate was not directly proportional to the size of the mark it left. Leavitt needed to devise creative, seemingly wacky photographic techniques to pull the bright and faint stars of her North Polar Sequence into conversation with her midrange stars. Wendy relates to this experience: "Photographic plates had all sorts of issues. There were errors introduced at very low light levels and very high light levels." With CCDs, the number of electrons counted directly corresponded to the intensity of light received. And unlike the glass plates, CCDs could read starlight toward the red end of the spectrum as well as the blue. Also significant: they were about a hundred times more sensitive than photographic plates.

Wendy proceeded with this new technology. "What I did in graduate school was to be able for the first time to measure Cepheids with a range of wavelengths—so from the blue to the visual to the near infrared. And what that gave us the opportunity to do, for the first time, was to correct for the presence of interstellar dust." Wendy's 1984 graduate thesis demonstrated how results shifted depending on what wavelength was used to measure starlight. "The dust particles that are in the regions between stars have a size that is comparable to the wavelength of blue light. As a photon comes from your star, it can be absorbed by a dust particle, or scattered." Consequentially, that star appears redder and fainter than it intrinsically is. "If you don't correct for the presence of dust, you think it's farther away."

Wendy used a simplifying principle similar to one of Leavitt's: Leavitt had reasoned that all of the variables she found in the Small Magellanic Cloud were the same distance away. Wendy assumed the Cepheids she was observing in the Andromeda Galaxy were essentially equidistant. As she plotted their luminosity against the inverse of the wavelength used to measure their light, the distance modulus—the gap between apparent magnitude and absolute magnitude—decreased as she went into the near infrared. Correlating her data with the interstellar extinction law (how dust affects light) she could correct her observations for the amount of dust present. Photographic plates did not deal well with interstellar dust, but, Wendy says, "with CCDs, for the first time, you could correct for the reddening." The result? "Galaxy distances came in." They were closer, which led to an increase in the calculated expansion rate of our universe—a contentious assertion. There was strong disagreement about that number, and most of the uncertainty lay with the distances to galaxies close by. As Wendy describes, "Correct for reddening, use the more accurate CCD detectors, and suddenly you had some really good measurements." What would become possible with the imminent launch of the Hubble Space Telescope—the first astronomical observatory to be placed into orbit around Earth—seemed very promising.

Wendy's résumé is long and impressive. She is currently the John and Marion Sullivan University Professor in Astronomy and Astrophysics at the University of Chicago, where she has taught and undertaken her research since 2014; she was the first woman to join the permanent scientific staff at the Carnegie Observatories (in 1987), where she remained for thirty years; she became the director of the Carnegie Observatories in 2003; and she was a principal investigator of the Hubble Space Telescope Key Project on the Extragalactic Distance Scale, a project to measure the current expansion rate of the universe (known as the Hubble constant), which builds on the law Hubble established that galaxies are moving away from Earth at speeds proportional to their distance. Wendy used the Leavitt law to calibrate the Hubble constant by improving the precision of measurements to observable Cepheids. And it was Wendy who introduced Dava Sobel to Henrietta Leavitt's story, which led Dava to the story of the glass plates and the women who studied them, which became the spark for *The Glass Universe*.

Wendy says that Leavitt has always been part of her professional life. She knows firsthand how significant Cepheids are to our understanding of the universe, and therefore knows the significance of Leavitt's contribution to modern and contemporary cosmology. Wendy has always seen Leavitt, and she has also seen how Leavitt has remained largely unseen.

Which was not true in Leavitt's lifetime. Contrary to the assumption that it was the sexism of Leavitt's day that dampened subsequent recognition, when conducting research for this book it became evident that it is not so much history itself (that is, how Leavitt was treated as a female astronomer) but rather the *telling* of history that needs correcting. The astronomical community knew what Leavitt was up to, as manifest in the unsolicited praise from Princeton astronomy professor Charles Young in his 1905 letter to Edward Pickering: "What a variable star 'fiend' Miss Leavitt is—One can't keep up with the roll of the new discoveries." In a folder marked "Leavitt" among Harlow Shapley's records in the Harvard University Archives is a newspaper clipping from the *New York Herald* published a few days after her death: "While Miss Leavitt's labors were not in a field that made her known to the general public, her fame among astronomers has long been world-wide and is built upon a foundation that is enduring." Also in this folder is a letter from Leavitt's mother, dated December 31, 1921, thanking Shapley for the flowers and condolences from the observatory staff, and saying of her daughter's accomplishments, "But while she was so modest about it, a remark once in a while showed me that she understood the standing she had among the astronomers." Leavitt caused a stir.

João Alves first encountered Leavitt's photograph in the 1943 edition of Shapley's *Galaxies*. In the 1947 edition her photograph remains. But in all

In the World of Stars

Astronomy's Debt to American Women

By Grace Humphrey

WHEN you were a little girl did your grandmother tell you stories about Maria Mitchell? Did you wonder at the pride in her voice when she spoke of "Miss Mitchell's comet"—as the newspapers of that time always referred to it, instead of using its long scientific name? Women of that generation were enormously proud of the achievements of one of their sex, for those who won distinction were few and far between. In this country Maria Mitchell stood alone as a real contributor to science. People compared her only with Mary Somerville or Miss Herschel in England.

With a thrill of pride too perhaps you listened to the story of her childhood on Nantucket — how her father taught her navigation along with her brothers, how she discovered her comet that October night in 1847 and how its discovery brought her the gold medal offered by the king of Denmark; how Matthew Vassar invited her to the college he was starting for girls and built for her an observatory—with the third largest telescope in this country, your grandmother would add proudly. Did grandmother realize all that it meant, this opening to women a new employment, a new avenue of usefulness?

Today the progress of astronomy in America is deeply indebted to women. Two generations of girls have been edu-

Photographs by William Henry

Henrietta S. Leavitt

cated at Vassar, rich in Maria Mitchell traditions. At every woman's college astronomy is taught. It was a woman who gave the beautiful marble observatory to Wellesley, and later added a residence for the staff of this department. It was a titled English woman, herself an astronomer at the famous Tulse Hill Observatory near London, who gave Wellesley the Huggins collection of astronomical objects—the gift of a woman in the old world to an institution in the new, with which she had no connection save her deep interest in the work it offered to young women. It was a woman who gave the twenty-four inch Bruce telescope to the observatory at Arequipa, Peru, and who established the Bruce medal awarded each year for distinguished work in astronomy. It was a woman who founded the Draper Memorial at Harvard, and to her continued interest and generosity were due the growth and achievements of the Harvard department of astronomy.

In 1918 the American Astronomical Society, meeting at Harvard, spent a day at Wellesley. And last year, for the first time, the four days' meeting was held in a woman's college, at Smith, with one session at Mt. Holyoke. The treasurer of this society is a woman. The secretary of the American association of observers of variable stars is also a woman. Thus men of science are recognizing the value of American women's contribution in the field of astronomy.

In biblical times, and still earlier during the reigns of the first Pharaohs in Egypt, people in eastern countries studied the stars. Literature, from the writings of primitive civilizations to present-day volumes, abounds in references to the stars. As far back as record goes, the sky has been the greatest of mysteries. But though for many centuries men have tried to learn its secrets, to make rules for mysterious stellar appearances, they have been baffled by space and time that seemed almost limitless. Progress in astronomy has been very slow. Only recently has this been altered, and the change came about as a result of discoveries and improvements in another line, photography.

As early as 1850 Harvard was taking pictures of stars, but the plan to secure a complete record of the sky by this means had to be abandoned. Wet films were too slow. The introduction of dry plates made a great change in photography; in astronomy it made a greater change than any since the days of

Annie Jump Cannon

Galileo. It amounted virtually to a revolution. The new astronomical photographs opened another field for woman's work. At first women were called on merely to examine plates and make simple computations. Gradually work of more and more responsibility was turned over to them, till they began making independent investigations—the goal of every scientific worker.

Astronomy today does not mean sitting up all night with your eyes glued to a telescope, as your grandmother pictured Maria Mitchell. It means rather days, weeks, months, in a laboratory, poring over glass plates and enlargements of photographs, computing position of stars and light curves, with the most complicated of mathematics. It means slow, careful, painstaking work, covering a long period of time, using the observations of many people. It may mean a long piece of research that ends in negative results—disappointing, but indispensable for ultimate progress. Said Maria Mitchell, when asked the reason for her success, "I was born of only ordinary capacity, but of extraordinary persistency." Whether we agree with the first, we must with the second; for extraordinary persistency is one of the requisites for this work. It is not sufficient to make deductions from observations taken in one place. For the study of variable stars there are now associations here and in Great Brit-

subsequent revised editions, Leavitt's image has been replaced with a photograph of the Bruce telescope. (Some photographs of male astronomers are also replaced by telescopes.) Those who shape history's telling seem to prefer the triumph of technology, while Leavitt—who calibrated that technology and translated its data into comprehensible, usable insight—fades into the background.

As director of the Harvard College Observatory following Pickering, Shapley came into contact with Leavitt during the final years of her life. His acknowledgment of her is direct. The lead-in to Shapley's quote that João offers at the beginning of his essay—*The Clouds were first being seen by a young woman sitting at a desk in Cambridge, Massachusetts, in her hand an eyepiece, with which she could examine a confusion of little black specks on a glass plate*—contradicts the editorial decision to remove Leavitt's photograph. Shapley's paragraph containing that quote begins, "The Clouds had been looked at for four hundred years"—a reference to the amount of time these celestial objects had been named the Magellanic Clouds—"but only now at the turn of the century were they beginning to be seen. They were being accurately observed, not by an ardent stargazer on the quarter-deck of an exploring frigate; not by the celestial explorer at his temporary observing station in Australia, South Africa, or South America; not even by the Harvard astronomer laboriously exploring large photographically sensitive plates in a powerful camera at the foot of El Misti in Peru. The Clouds were first being seen by a young woman." Shapley recognized that neither the telescope nor the men operating it were able to see what Leavitt saw.

The same tender language that João surfaces shows up again in Shapley's autobiography, *Through Rugged Ways to the Stars*: "Miss Leavitt was one of the most important women ever to touch astronomy." To think that Leavitt only examined the cosmos by daylight as it was suspended on her glass plates, yet her attention to them centered her. Wendy has told me how happy she is that Leavitt's story is emerging, as it should. Leavitt has been here all along, just as Cepheids have been present in cosmology for the past hundred years.

All stars are supported by the balance between gravity drawing things inward and that inward pressure heating things up and pushing back out—a stasis between the collapsing pressure of gravity and the expanding pressure of energy released from nuclear fusion at a star's core. The atmospheres of Cepheid variables have just the right temperature for this balance to be in flux. When a Cepheid is the most compressed (tipping the scales in favor of gravity) it is the hottest. The compression results in a temperature at which photons released from the center of the star doubly ionize the surrounding helium. Now a bunch of electrons are no longer bound to the helium. The photons emanating from a star's nuclear furnace scatter off these free electrons, making the star more opaque,

therefore less bright. The photons then push on the electrons, which expands the star's outer atmosphere as it tries to accommodate this pressure. The scales start to tip the other way. With expansion comes cooling; the electrons become less excited, dropping from doubly ionized helium down to singly ionized helium. Now the star is more transparent, aglow; the photons can more readily escape. But the decreased pressure from cooling allows gravity to once more dominate, and the atmosphere of the star starts to collapse again. With that compression, higher temperatures return. The helium is doubly ionized, and the cycle repeats. This expansion and contraction of a star's atmosphere produces variability in a star's light. This dynamic occurs in stars that are many times the mass of our sun, which translates to a luminosity that can be, staggeringly, 30,000 times as bright as our sun. These bright stars can be seen from very, very far away.

Cepheid variables are young stars. They haven't yet migrated from the place of their birth, which is why, when Leavitt first went searching for variables, she found so many of them in the Orion Nebula, a region of collapsing gas and dust creating the necessary environment to form new stars. The Orion Nebula, as represented on two glass plates, is where I first looked to try to see what Leavitt saw, taking some of Leavitt's actions as a way to understand them. Previously I had used a needle and thread to convey my ideas, but for the first time in my career as an artist I held a pencil in my hand and tried to draw. I figured if I paid attention I would learn how. Attention would lead me somewhere surprising.

The density of stars in these nebulous regions causes readings of their light to blend. Leavitt often needed to parse stars from their neighbors. "No. 12 re-examined on last five plates," she recorded in a logbook entry dated January 18, 1905. "There is no good evidence of change. This star is difficult to measure on account of the close proximity of two fainter stars." Wendy had to devise her own ways to separate the overlapping light of stars as she prepared her analytic tools in advance of the launch of the Hubble Space Telescope. One of her team members developed an algorithm to extract the true brightness of individual stars. As Wendy explains, "You knew what these stars should look like going through a telescope; that was well determined." If the telescope received the light of many stars at once, the algorithm separated out the profile of each star and then fit them back together, specifying the light of individual stars in an examined group. Different technology, same intention: to study these variables as a way to build greater understanding.

Variable stars were also the focus of study for young Harlow Shapley, arriving at Mount Wilson Observatory in 1914. Shapley credits Solon Bailey (who would later act as interim director of the observatory between Pickering's and Shapley's tenures) for the idea to look for variable stars in globular clusters. On a visit to

Harvard just before his time at Mount Wilson, Shapley writes in his autobiography about going to see Bailey "upstairs by the observatory dome." Bailey told Shapley: "I hoped you wanted to come up here; I have been wanting to ask you to do something. We hear that you are going to Mount Wilson. When you get there, why don't you use the big telescope to make measures of stars in globular clusters?" The 60-inch telescope at Mount Wilson was in place by 1908, and plans for the 100-inch were already developing. Bailey had done his best to search for variables in globular clusters on Harvard's glass plates during his time heading the Boyden station in Arequipa, Peru, but he wasn't territorial about his research. He was curious, and maybe with access to the 60-inch, Shapley could help find some answers.

Globular clusters are strange relics from our early universe, conglomerates of hundreds of thousands of stars. The fact that the stars in these gravitationally bound, dense spheres are poor in "metals" (astronomers' word for elements heavier than helium) is evidence that they are vestiges of a young universe, when hydrogen and helium were essentially the only two ingredients available for star formation. Whatever inspired these stars to erupt into being all at once—well, that criteria must no longer exist, because only about 150 globular clusters are currently found in the Milky Way (with perhaps a few dozen more hidden by galactic dust), making them rare sights in the night sky. If Shapley could map the hundred clusters he could observe, as they piled the shared light of their stars onto glass plates, their distribution might convey an underlying structure latent in the heavens' innumerable pinpoints of light.

Shapley began locating these globular clusters in space, using Ejnar Hertzsprung's work to calculate distances. Hertzsprung had been the first to try to connect Leavitt's law to concrete measurements using parallax to calculate the distance to the nearest Cepheids. Previous calculations using this trigonometry relied on the Earth's orbit around the Sun, but even the closest Cepheids were still too far away to use this technique effectively. As George Johnson describes in *Miss Leavitt's Stars: The Untold Story of the Woman Who Discovered How to Measure the Universe*, Hertzsprung used the Sun's "slow drift through the Milky Way" (pulling Earth along with it) to form the base of a much larger triangle. Making observations of nearby Cepheids a few *years* apart, Hertzsprung triangulated the distances to them and tied those tangible distances to the lengths of their pulsation periods. Plugging that information into Leavitt's graphed relationship, Hertzsprung could determine how bright a Cepheid *should* be simply based on the length of time it took to pulse, and from that calculate the amount of space—the finite distance—causing that light to dim to its observed brightness. When Hertzsprung applied his metrics to the luminosity of Cepheids in the Small Magellanic Cloud, his published findings indicated it was 3,000 light-years

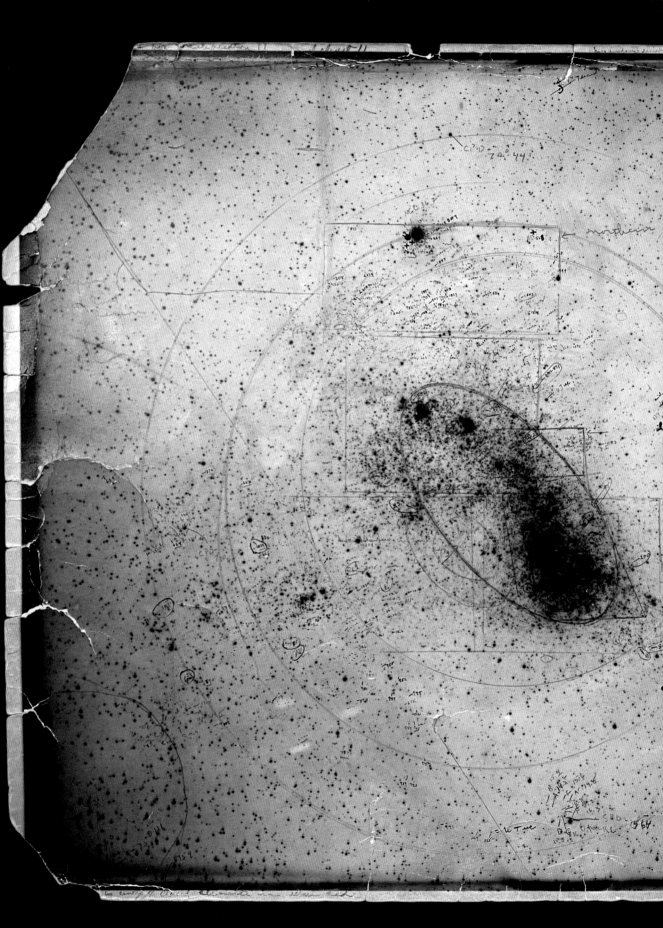

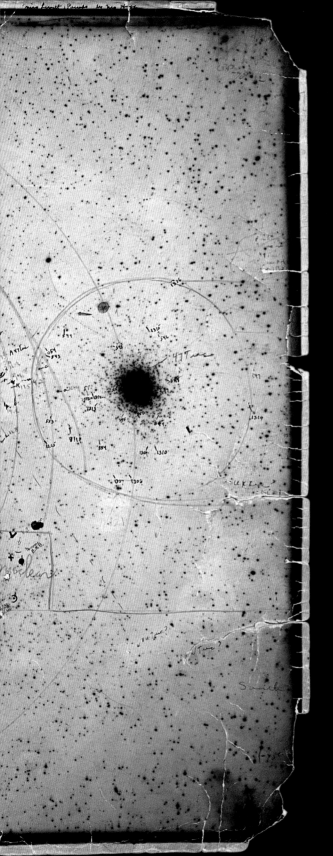

Contact print of the Small Magellanic Cloud made from negative glass plate A3393.

UAV 630.253 (box 1), Harvard University Archives. Photo by Jennifer L. Roberts.

Photographs accompanying this essay were created by Jennifer L. Roberts, most with her macro lens, of a holding in the Harvard University Archives titled "Harvard College Observatory finding charts of Small Magellanic Clouds," which contains seventeen large contact prints on which Leavitt's handwriting often appears. Jennifer's eye was drawn to the objects NGC 104 and NGC 362, both globular clusters that appear near the Small Magellanic Cloud on many of the photographs, including one with an area labeled "Seq. 35 Miss Leavitt's region" among the printed stars.

away. Johnson writes: "This was enormous by the astronomical standards of the time. In fact it was a misprint. Maybe a journal copyeditor had recoiled at the real number, inadvertently dropping a zero. According to Hertzsprung's calculations, the nebula was ten times farther, 30,000 light-years away."

In his early years at Mount Wilson, Shapley was the first to propose that Cepheid variables are single, pulsating stars—that the engine within them drives its cycle, not a second orbiting object periodically obscuring the star's light. But theorizing *what* they were didn't reveal *where* they were. It was Leavitt's discovery that steered Shapley toward the potential of these variable stars: "Finally I hit upon using the period-luminosity relation that had been foreshadowed by Miss Henrietta Leavitt at Harvard in a paper published in 1912." That "foreshadowing" was stated plainly enough in Leavitt's remarks in *Circular* no. 173 alongside her establishment of the light curves for twenty-five variables in the Small Magellanic Cloud: "A remarkable relation between the brightness of these variables and the length of their periods will be noticed." Indeed, it had been noticed and noted in Leavitt's original 1908 paper, "but at that time it was felt that the number was too small to warrant the drawing of general conclusions. The periods of eight additional variables which have been determined since that time, however, conform to the same law." It was the natural law that would become known as the Leavitt law.

Two sentences toward the end of Leavitt's paper offer suggestions for further investigation, demonstrating both the ethos of generosity that permeated the Harvard College Observatory during Pickering's era and the interchange of ideas that is a way science is shaped. The first anticipated Hertzsprung's achievement: "It is to be hoped, also, that the parallaxes of some variables of this type may be measured." The second hinted at the challenges Shapley would face: "Two fundamental questions upon which light may be thrown by such inquiries are whether there are definite limits to the mass of variable stars of the cluster type, and if the spectra of such variables having long periods differ from those of variables whose periods are short." Shapley hoped to apply Leavitt's principle to the variables he found in globular clusters scattered throughout space. But most of the cluster variables he observed behaved a little differently than the ones Leavitt had pinpointed in the clouds. Hers took between a day and a week to cycle fully, a handful extended longer than that, and one whopper had a pulsation cycle of 127 days. Shapley's cluster variables blinked rapidly, often in less than twenty-four hours. Nonetheless, the longer-period variables in the clouds seemed related. Even Leavitt's 1912 paper speaks to this connection: "They resemble the variables found in globular clusters, diminishing slowly in brightness, remaining near minimum for the greater part of the time, and increasing very rapidly to a brief maximum."

Like Hertzsprung, Shapley began his calibration of Leavitt's law by estimating the distance to the nearest Cepheids using the observed *transverse* velocity of a star—similar to how the apparent pace of an airplane tracking across the sky indicates how far away it is. Shapley could then apply this information and extend the curve of Leavitt's relationship to his faster-blinking cluster variables. Eventually Shapley ran out of globular clusters where even shorter-period variables could be identified. Shapley needed a new tactic for more distant clusters. He reasoned that the brightest stars in one cluster would be comparable to the brightest stars in others, so he created a "standard candle" by grouping the same number of bright stars in each cluster and averaging their luminosities. Using the inverse square law to calculate the dimming effect of space (for example, if an object is twice as far away it appears one-quarter as bright), Shapley measured distances by gauging this set number of brightest stars in each cluster against that average. For the faintest clusters, where not even a single star could be resolved, he took the overall luminosity of each cluster and averaged them to establish a standard brightness, and again used the inverse square law to quantify the most distant clusters' successively receding light. This strung-together logic might have placed Shapley far out on a limb, but it appeared that the branch would hold.

When Shapley finished his estimations, a surprising shape took form: most of the clusters were in one direction, lumped together. This "cluster of clusters," as Shapley puts it in his autobiography, "is in one part of the sky, in the region of Sagittarius—'the home of the globular clusters,' it has been called." (This region is now known to be home to Sagittarius A*, the supermassive black hole at the heart of our galaxy.) Equally significant, this left the remainder of the sky mostly empty of globular clusters. It had once appeared that our solar system sat in an amorphous ocean of stars, perhaps at the center of that sea. But these one hundred clusters mapped out a structure within that uncertainty, and this cluster of clusters had identified a center while placing Earth at the edge, with philosophical, not just spatial, implications. Shapley wrote of this reordering: "In it the solar system is off center and consequently man is too, which is a rather nice idea because it means that man is not such a big chicken. He is incidental—my favorite term is 'peripheral.' He is on the perimeter of this operation."

But all of this hung on the armature of Shapley's pieced-together reasoning, which stemmed from his application of the law Leavitt found in the Small Magellanic Cloud to globular clusters. This is why Shapley was so persistent in writing to Pickering about Leavitt's research. In a letter dated August 27, 1917, Shapley inquired about the faintest variables Leavitt might have seen in the Magellanic Clouds: "Does Miss Leavitt know if they have shorter periods, that is, are their periods shorter than one day, similar to cluster variables?" And again

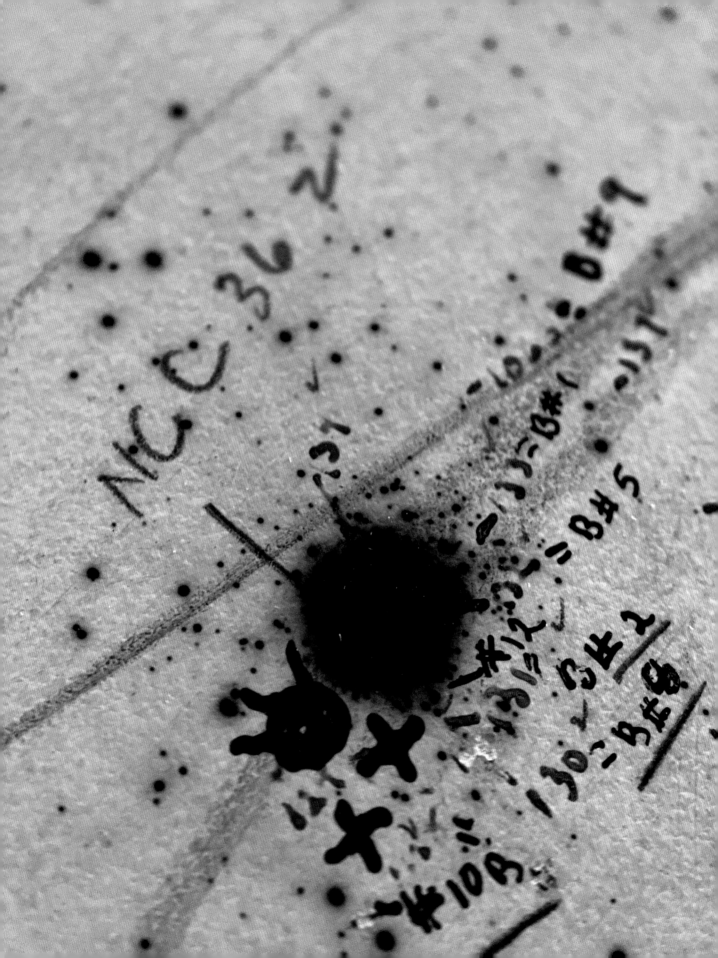

on September 24, 1917: "Her discovery of the relation of period to brightness is destined to be one of the most significant results of stellar astronomy, I believe. I am quite anxious to have her opinion as to the periods because of its bearing on some statistical work I am now bringing to a close." After more correspondence, almost a year later Shapley's insistence finally made headway: "A few days ago I talked with Miss Leavitt," Pickering wrote on September 1, 1918. "She has the material for about a third of the brighter variables, and photographs are now being taken with the Bruce 24-inch, which I hope will provide the remainder." But this is the last letter from Pickering in Shapley's Harvard University Archives files. Four months later, after decades of useful (as Pickering would have hoped) astronomical work, Pickering died of pneumonia at the age of seventy-two.

When Shapley became director, his focus had not changed. Based on the opening sentence of a letter Shapley wrote to Leavitt, dated May 22, 1920, she had evidently asked Shapley for advice about where to take her research. His letter begins:

My Dear Miss Leavitt:

In compliance with your request may I make the following suggestions relative to your research on the stars in the Magellanic Clouds.

1. Of first importance I consider the investigation of the periods (very rough estimate, if need be) of some of the variables in the Small Magellanic Clouds just fainter than the faintest already studied (those faintest ones had periods of less than five days). Some of the many hundred faint stars will surely have sufficient observations to tell whether the period is of the order of twelve hours, or much longer.

His letter has three more numbered points: Shapley wonders if her "period-luminosity law" holds just as strongly in the Large Magellanic Cloud as she demonstrated that it did in the Small Magellanic Cloud; hopes she might make "a comprehensive determination" of the periods and range of the bright variables in both regions; and suggests working on determining in these regions the color of the brightest "variable and invariable" stars. While noting that the publication of light curves should wait for standardized magnitudes (there is the importance of Leavitt's North Polar Sequence showing up again), Shapley felt that her study of the kinds of variation she found in the Magellanic Clouds should not be held up on this account. (He was still wondering: *Did* the shorter-length variables follow the same principle as her longer-length variables?) Of his four-point list, Shapley wrote, "The first of the four items above is of enormous importance in the present discussions of the distance of globular clusters and the size of the galactic system." The letter ends, "With best wishes for your success with this interesting problem."

Shapley was right to worry about whether his more rapidly pulsing cluster

variables aligned with the principles underlying the slow-blinking variables Leavitt found in the clouds. It wasn't until decades later that Walter Baade, under unique circumstances, revealed that they were indeed from two separate categories of stars. During World War II Baade was working at Mount Wilson Observatory, but as a German citizen he was considered an "enemy alien," so while the other Mount Wilson astronomers paused their research to contribute to the war effort, Baade was confined to the observatory but allowed to continue his work. Blackout orders extended along the West Coast after the bombing of Pearl Harbor, which provided ideal viewing conditions despite a world in turmoil. With little competition from other astronomers for time on the 100-inch telescope (the largest in the world at the time), Baade could take longer exposures of the Andromeda Galaxy that resolved stars toward the center of the galaxy, not just in its spiral arms. These stars were different than those previously observed, leading Baade to the realization that there are "populations," or generations, of stars. The central stars were older, confirmed through spectroscopy to lack heavier elements. The variables Hubble and others had found farther from Andromeda's central bulge *did* contain heavier elements, which indicated these stars had formed from the stellar dust of a more mature universe enriched by the deaths of generations of stars. This led to a recalibration of the Leavitt law according to the metallicity for each type. Both followed the same principle—the length of their pulsation periods was directly linked to their intrinsic brightness—but Shapley's cluster variables were older, low-mass stars, and intrinsically less bright. His scale had been off; Shapley had assigned these stars much greater brightness than they actually possessed, placing them farther away than they actually were. The size of our galaxy was staggering, just not to the extent he had specified.

Shapley's great scientific contribution was the revelation of the vast breadth of the Milky Way and our place in it not being central. But his name is just as strongly tied to his participation in the Great Debate, held on April 26, 1920, at the Smithsonian Museum of Natural History, in which he erroneously upheld the theory that the Milky Way constituted the whole of our universe. Shapley would later argue that it was only history's memory that ascribed capital *G* and *D*, as it were, to this event. In his mind it was originally billed as a symposium, with him and Heber Curtis from Lick Observatory presenting on "The Scale of the Universe," with a rebuttal apiece. This was another point that Shapley wished to emphasize: the discussion was about the *size* of the galaxy, less about whether the fuzzy regions with spiral forms were wispy structures detached from the milkiness of the Milky Way or so-called island universes separate from our own. He was open to such an idea, but the vastness of the Milky Way as he had recently calculated it made him think that it must encompass any and all outlying objects.

Shapley's calibration of Leavitt's law produced a Milky Way that was 300,000 light-years across; Curtis's string of calculations based on different methods estimated its size to be 30,000 light-years across (which happened to match Hertzsprung's calculation of the distance to the Small Magellanic Cloud—those spiral nebulae could still be within the Milky Way's reach). According to the published version of the Great Debate, Curtis ended with this point: Why were the spirals all located at the poles, above and below the Galaxy's central bulge, while none were seen in the galactic plane, where most stars reside? None had been observed in the "zone of avoidance" (a term still used today to describe the line of sight—or lack of it—through the galactic disk where interstellar dust obscures the visual range). If the spirals were a part of our galaxy, Curtis argued, wouldn't they be equally distributed throughout? He correctly reasoned that they existed beyond our galaxy, and if the Milky Way took the same form as these spiral nebulae, then it would contain the same dense lanes of dust he had observed in them, and that density would visually "obliterate the distant spirals in our galactic plane." Curtis then used Shapley's own previously published words against him: Shapley had suggested that if spiral nebulae were within our galaxy, "the dynamical character of the region of avoidance" might have pushed these spirals from the galactic plane with the radiating pressure of its abundant stars. Curtis was dismissing Shapley's argument, yet simultaneously demonstrating that one can shape an argument to support what one wants to believe.

Shapley is infamous for losing the Great Debate, but he wished to correct that history: "I was right and Curtis was wrong on the main point—the scale, the size. It is a big universe, and he viewed it as a small one." It would not be long before the size of our galaxy—whether 300,000 light-years or 30,000—would be irrelevant.

Edwin Hubble broke the news to Shapley in a letter dated February 19, 1924. By this time, Shapley was the director at the Harvard College Observatory. (Hubble and Shapley had both worked at Mount Wilson, but hadn't gotten along. As Johnson notes, "For two boys hailing from rural Missouri, Harlow Shapley and Edwin Hubble didn't have much in common, except perhaps for the size of their egos.") Hubble's letter to Shapley begins, "You will be interested to hear that I have found a Cepheid variable in the Andromeda Nebula (M31)." This was the famous Cepheid captured on glass plate H335H that Hubble labeled "VAR!" in red ink. Plotting its light curve with subsequent observations and using the Leavitt law to determine its true brightness, Hubble calculated that its dimmed light placed Andromeda close to a million light-years away. There were no encompassing arms of the Milky Way that could reach that far.

But Shapley wasn't ready to be convinced, as was plain in the opening sentence of his response: "Your letter telling of the crop of novae and of the two variable stars in the direction of the Andromeda nebula is the most entertaining piece of literature I have seen for a long time." Shapley reminded Hubble that any star in these indistinct regions might look like a variable: "Incidentally, your experiences probably show you that in the denser parts of the nebulicity every star is a variable, depending upon exposure time, development, and other factors." (Shapley's words also act as a reminder that the world Leavitt tried to decipher was filled with false images and potential misperceptions.) But within the year, Hubble's identification of variables in Andromeda had started to undeniably pile up.

What's more, Shapley had an earlier opportunity to believe. Wendy shared with me a story from her former Carnegie colleague Allan Sandage, who had been Hubble's assistant as a graduate student and extended Hubble's research after his death in 1953. It begins with Milton Humason, who started working at Mount Wilson Observatory as a mule driver, bringing equipment up the mountain to build the 60-inch telescope. (In the early days there was no paved road up the mountain. According to Shapley, it was a nine-mile hike just to spend a cold night observing—one of the "rugged ways" referenced in *Through Rugged Ways to the Stars*.) Humason then became a janitor at the observatory and volunteered nights as an assistant operating the telescopes and observatory dome. Wendy says Humason was "keenly alert to details" and reportedly "had a real ability to reduce the photographic plates." Like the Harvard Computers, he was adept at trans- lating between technology and meaning. His talent and insights were evident to those who worked around him—Mount Wilson Observatory director George Ellery Hale made him a staff member in 1919, an unprecedented promotion for someone without a PhD, much less without a high school diploma. Shapley acknowledged, "Humason became one of the best observers we ever had."

Wendy's story continues: "One day, Humason had been developing some plates of Andromeda, and he walked into Shapley's office, as I heard Sandage tell it, and he showed Shapley that there were stars on the plates that he thought might be Cepheids." Shapley got annoyed, took out a handkerchief, and wiped off the circles that Humason had drawn on the glass to indicate potential Cepheids. "If Shapley had not been so convinced that the Milky Way was the entire extent of the universe and open to the idea that maybe it was larger and maybe you really could find Cepheids in Andromeda, he could have made that discovery. But he didn't. He wasn't open to it."

How interesting that one of the great minds of astronomy wasn't receptive. Shapley redefined our place in the cosmos. Acknowledging the radical nature of the new worldview his distributed globular clusters produced, Shapley said that

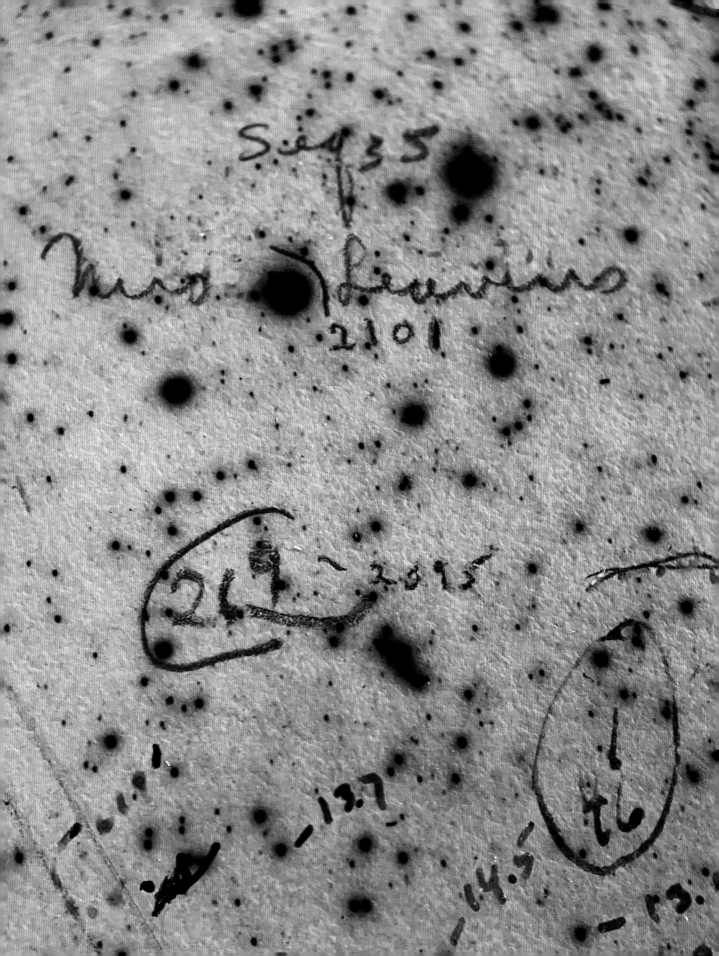

his findings were for the most part immediately accepted, "except by the cautious people who did not want changes." We are all capable of taking turns in these roles. But it also struck me in my conversations with Wendy how willing she was, and is, to look. As she prepared for the Hubble Space Telescope Key Project, there was a "fierce debate" as she puts it, about the expansion rate of the universe. (From those around Wendy at the time, this is apparently an enormous understatement.) A lot was resting on that number. Wendy figured she'd see if Leavitt's Cepheids could help.

The goal of the Hubble Space Telescope Key Project was to measure the expansion rate of an *expanding* universe. This was the second revelation that Hubble and Humason produced: our universe is dynamic, not static. With one Cepheid located in Andromeda, Hubble had been able to show that there were galaxies beyond our own. Continuing his calculations of distances to other spiral galaxies—aided by the spectral analysis of those galaxies done by Humason as well as Vesto Slipher, who at Lowell Observatory in Arizona had been determining the redshifting of what were then called spiral nebulae for years—Hubble was able to show that the distance to a galaxy is related to its velocity of motion: the farther away it is, the faster it is traveling. This direct relationship is known as the Hubble law, and the specification of that relationship is known as the Hubble constant. In other words, when the velocities of galaxies are graphed against their distances, the resulting linear fit illustrates Hubble's law, and the incline or slope of that line is the Hubble constant. If distances increase, the graph stretches out, lowering the slope; if refined measurements indicate galaxies are closer, the slope steepens. So depending on the calibration of distances—and Wendy confirms that Cepheids have been the "gold standard" for that calibration—the slope of that linear relationship will rise or fall.

The Hubble law is also known as the Hubble-Lemaître law (members of the International Astronomical Union voted in 2018 to recommend the change), a recognition that theory and observation work in concert. Albert Einstein's field equations for his theory of general relativity suggested a dynamic universe, but Einstein himself had resisted that notion—the idea of an expanding universe was radical at that time, even for Einstein—and he had added a cosmological constant (the math allowed for it) to maintain a calculated static universe. It was a Belgian mathematician and Catholic priest, Georges Lemaître, who expounded on Einstein's theory to predict that the universe had a singular, precise beginning and has been expanding ever since. (Lemaître's solution was later mocked as a "big bang" and shadowed by the assumption that his religious beliefs had clouded his insight, that he was seeking a creation story for our universe that would align with his faith.) While mathematician Alexander Friedmann had played with solutions for either a static or a dynamic universe, it was Lemaître who paired his own

independent calculations with observations. He followed Hubble's work closely and visited him at Mount Wilson Observatory in the summer of 1925. Hubble's distance calculations, taken together with Humason's and Slipher's spectral analysis of galaxies documenting how their wavelengths stretched into the red end of the spectrum as they receded, proved galaxies were hurtling away from us. The title of Lemaître's 1927 paper (translated from the original French) shows how cognizant he was of this data: "A Homogeneous Universe of Constant Mass and Increasing Radius Accounting for the Radial Velocity of Extra-Galactic Nebulae." Hubble's, Humason's, and Slipher's observations, announced in 1929, allowed for Lemaître's application of Einstein's equations to take hold. Leavitt's Cepheids had transported us back in time, revealing our universe's origin.

So why was there fierce debate around the number assigned to the Hubble constant? Hubble and Humason had first calculated the expansion rate to be 500 kilometers per second for every megaparsec—roughly 3,260,000 light-years—in distance. This number has required tinkering ever since. Each attempt has begun with a calibration of Leavitt's law, trying to apply to the rest of the universe what she noticed in the clouds. Like Shapley, Hubble came to generally correct conclusions, but his distances were off because he, too, had clumped Cepheid and cluster variables together. Decades later the work of Walter Baade parsing those two categories—and the realization that some of Hubble's most distant stars were actually groups of stars—resulted in *doubling* the estimated size of the universe, which dropped the constant down to 250 kilometers per second per megaparsec. As Wendy made preparations for the Hubble Key Project in advance of the tele-scope's launch, the number had dipped to its lowest estimation: potentially around 50, but possibly as high as 100 ("the factor-of-two debate"). Despite this wide range, Wendy says the advice she was given as a postdoc starting out in the field (on two occasions, from two observatory directors) was essentially: "Stop working on the Hubble constant. We know what the answer is." That presumed answer was based on the known age of stars in globular clusters—the same relics of the early universe that had proved so revealing for Shapley—which implied a corre-spondingly ancient universe, as much as 16 or even 18 billion years old. As Wendy succinctly puts it, "You can't be older than your grandmother." If the Hubble constant were much larger than 50, suddenly the universe would be younger than its oldest stars. Sandage (Hubble's long-ago protégé) remained *extremely* invested in the constant being this lower number. Wendy's reply to all of this: "My feeling at the time was, well, we better measure it."

There is an echo of Edward Pickering's words here: *Speculations unsup-ported by fact have little value, and it is seldom necessary in such investiga-tions as are carried on here, to form a theory in order to learn what facts are needed.* When I ask Wendy what she considers, as an observational cosmologist,

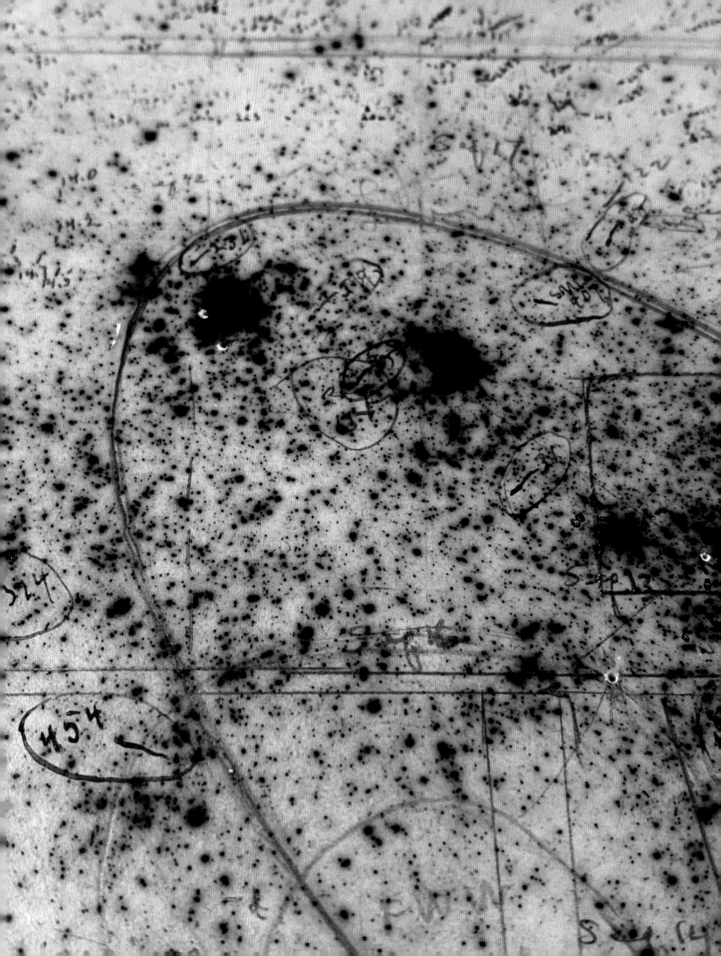

to be the relationship between theory and observation, she replies, "Sometimes theory will anticipate or predict something; sometimes the data will show you that your conception of something is wrong." Observation can precede theory, or sometimes it can be the other way around. "But the data is the arbiter," she insists. "A theory can look really plausible—be very elegant, you know? But if Nature doesn't agree, it's not a useful theory." She wasn't interested in getting into arguments with people about what was right and what was wrong. In the face of strong personalities, Wendy stuck close to the data.

And it was really good data, though some had doubted it would be obtainable. Theorists had told Wendy that what she wanted to do was impossible, their pessimism based on simulations of how many Cepheids could be found in distant galaxies based on the number observed in the Milky Way. Wendy describes the experience of getting the initial data from one of the brightest galaxies in the Virgo Cluster—a gathering of galaxies that had been the farthest reach of Hubble's research, where he had been able to use only the average overall luminosity of galaxies to estimate distances. Cepheids were "popping out," she says. "It was exhilarating." Speaking to the warning that her team wouldn't be able to individuate Cepheids there, Wendy says: "We did find them, and they were bright. It was so obvious from the first measurements our project was going to be possible." The data points in the light curves were beautifully unambiguous. Those familiar bright stars.

The Hubble Key Project used observations in addition to Cepheids, all trying to see the same thing (the distance to a galaxy), so that independent approaches could be compared. One of these methods was using stars at the tip of the red giant branch (its place on the Hertzsprung-Russell diagram charting the life cycles of stars) as a standard candle. "These stars evolve to a certain brightness," Wendy explains, "and then there's something called a 'helium flash' where the star rearranges itself, and then becomes fainter." This phenomenon makes them excellent standard candles because they can't exceed that peak luminosity. While these red giant stars are not as bright as Cepheids, they have the advantage that they can be observed in the outer halos of galaxies, where they are isolated and easier to distinguish. Their light isn't blended together like that of young Cepheids hanging out with all that stellar dust and still-forming stars in the galactic disk.

With its ability to see deeper into space, the Hubble Space Telescope was also able to connect Cepheids to more distant lights. Wendy explains this potential: "If we can tie into another method—for example, very bright supernovae—and calibrate them using Cepheids, then we can make measurements of the Hubble constant at far greater distances." Supernovae are extraordinarily bright; the death of a single star can briefly override the luminosity of an entire galaxy. But they are also extremely rare, occurring maybe once a century in a

given galaxy. Before the launch of the Hubble telescope, none of a particular kind of supernova that has a quantified, signature brightness had appeared in a galaxy near enough to bridge the known distance of a Cepheid to one of these flares. The Hubble Space Telescope was able to make that connection for the first time. The relative brightness of far-off galaxies had been established by comparing galaxies containing observed supernovae, but until a Cepheid could be seen in a galaxy alongside one of these supernovae—which tied them to the same known amount of space—those comparisons were solely relational. Cepheids anchored those blazes of light. A chain of effort, experimentation, thought, and action: Leavitt made her discovery. Cepheids were coupled with parallax. The reach of knowable distance was then catapulted, through the bright death of stars, out into space, yet still tied to Earth, the distance from us.

Wendy's team published their results in 2001. Fortified by independent methods of measurement, the calibration of supernovae, an algorithm that separated out the light of each star, readings taken from above the distortion of our atmosphere, and linear detectors that could both correct for reddening and see deeper into space than ever before, the Key Project's number for the Hubble constant landed at 72, landing almost exactly in the middle of the 50-to-100 debate. But the data didn't make sense. Here was a universe younger than the stars that were in it.

That contradiction was reconciled with the discovery of dark energy—the expansion of space as a property of space—and the realization that our universe isn't just expanding; that expansion is *accelerating*. As light travels to us from distant regions of the universe, its wavelengths are stretched by the expanding space it journeys through, its redshift ever deepening. Dark energy brought into agreement the calculated age of the universe based on the Key Project's number and the age of the ancient stars found in globular clusters. With dark energy, the math of those two realities aligned. It was the "missing component," Wendy says. Measuring can tell you something—and it can tell you when you don't know something. It reminds me of Henry Norris Russell describing Pickering as they puzzled over the spectral inconsistencies of the first-identified white dwarf: "Pickering smiled and said, 'It is just such discrepancies which lead to the increase of our knowledge.'"

When I ask Wendy if she has been looking for Cepheids with the James Webb Space Telescope (JWST), she replies with a smile, "You bet." JWST's primary mirror is about three times larger than Hubble's, which translates, Wendy excitedly shares, to a resolution that is three times better. And it sees in the infrared. Here is a technology that can read light in the favored wavelength; a telescope that sees through dust. The crowding and blending effect of Cepheids in nebulous

regions disappears. "It's like putting on eyeglasses. Suddenly, you can accurately resolve Cepheids for the first time in these distant galaxies. You can see what's there." And, with the telescope's greater sensitivity, we can see farther out. Wendy continues, "You can look at a galaxy that is sixty million light-years away, and you're looking at a tiny point of light that is a Cepheid, and seeing that these stars are obeying the same laws of physics in different places in the universe. You plot out Leavitt's law and they are doing exactly what she discovered they were doing." There were Leavitt's Cepheids, blinking just as predictably as she said they would. The same science unites us, holds true. Wendy marvels at the scope of Leavitt's work: "She measured a couple thousand variables—and to find those couple thousand variables she had to measure, I don't know, maybe hundreds of thousands of stars, and then pay attention and notice what these stars were actually doing, notice that Nature is telling us something about the physical nature of these objects." I tell Wendy that her seeing these far-off Cepheids reminds me of Annie Jump Cannon thinking of Leavitt when she traveled to Peru and sighted the Magellanic Clouds. Wendy, too, was encountering an old friend. She pauses, and then in response says simply, "Science is a continuing conversation."

As with the Key Project, Wendy is using her time on JWST to make measurements in different ways. Her team is using three kinds of stars (Cepheids, red giants, and carbon stars), each as standard candle, to see how the results align. "Three different methods, all in the same galaxies. So either they will all agree really well, or they will be spread—which will indicate that there are systematics—or maybe two will agree and one won't. But we'll see in the end how this comes out."

Wendy was addressing the Hubble tension, the fact that two different means of measuring the expansion rate of the universe currently conflict. Cosmologists have been able to study the cosmic microwave background (the universe's earliest light) with incredible accuracy. Using that data to determine how much stuff is in the universe—visible matter as well as dark matter and dark energy—computer models then run simulations of an evolving universe. The one that best matches our current, observable universe specifies the expansion rate. This approach computes the Hubble constant as 67. Wendy's refinement of the distance to Cepheids places the number at 72. Both methods have been honed to extreme precision. The small amount of uncertainty for each number doesn't allow any overlap. But checking the Cepheid yardstick against the tip of the red giant stars—and Wendy reports that there has already been tremendous progress with this technique—that number comes down to 70. The approaches are still converging.

The conflict between the measurement of the local expansion and what cosmologists infer from computer modeling based on the cosmic microwave

background is an open question in cosmology. Wendy acknowledges that there might be missing physics, a new understanding required to resolve the disagreement. But she wants to make sure it's not just a question of systematics. "You make measurements, and each time you do, you beat down the uncertainty in that measurement if it's scattered in an even way. It's too early to say unambiguously that we need new physics. It would be very exciting, but we want to make sure there is strong evidence for it." Wendy's approach has always been to make independent measurements so that they can speak to each other. That tells you how to look—the most accurate way to look—instead of just seeing what you hope to see. "I care about making the most accurate measurement possible with the current technology. That's how you make progress. Keep testing. Keep testing."

Aided by JWST's infrared vision, Wendy shows me the new possibilities. Sharing her computer screen with me over a video call, she provides four examples of Cepheids imaged with the Hubble Space Telescope, explaining that it is best to detect (locate) Cepheids in the blue range, but then observe (measure) in the red range to see through the dust. Four computer-drawn circles indicate where, confirmed in the optical range, "we know Cepheids should be." Nothing announces itself. In each instance the field was overloaded with dust and other bright stars. At the center of each drawn circle there was no indication—or perhaps, squinting, there was the tiniest of hints—that something might be there. Then Wendy switches to the infrared. Crystallized into view, there they are: four points of light. It strikes me at that moment that Wendy's job is the same as Leavitt's. The means of receiving information may be wildly different (a space telescope a million miles from Earth versus a pane of glass), but the action is the same: they measure a circle of received light to know the brightness of a star, trying to discern how far away it is, building an awareness of the space around us. This is their gift: a sense of where we are.

I had the chance to ask George Johnson where he first encountered Leavitt's story in the years before writing *Miss Leavitt's Stars*. He said astronomy textbooks sometimes included "oblique mentions" of Leavitt, perhaps in a sidebar. "There is one iconic picture they always seem to use." (George was talking about the portrait that João came across in Shapley's *Galaxies*; it is one of only two photographic portraits of Leavitt that remain.) George looked at one of those little text boxes about Leavitt and decided that he wanted to "reverse foreground and background, to make Leavitt the focus of the story, which she deserved to be." Which makes me think of the backdrop of stars against which astronomers calculate stellar parallax. Those myriad stars equally signify a shift, telling us what we need to know.

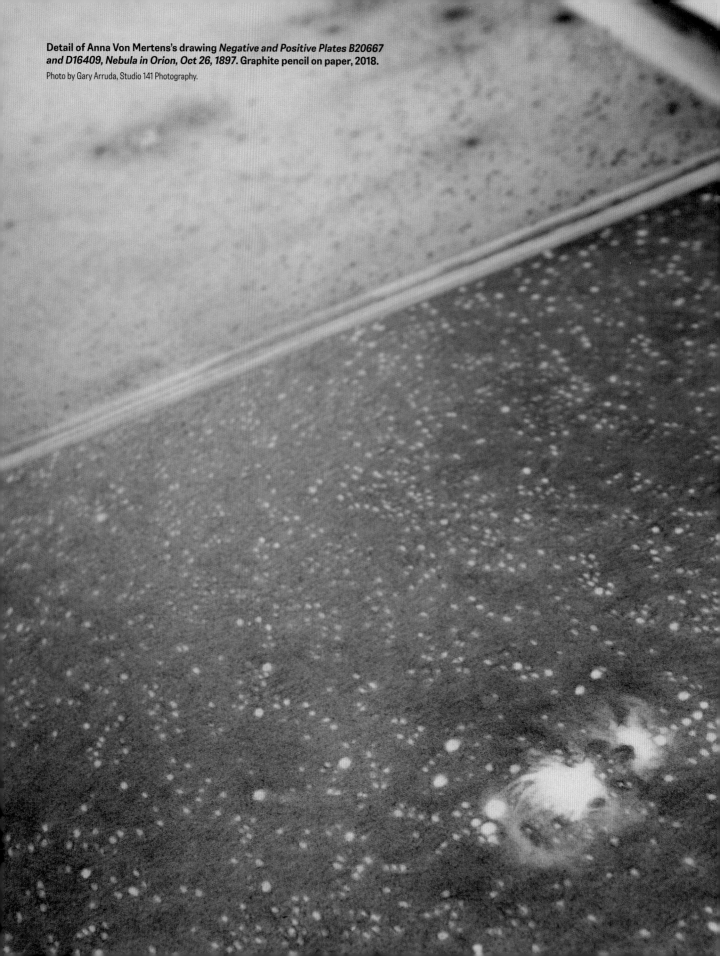

Detail of Anna Von Mertens's drawing *Negative and Positive Plates B20667 and D16409, Nebula in Orion, Oct 26, 1897*. Graphite pencil on paper, 2018.
Photo by Gary Arruda, Studio 141 Photography.

A symposium held at Harvard University celebrated Leavitt's legacy on the centennial of the 1908 paper that announced her discovery of 1,777 variables in the Magellanic Clouds and her discovery of the intrinsic, consistent, predictable, knowable pattern of their light. Both George and Wendy gave talks as part of the event. The symposium concluded with a resolution to adopt the name "the Leavitt law" for the period-luminosity relation, which was sanctioned by the American Astronomical Society at their annual meeting the following year. Its usage is slowly increasing. A recognition of Leavitt's centrality is returning into view.

Referring to my drawing of two glass plates of the Orion Nebula, one positive, one negative (the result of holding a pencil in my hand to see what might happen, to see where the act of drawing would take me), Dava writes: "How many stars are here revealed? Without counting, I feel safe in assuming that nothing has been omitted from the original, nor anything added for exaggerated effect." No exaggeration was needed—in my drawing or Leavitt's story. Here are the facts of Leavitt's presence. Perhaps the most revelatory, meaningful—or, to use a word from my conversations with Wendy, *exhilarating*—thing you can do in this world is look and see what is truly there.

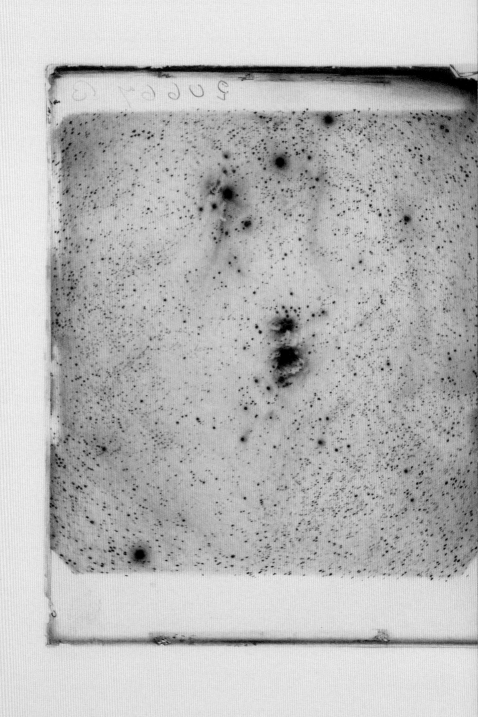

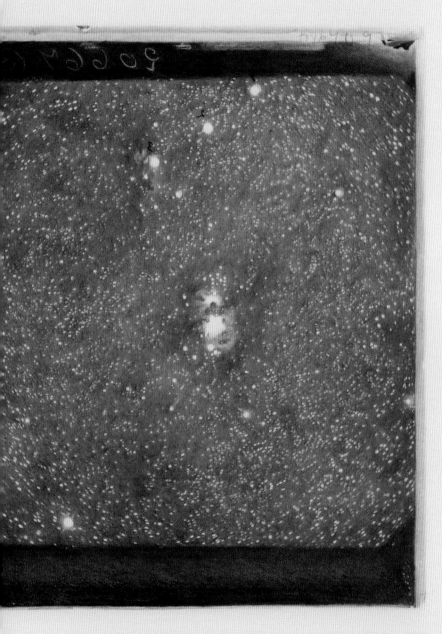

Leavitt stacked positive and negative plates to detect variable stars as tiny misalignments
of dark and light. In this drawing, representations of two glass plates—one negative, one
positive—abutted side by side allude to this methodology. Requiring opposite drawing
techniques to render (one defines shapes with the addition of graphite, the other delineates
them by its absence, the maintenance of white paper), these stars and their inversion echo
how the stars shining in the night sky are simultaneously connected to and separate from the
stars illuminated by daylight on Leavitt's glass plates.

Name and

XVIII

The Small Ma

Observations

Present Occupation

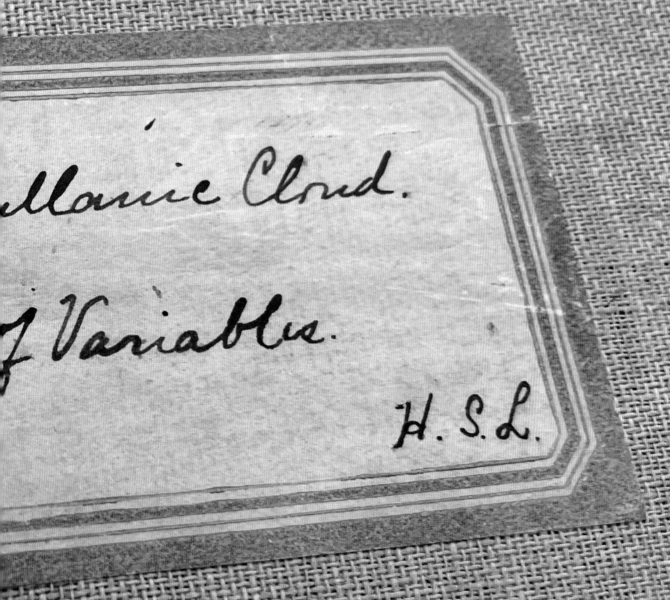

Marie Cloud.

of Variables.

H. S. L.

There are times when I use the name Henrietta. In my studio, spending hours at my desk drawing, hours sitting and sewing, her first name surfaces. Repetition—a stitch, a mark, a comma, a choice, a strikethrough—creates intimacy. (When John Kramer and I were finalizing all of the finalizing for Radcliffe's *Measure* catalog, we definitely used the name Henrietta.) Among all the colleagues who became friends, Henrietta became one, too.

Then again, she might ask: *Who the heck are you?* In many ways, Henrietta, but not in all ways, I am a stranger.

∴

She was addressed as Miss Leavitt by her colleagues, a name respectfully formal yet softened by closeness. As Dava Sobel phrases it, "An exaggerated though genuine politeness characterized the directorial style of Edward Charles Pickering." This was important work, and it was treated as such.

∴

"H. S. L." is how she asserted her presence in her logbooks, or marked ownership on clarifications that sometimes appear on the manila envelopes sheathing the precious glass plates—a guideline or remark for the next woman pulling that particular plate from the stacks. When her initials appear, there is a period after each letter, always. Once I came across a rare notation on one of the glass plates that included those three letters in red ink, a period after each one. Each dot had the same circumference—a result of her knowing the exact distance needed to bring her pen to glass. Oh, the steadiness of her hand!

∴

Her full name stretches out: Henrietta Swan Leavitt. Evocative, yes, but that added word feels unnecessary. I don't know Edwin Hubble's middle name. Twice I have looked it up and promptly forgotten it. Encyclopedic entries tend to state his name plainly: Edwin Hubble. I notice that for Henrietta Leavitt, biographical summaries can't seem to resist inserting that Swan. It sends my mind to Cygnus the Swan (our Northern Cross), and within that constellation the X-ray binary of a supergiant and an unseen black hole in a perpetual do-si-do that made two famous scientists place a famous bet. With Swan, it's easy to get carried away.

PRECEDING PAGE:
Front cover of Henrietta Leavitt's logbook *Small Magellanic Cloud.*
Observations of Variables. H. S. L. **(volume 18).**

Photo by Anna Von Mertens.

In Gala Bent's poem: *unless we dive out into / Henrietta's middle name*. It's a poem that sings the songs of women's names that deserve to be sung. In the first line is the name of another scientist who ignored distractions—internal, external—and did the work: *Vera! Vera Rubin!* (How adjacent is Hubble's "VAR!")

∴

In the index of a book about how our modern universe became known, a single page number is listed under "Leavitt, Henrietta." When I turn to that page, I find twenty-six words describing her accomplishments. In another book on cosmology (also to remain nameless), I see "Hubble's Cepheids." I get protective. Those are Leavitt's Cepheids. She understood them better than anyone else.

∴

Recently I heard a reference to Hubble, the man, in an interview, and in the next sentence Hubble, the telescope, without clarification. The Hubble constant is measured to understand the expansion of space, our cosmic acceleration. Now there is the Hubble tension, the discrepancy between methods for how that expansion rate is calculated. Hubble's name has been condensed to one word, yet is expansively synonymous. Think what *Leavitt* could become.

∴

There is another consideration: What word to use for her job, her life's work? The historical term applied to Leavitt and her colleagues based on their original job description, the Harvard Computers, in many ways feels right. A bunch of women sitting around doing math. But it does not acknowledge their individual roles at the observatory, the varied lines of research, or the singular reflections and preferences in the Brick Building.

∴

Williamina Paton Fleming was born on May 15, 1857, and died on May 21, 1911. Carved into her gravestone is only one additional word: ASTRONOMER.

This is also the word Fleming chose to describe herself in life, evidenced by her 1907 petition for naturalization. (Present for the occasion were Edward Pickering and Solon Bailey—her observatory family—as signing witnesses.) To complete the line "My occupation is," Fleming wrote, "Astronomer."

In a 1908 Oberlin College alumni survey to inform its *Anniversary Catalogue of Former Students*, one line reads: "Present occupation?" The inclusion of a question mark is almost quaint. Leavitt answered "Astronomical Research," as if in wondering what title to take on she decided instead to write the subject of her study.

In the year before her death, Leavitt was living with her widowed mother in an apartment near the observatory. On the 1920 United States census form her mother is listed as the head of the household, followed by "Henrietta S., daughter." Under the header "Trade, profession, or particular kind of work done, as spinner, salesman, laborer, etc."—among the many answers like *teacher*, *maid*, *salesman*, *clerk*—is that surprising yet obvious word: *astronomer*.

We can easily designate Leavitt an astronomer, the woman who helped us place the stars. But I like staying for a moment in the ambiguity of her answer to the Oberlin survey. There, in the middle of things, I see Leavitt's word *research* as a verb, not a noun. She investigated. Leavitt cared about the work; she dedicated her life to it. Like the faithful placement of dots between her initials and the pursuit of faint stars, it was the work—the action of it—that seems to have been most important to Henrietta.

Photograph by Jennifer L. Roberts of a note in Henrietta Leavitt's handwriting on plate MC144, 8 × 10 inches. Exposure of 60 minutes made with the 16-inch Metcalf telescope on January 7, 1910, Harvard College Observatory, Cambridge, Massachusetts.

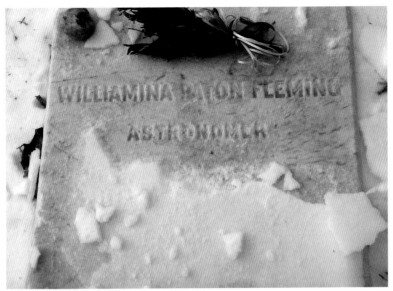

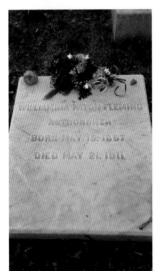

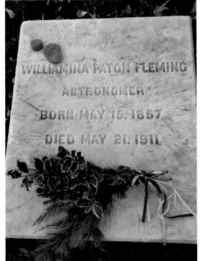

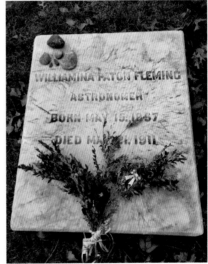

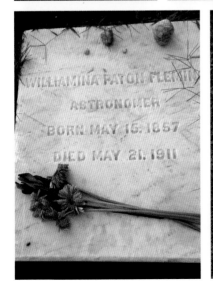

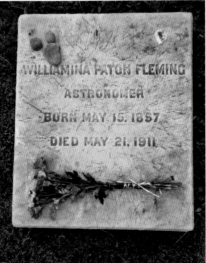

When visiting the graves of her parents at Mount Auburn Cemetery, Wolbach librarian Maria McEachern also visits the graves of Williamina Fleming and Edward Pickering. I had known about these visits from Dava Sobel, who mentioned receiving an image of Fleming's gravestone from Maria "a few Christmases ago." Now Maria emails me similar photographs from her annual pilgrimages to, as she describes them, "'the gang' at Mount Auburn Cemetery."

THIS PAGE: Photos by Maria McEachern.
OPPOSITE PAGE: Photo by Anna Von Mertens.

Data's Presence and

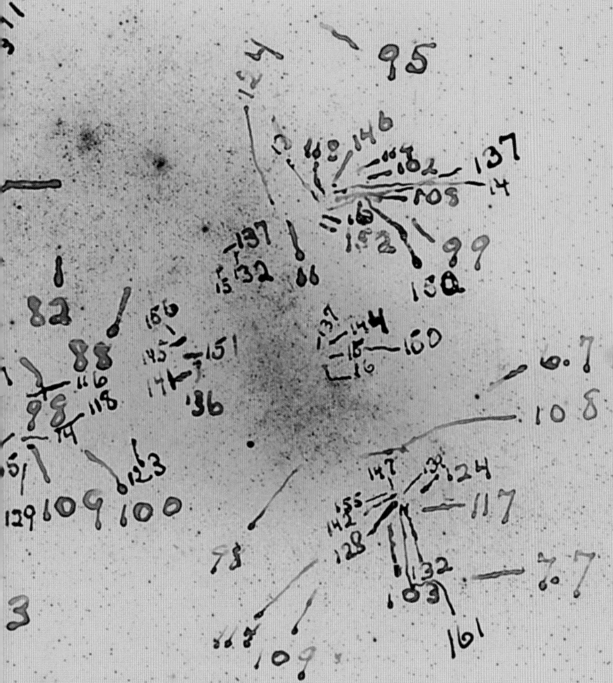

Erasure

Plate jacket for negative glass plate B20650 of the Small Magellanic Cloud, 8 × 10 inches (see page 2 for full plate). Exposure of 240 minutes made with the 8-inch Bache telescope on October 20, 1897, Harvard Boyden Station, Arequipa, Peru.

Astronomical Photographic Glass Plate Collection, Harvard College Observatory.

Markings
Leavitt

No. B 20650
CLASS, L
R.A. 0 52
DEC. -72.3
QUALITY, 4
DATE Oct 20- 1897
EXPOSURE, 240-

S.M.C.

Reject for lantern slide !

Reject
for DASCH

This plate may have been used by Henrietta Leavitt for her 1908 paper on variables in the Magellanic Clouds
(L.Smith, 2016)

THERE IS NO QUESTION that the Harvard College Observatory's Astronomical Photographic Glass Plate Collection is invaluable. As George Johnson articulated in a 2007 *New York Times* article, the Brick Building holds "more than half a million images constituting humanity's only record of a century's worth of sky." The collection—now under the umbrella of the Center for Astrophysics | Harvard & Smithsonian (a collaboration between the Harvard College Observatory and the Smithsonian Astrophysical Observatory)—represents 25 percent of all astronomical glass plates on Earth. More importantly, it is the oldest record of the night sky, and because of Edward Pickering's ambition to establish an outpost in Peru, it is the only historical record that includes the Northern *and* Southern Hemispheres.

This resource lends itself to a field known as *time domain astronomy*: the study of astronomical objects over extended timescales. When Henrietta Leavitt established the light curves for twenty-five of her Cepheid variables in her 1912 *Harvard Circular* paper, the vast majority of these stars completed their cycles of brightening and dimming in less than two weeks. The collection's accumulation of captured time opens new breadths of possibility. If able to access this potentiality, astronomers could identify long-period variables whose cycles span decades. Novae that exploded into visibility (able to be seen on photographic plates, but not yet noticed) but have since receded could be analyzed—both their population within a single galaxy and their distribution throughout galaxies. Novel celestial phenomena such as superluminous quasars could be traced; they are listed, along with long-period variables and novae, among the six "primary scientific goals" of the current, active digitization of the collection. Described as "quiescent black holes in galactic nuclei revealed by tidal disruption of a passing field star and resultant optical flare," quasars are supermassive black holes at the centers of galaxies that (from time to time) strip a nearby star of its mass, build up a bright accretion ring of material, and send enormous amounts of energy radiating out into space.

To facilitate investigations of these astronomical objects, the entire collection—upward of 550,000 glass plates—is being scanned. The digitization project was initiated in 2002 with the acronym DASCH (Digital Access to a Sky Century at Harvard). Just as Pickering strove to make the Harvard Computers' research available to the international astronomical community, DASCH aims to make digital images of the glass plates accessible to contemporary researchers around the world. The Computers once assessed the magnitudes of objects captured on the plates while accounting for subtle discrepancies caused by humans and equipment; now an algorithm calibrates scanned readings of starlight based on known values from an online catalog. This will produce a searchable database that will open up this extraordinary field of study.

But as we know, the patterns of emulsion are not the only information present on the glass plates. Jennifer Roberts relates how the ink notations Leavitt and her colleagues made on the glass resulted in the activation of the plates as objects:

> In order to preserve the photographic emulsion that she studied, Leavitt (like all of the Computers) made her notations on the opposite side of the glass. This means that, as she worked on the plate emulsion-side down, her ink markings floated about a millimeter above and away from the star-filled layer on the other side of the pane. The stars were thus always held away from her; each ink line pointed toward a star image that it could never touch. In fact, as Leavitt reached for each star with her pen, it instantly receded from her, because her ink announced the presence of "her" side of the glass and activated the thickness of the pane as a limit (without the ink marking the "front" of the glass, the glass disappears, its thickness unnoticeable). She was thus always an active agent in this dynamic of distance; her ink, we might say, charged the plate with a spatial and material complexity and conflict. Every mark opened up the plate, simultaneously splitting it in two and straining to tie it back together.

To get clean, unobstructed astronomical data from the emulsion side of the plate, the removal of the information on the notation side was deemed necessary—thus erasing evidence of these women. Jennifer goes on to describe in her essay "Open Span" how "all day every day in the basement digitizing lab of the observatory" the hum of the scanner was the ominous, perpetual soundtrack to Leavitt's drawings, and those of her colleagues, being wiped from the plates. Each plate was first documented, but as Jennifer writes, a photograph of a glass plate "cannot record what is perhaps the most fundamental reality of the plates as Leavitt knew them: the thickness of the glass that scripted the quality of her access to the stars each day."

When Jennifer wrote these words in 2018, coinciding with the run of my exhibition *Measure* at the Harvard Radcliffe Institute, this erasure was to me pure heartache—a felt, tangible loss. As DASCH's scanning process forged ahead, Sara Schechner, curator of the Collection of Historical Scientific Instruments at Harvard University, led a collective effort to think responsibly about what value the notations might have, and was one of many voices among historians, conservators, librarians, and scientists who argued for their safekeeping, or at minimum improved documentation of the marks being removed. At the time they were being preserved only as small JPEG files that could not even begin to conjure what was being lost. (Recently, when I tried to closely examine a plate using such a JPEG, a pixelated world rushed toward me as I zoomed in.)

In 2016 Schechner coauthored, with David Sliski (who worked for many years as a curatorial assistant in the plate stacks), a paper titled "The Scientific

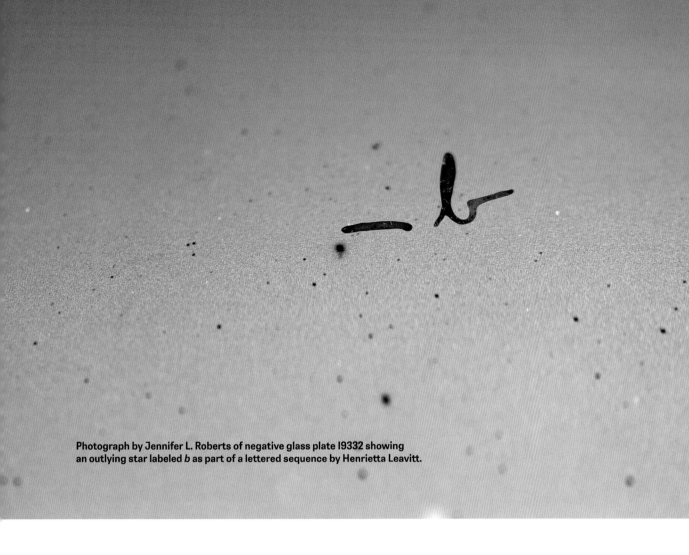

Photograph by Jennifer L. Roberts of negative glass plate I9332 showing an outlying star labeled *b* as part of a lettered sequence by Henrietta Leavitt.

and Historical Value of Annotations on Astronomical Photographic Plates." Published in the *Journal for the History of Astronomy*, the article documents their informal survey of professional astronomers and historians on the possible significances of the ink markings and what to do about them. "One surprise of the survey was that most reasons given not to erase plate markings were scientific rather than historical." Beyond the key point that no one can presume to know all potentialities, reasons included that they might confirm a finding or, conversely, provide evidence of a misidentification; illustrate a scientific method; indicate which astronomers had studied a plate; contain information about the glass plate itself; and enable recognition of a "first discovery." A substantive list before the question of cultural significance is even raised.

But elevating a scientific rationale ahead of a historical context reinscribes a contested binary. There is the broader philosophical question of whether

so-called clean data is even achievable. The production of scientific knowledge holds bias, a fact more and more widely recognized. Can (and should) time domain astronomy be isolated from the environment from which it emerged? Facts are not simply lying about, self-evident, waiting for anyone to find. Data must be shaped in collaborations between technologies and humans. Schechner and Sliski's paper identifies how objectivity and subjectivity are continually negotiated as part of this endeavor, the line between them never really there. The objective data presented in a picture of the night sky quickly proves itself otherwise: the orientation of the telescope, the skill of the technician, the length of the exposure, the mutability of the technology, all create particular results. As Schechner and Sliski write, "In practice, scientific photography by different individuals of the same subject—whether a Transit of Venus, a solar eclipse, or a horse race—could be as different as written reports or drawings of observations, leading historians and philosophers to ask if it might be better to talk about 'making' rather 'taking' a photograph."

Under DASCH, the technology was seen as solid, the presence of the women nebulous. But technology and the human hand are not separate: for example, the angle of a dry plate set just askew could produce its own set of facts. The women's annotations righted the data. The stars suspended in the emulsion tended to slip away, stretching and receding to the edges of the photographic plate. The Harvard Computers pinned them down, establishing their places. How surprising that their colloidal ink markings—the liquid touch of pen nib to glass—added certainty. The Harvard Computers reduced the data: they took the complexity, inconsistency, and unreliability of the technology and made it reliable, dependable, concrete. Data and the people who create that data are in ongoing relationship. The emulsion and ink that hover on a glass plate, just a millimeter apart, form an object. Remove one side and that space collapses; discard one and that relationality is destroyed. Can we even imagine the scientific community choosing to erase Hubble's "VAR!" on plate H335H?

Binaries are persistent. Another one surfaces: Are the glass plates a dataset, or is the collection an archive? When I spoke with Daina Bouquin (who was then head librarian at the John G. Wolbach Library at the Center for Astrophysics) about the current status of DASCH, she talked about the "care work" provided by the Harvard Computers in building and maintaining the collection. The actions they contributed were never made prominent: "The sharing of information, the pulling of data off of it—all of that was diminished, and that carried into the twentieth century in a lot of ways. The focus on the plates themselves and the data has always overshadowed anything else having to do with the collection." The answer to any objections about the handling of the plates was that once DASCH

DASCH documentation (uncorrected JPEG color) before erasure of the markings from several researchers on negative glass plate B20645 of the Small Magellanic Cloud, 8 × 10 inches. Exposure of 130 minutes made with the 8-inch Bache telescope on October 19, 1897, Harvard Boyden Station, Arequipa, Peru.

Astronomical Photographic Glass Plate Collection, Harvard College Observatory.

was finished, *then* their historic and cultural value would be considered. There was not an obvious moment when the collection transitioned from being seen as a resource of astronomical information to being recognized as an artifact. That required a mental shift, says Daina, and DASCH missed it. "The need to 'consume the data' got put in front of the historical relevance of the collection, the people and their stories—and that wasn't maliciously done." It makes a certain sense that the data was prioritized—or, put differently, that data on one side of the plates was prioritized. That is what the Harvard Computers themselves prioritized. It might be said (and has been said to me) that the actions of DASCH mimic how a Computer at times erased one set of notations before studying a plate anew; a contact print would be made before erasure if desirable markings needed to be referenced at a later date. But seen from a contemporary vantage point, recognizing the glass plates as layered, complicated objects acknowledges how this information came into being, how it exists. The technology didn't produce the shareable data; the women did.

Lindsay Smith Zrull, curator of astronomical photographs from 2016 to 2022, held the position that Williamina Fleming inaugurated in 1899. Lindsay began her job just after a devastating flood in January 2016, when a water main beneath the Brick Building ruptured, submerging close to 64,000 glass plates on the lower level. The plates were rescued, frozen (to protect them from mold), cleaned, and returned. Lindsay needed to start from scratch in many ways. Records from the previous curator had been ruined in the flood, and Lindsay received no orientation to the plates or astronomical logbooks. So, like Leavitt, Lindsay found her way. In her own form of pattern recognition, Lindsay distinguished methods of working based on different kinds of ink notations, which supported various areas of investigation. She started to recognize handwriting and linked the names of Harvard College Observatory employees from payroll archives to initials on the envelopes encasing the plates. Lindsay identified 216 women who left their mark. One challenge was that Leavitt's published findings often omitted the plate number of the images she studied, instead simply indicating the date the photograph was taken. Lindsay began sleuthing, working to correspond plate numbers to logbook pages. I have often come across Lindsay's own handwriting on the plate jackets alongside clarifications from different Harvard Computers, a hundred years passing in between. "This plate may have been used by Henrietta Leavitt for her 1908 paper on variables in the Magellanic Clouds (L. Smith, 2016)." But the most declarative words associated with Lindsay's name are "Reject for DASCH." Sometimes her directive appears as "Reject DASCH!" (Yet another exclamation point showing up.) Such notes appear on the envelopes of plates with significant markings. These are not to be erased.

DASCH scan of negative glass plate B20645 after erasure.

Astronomical Photographic Glass Plate Collection, Harvard College Observatory.

Nonetheless, many hours of Lindsay's workdays were spent participating in the erasure of the very evidence she was meticulously preserving. The enormity of DASCH's undertaking meant that a large part of her job as curator of astronomical photographs had evolved into supervising and ensuring the successful scanning of the plates. Lindsay directly experienced the strain produced by the two conflicting understandings of the collection's value. Her research into the methodologies of those who had worked with the glass plates had been her own initiative, and was explicitly seen by her supervisor as a distraction from the demands of DASCH. When I talked with Lindsay about her years in the plate stacks, familiar with her staunch stewardship of the collection, I teased her about hiding some of the plates. Daina later confirmed, "She absolutely hid them." Qualifying that statement, Daina continued, "If anyone had gone and looked for them, it wasn't like she didn't label them." Lindsay had offered the same clarification: perhaps "relocating" them to a nearby cabinet was more accurate. They were technically in plain sight, but it's pretty easy to hide a glass plate among approximately 549,999 others.

Maria McEachern (Wolbach's reference and resource sharing librarian) noted that Lindsay's conflicted, pressurized circumstances were not unprecedented. Dorrit Hoffleit earned her PhD in astronomy from Radcliffe College in 1938 and returned to work at the observatory after World War II (during which she had worked at the Aberdeen Proving Ground's Ballistic Research Laboratory in Maryland, supervising a team of women who calculated trajectories of anti-aircraft missiles), despite receiving job offers with much higher pay. The glass plates called her back. As Hoffleit wrote in her memoir, "I had gladly returned from Aberdeen to low-salary Harvard primarily because of the potentialities of this unique plate collection." The collection had long been known as a resource for time domain astronomy. Hoffleit emphasizes, "Whenever a new variable or nova was discovered, observers worldwide wanted to check the Harvard plate collection to discover the past history of the newly discovered object." Hoffleit had a close relationship with Harvard College Observatory director Harlow Shapley, but when Donald Menzel succeeded Shapley in 1952, the environment changed. Maria pointed me to a chapter in Hoffleit's memoir that she described as being about "Menzel fanatically throwing things away." Hoffleit recalls Menzel requesting, upon his arrival at the observatory, "to discard a third of the plates in the plate stacks in order to make room for more office space." She writes that "some astronomers took courage to object," with the resolution that instead of being tossed aside, some of the plates were removed from the collection and stored on sagging wooden shelves in a dirt-floor cellar beneath one of the telescopes. Hoffleit adds, "Inevitably the plates were doomed." (Indeed, many corroded plates were later discarded.)

From even the most sympathetic perspective, Menzel's impulse was short-sighted. Hoffleit speculated on his motivations in a 1979 American Institute of Physics interview with David DeVorkin: "What Menzel really was doing was trying to obliterate as much as he could of what Pickering and Shapley stood for. When Shapley came, he was really building on what Pickering had done, as a foundation. Menzel did not want to build on another person's foundation. He wanted to demolish that foundation, in order to put himself alone above all other considerations. Theoretical astrophysics and solar astronomy [Menzel's areas of interest] were to be the rule of the day." In pushing aside observation so that theory could triumph—as if the two could be separated—future observations, too, were precluded. How easy it is for one line of thinking to exclude foresight.

In fraught situations, Lindsay and Hoffleit resorted to similar solutions. Lindsay's cabinet of squirreled-away plates echoes a story from Hoffleit's memoir: "I had in my office a cabinet full of the plates on the spectra of southern stars that Dr. Paraskevopolous at Bloemfontein had taken during the war for my program for the determination of spectroscopic parallaxes of southern stars. One day Menzel came into my office and said, 'Nobody should have a whole cabinet full of plates in her office; return those plates to the stacks immediately.'" Hoffleit pointed out that they had never belonged in the plate stacks: they had been taken and shipped directly to her for her focused project. She understandably wanted to keep a custodial eye on them, having been told by Menzel that her research was obsolete despite written interest from international astronomers, including Henry Norris Russell. Over time, Menzel's dismissive attitude wore Hoffleit down; after four years of working with him, she left for Yale University Observatory, where she stayed until her retirement in 1975.

The people, predominantly women, who have championed the rich complexity of the glass plate collection have often been ignored. The science the Harvard Computers achieved is a triumph. Tending to these stories, and caring for the objects that hold them, are also generative acts.

There has been a recent development in the digitization process. The software created to support the world's highest-speed precision scanner—software designed to stitch together the considerable number of small, high-resolution scanned sections from each plate into a single, overall image—was unique. Which also means it was unsupported. When it crashed in 2021, the data crashed along with it. Daina explained that there were "closed practices" around the build-out of the technology (not uncommon twenty years ago, when DASCH was initiated), in contrast to the open science practices that are encouraged today, which allow transparency and accessibility to strengthen scientific research (encompassing publications, data, software, and hardware). Daina said that DASCH's

"development practices didn't adapt over time," leaving the software in a kind of "time capsule." Without collaboration, the technology became isolated, a self-contained world no longer in touch with our own.

With the project stalled, Lindsay recognized a possibility and committed to it: she took 611 plates that she had "relocated" and transferred their stewardship to the Wolbach Library. Her final act before resigning was to make sure those plates were in good hands. Honoring Lindsay's request, those plates are now the Williamina Fleming Collection.

The collection of saved plates begun by Lindsay is growing. When markings found on a plate are demonstrative or captivating, those plates are deemed "treasure plates" and added to this named collection. The original 611 have already become 670. And we can expect more to be added: hundreds of plates that have been tagged by Lindsay with purple DASCH rejection marks on the spine will slowly be discovered interspersed throughout the massive collection. Hidden in plain sight is Lindsay's careful work.

DASCH quickly became so outsized, with its nonstop processing of thousands upon thousands of plates by people and custom-made software, that its momentum seemed impossible to redirect. Even when its narrow focus and practices were successfully argued against and new ones outlined in detail (such as in 2013 when Sara Schechner and David Sliski convened a roundtable of experts that included Brenda Bernier, who wrote the international standards for how to handle glass plates), changes felt impossible to implement. DASCH needed to come to a halt in order to change direction.

Sarah Lavallee, who had for five years worked as a digitization assistant for DASCH, became the interim curator after Lindsay's departure. Sarah saw what Lindsay had seen and used her brief tenure as curator to take action. On April 1, 2022, the glass plate collection became a part of the Harvard library system. No longer were the plates merely data; they were recognized as complex objects in need of preservation. On that date all of the digitization technicians became plate stacks curatorial assistants.

Stabilization and digitization of the Williamina Fleming Collection became the foremost priorities in this transfer, including taking high-resolution scans of these plates without wiping them clean. The envelopes containing metadata (the strata of accumulated handwriting) will continue to be included in the documentation process. In my interview with Daina she described how, moving forward, one of the goals is to "build a bridge between the women and the data." As astronomical information is requested from the glass plates, the names of the women who studied them will be retrieved along with the data, as well as the pages of the Harvard Computers' logbooks corresponding to specific plate numbers. These have been scanned and are in the process of being painstakingly transcribed by

a legion of volunteers under the Wolbach Library's Project PHaEDRA. Echoing Pickering's recruitment of volunteers to track variable stars, a diverse group of online volunteers have deciphered the cursive notes and handwritten numerical figures from more than 2,500 astronomical logbooks. In DASCH's new database, all of these layers of information and history will accompany each glass plate. Because Leavitt's vibrancy is not contained only in the distance ladder to the stars she helped construct. The plates help hold the indelible achieving of that solution, where meaning lives.

The collection is now under the purview of Harvard University's library system, facilitating crucial access to preservation support and standardizing policies around their handling and usage. The glass plates' status as artifacts is official. But the collection as a unique dataset for time domain astronomy is rightfully not being overlooked. Furthermore, DASCH received significant public and private investments, and the current curatorial staff were hired to work on DASCH. The project has a responsibility to come to a completion. So the Center for Astrophysics is exploring how it can be revived: the software updated, the data retrieved, the scanning resumed, and the remaining markings saved. The simultaneous existences of these objects as artifacts and data remain in tension, now with equal pull.

But what is done is done. It is estimated that 20 percent of the glass plates had historically significant markings. The vast majority of the collection had been processed, cleaned, and scanned before the software crashed. In past searches of the database, my pulse would quicken if I saw the condition report listing a plate as broken: the plate would have been rejected by DASCH's own criteria and any potential markings might be retained. (Broken plates were supposed to be mended, cleaned, and scanned, unless they were "too broken to mend," which became one way for Lindsay to work around DASCH.) The past cracking of a plate might guarantee its preservation.

I had thought another safe subset was the entire A plate series taken with the Bruce telescope—including the plates of the Magellanic Clouds Leavitt studied for her germinal discovery—because those plates are larger, seventeen by fourteen inches, and the DASCH scanner was typically set up for eight-by-ten-inch plates, the standard size for Harvard's other telescopes. But Lindsay corrected my assumption: roughly 30 percent of the A plate series had been cleaned and scanned before the machinery broke; many precious A plates bearing Leavitt's handwriting have been erased. Worse, some of these plates were used at the onset of DASCH as test scans, and we now lack even cursory JPEGs of their markings. When a resurrected DASCH makes its way through the thousands of A series plates that were untouched, perhaps this microcosm will reveal (and keep) its own set of wonders.

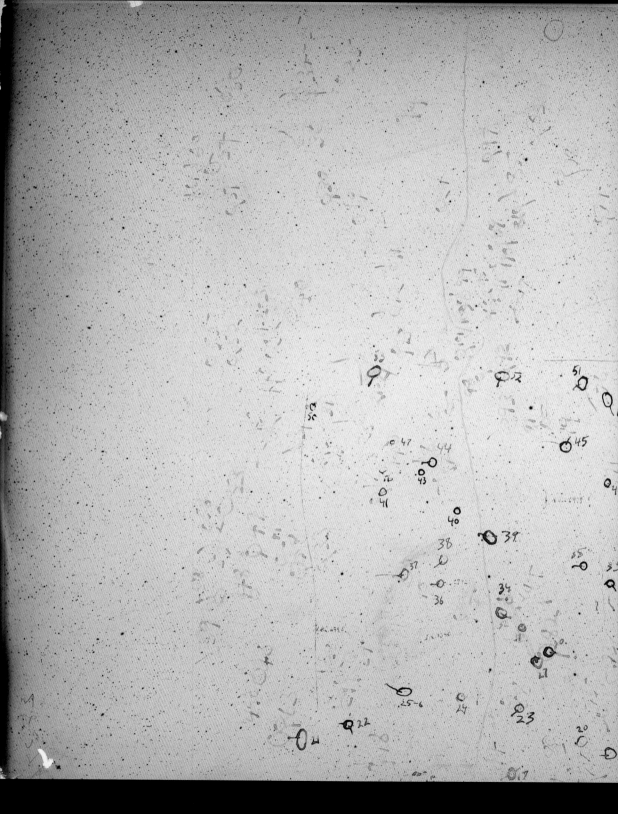

Negative glass plate A2837, 17 × 14 inches. Exposure of 180 minutes made with the 24-inch Bruce telescope on October 19, 1897, Harvard Boyden Station, Arequipa, Peru. This "treasure plate" shows markings from multiple users, including some nebulous regions circled and identified in the constellation Cygnus, and is cited by Leavitt in volume 13 of her logbooks as she searched for variable stars in this region.

Astronomical Photographic Glass Plate Collection, Harvard College Observatory.

Now that the scales have been readjusted so that DASCH is simply one aspect of the collection instead of its totality, an opportunity to look at what the collection *is* surfaces. What does this collection encompass? Preservation is of course important, but what (and who) will be afforded care? There are the glass plates themselves and their precarious condition: the emulsion needs a stable, temperature-controlled environment, as do the plate jackets, which have proven equally relevant, recording details about the making of the photograph and the region of the sky it documents, as well as notes about past discoveries, past noticing. But like a Russian nesting doll, the collection has successively larger shells: the metal cabinets that house the plates, the walls of the Brick Building itself. I can negotiate the narrow aisles of the plate stacks as Harvard Computer Ida Woods might have in 1925 when she went to retrieve a plate in response to a request from overseas; I can look out the window next to the desk where Leavitt sat and worked, the same window through which sunlight passed, reflected off a horizontal mirror, and illuminated the underside of the glass plates she studied. There is a narrative, an experience of being in the Brick Building, that also needs preserving.

More pieces of information slide between these shells, adding another layer: objects such as notated contact prints, observer logbooks, administrative records dating back to the 1870s, magnifying loupes, viewing mounts—even boxes of fly spankers named and labeled by the Harvard Computers. Thom Burns, who became the curator of astronomical photographs in 2023, points out that the Brick Building is a workplace that hasn't been thoroughly cleaned or cataloged in more than a hundred years. He recently came across a folder of handwriting samples assembled to help identify notable figures who have studied the glass plates. One of the pieces of paper he found inside this folder (repurposed from a scientific conference held decades ago) had a note on the reverse side: "This sheet was found in HSL Vol. XII between pp. 88–89." A folio had slipped from one resting place to another. On the front of the piece of paper, written in Leavitt's familiar hand, are her personal abbreviations for the descriptive terms she used to specify the quality of each photographed star she observed. *C* stands for *compressed*, *co* for *coarse*, *dif* for *diffused*, and my favorite, *RR* for *exactly round*. One of Leavitt's abbreviations indicated an orientation I had never considered: *b n* for *brightest toward north side*. Others related to time: *E* for *extended*, *g* for *gradually*, *s* for *suddenly*. When I caught sight of these words, I felt as if I had stumbled into a private conversation. How perilous these transports into the past are.

There is an additional argument for safeguarding these nested layers: an irreplaceable relationship is established when one object rests against another. On one of my many visits to the Brick Building, after Thom had discovered (as I am tempted to call it) a box of contact prints that had been shipped to Leavitt

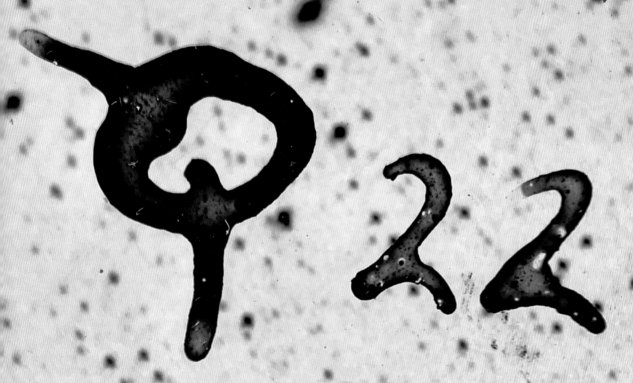

Photograph by Jennifer L. Roberts of negative glass plate A2837 (see preceding page for full plate).

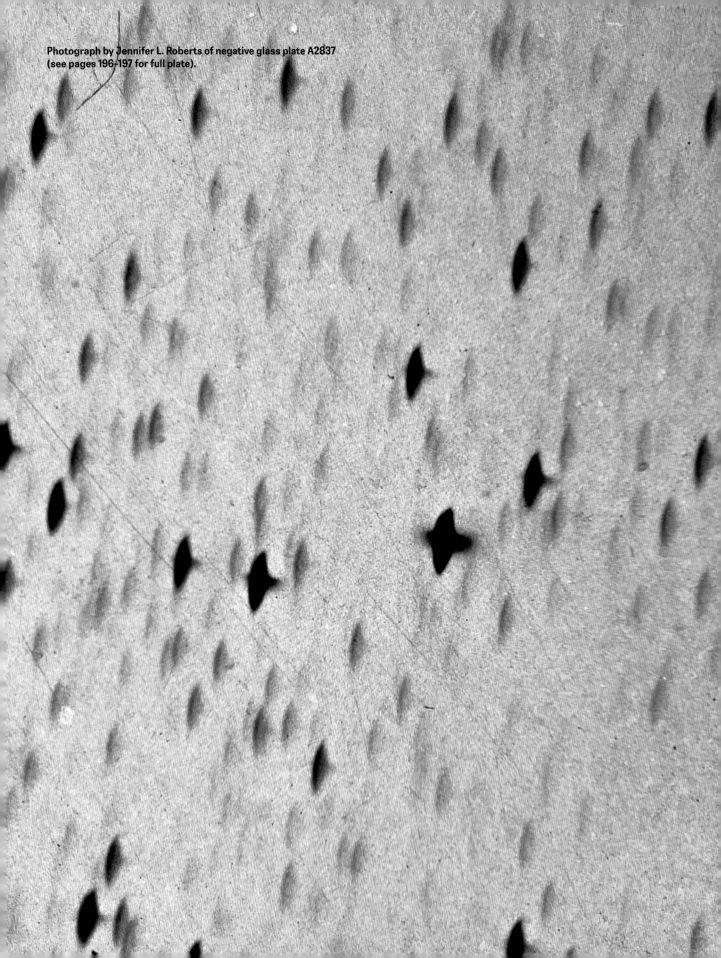

Photograph by Jennifer L. Roberts of negative glass plate A2837
(see pages 196–197 for full plate).

while she was convalescing at her parents' home in Wisconsin (a fact known only because it is stated in Leavitt's handwriting on the reverse side of one of the prints), we opened the box next to it, which contained work on variable stars initiated by Cecilia Payne-Gaposchkin and her husband, also an astronomer, Sergey Gaposchkin. Inside the first manila folder were documents titled "Instructions for Reduction of Series Plates," signed by Leavitt, spelling out the protocol for calibrating the measurement of starlight for different plate series. Her instructions had been glued onto backing boards—perhaps so they could be propped up and easily referenced by Leavitt and others working nearby, or perhaps because Payne-Gaposchkin had considered them so valuable they needed to be mounted to make sturdy enough to preserve; we can't tell. But because of their physical location, in this box resting atop additional folders of contact prints marked by Payne-Gaposchkin and her husband, we can be quite certain that Payne-Gaposchkin set her eyes on Leavitt's instructions, one generation of research informing the next. If this document had been dislocated, the evidence of this connection would have been lost.

As the multifaceted value of the plates is finally recognized and a commitment to the preservation of those layers made evident (the new members of the DASCH team have pledged not to erase another glass plate), how lucky I feel to be able to witness this moment before the collection may need to be scattered to preserve its pieces. The generosity that Pickering encouraged, maintained by Harvard University for more than a century, continues with Thom, who says, "My role is to create—and spark and enliven—that same aspect of discovery, desire, and intellectual intrigue, not only with people who have the means, the access, or the background to get through our doors, but to as many people as I can." Thom recognizes how each of us has our own biases, our own priorities, an aspect of this collection that feels most important to us. "Instead of gathering and pulling data, why can't we make the things that hold the data as accessible as possible?" Because, ultimately, the glass plates, residing as they do now in the Brick Building, are the only objects that contain every layer of these histories.

While writing this book I started a new drawing series, based on the glass plates, that I am calling Polaris "portraits" based on Jennifer Roberts's photographs of the visually radical ways light was dispersed (dimming, diffracting, spreading, splitting) onto the emulsion as an attempt to bring the stars of Leavitt's North Polar Sequence into relation. The magnification of Jennifer's macro lens takes us past what the unaided eye can see—and far past what a DASCH scan contains. In some regards, it feels like her photos take us altogether elsewhere. Yet it is the plates, and only the plates, that hold what Jennifer's photographs reveal. When working with this magnified information, at times I feel like I am drawing

nothing—simply the background noise of the emulsion that surrounds each exploded North Star. But even the specificity of that nothingness is held in the glass plates. The plates remain the source.

I was guided by Benjamin Sabath at the Center for Astrophysics through DASCH's new website, to be launched as this book goes to press. While historically most databases have required all data attributes and connections to be defined ahead of time, Ben is designing DASCH's new website to flexibly track novel attributes and connections by using a graph database that prioritizes *relationships*. The site is quite nimble, with the current prototype using only five gigabytes of data—a user queries the relationship between data, not the static data itself. The scanned plates require a massive amount of storage, yes, but that is now offsite in cloud storage, diversified and distributed around the country, no longer isolated and vulnerable. DASCH's new website helps the user navigate commonalities between plates, such as the astronomical objects they hold, the names of the women whose gaze they held, and the astronomical logbooks that cite evidence of their past use; full-resolution images are recalled from storage only as needed. As Ben ushered me through the back end of the site, his cursor rolled over one of these nodes of connection, which was pulled forward and magnified, making the web of arced lines to other nodes ripple into a new form. Moving his cursor, a different priority was emphasized and drawn forward, with room for future priorities to be added as this network of connections, shifting and shimmering, adapts and expands.

There is more good news: none of the data was irrevocably corrupted when the first iteration of DASCH shut down. Peter Williams, innovation scientist at the Center for Astrophysics, confirmed this when he sifted through the digital wreckage. Luckily a backup had been made just three days before the servers crashed. He says his job is more of a forensic one, just trying to locate where everything is. Once all of the data is organized and secured, Peter is eager to integrate it with WorldWide Telescope—astronomy visualization software that is excellent for handling datasets and extremely large images (both large files and large expanses of the sky). Peter says that because the integrating software avoids the extremes of tiny thumbnails and giant, cumbersome files, it is ideal for experiencing scans of the plates at full resolution: "It lets you explore this kind of data in the way that it deserves." You can even overlay data, and, say, step through a sequence of images to watch how a variable star pulses. This showcase of astronomical data and knowledge is free and open source.

When I first learned about the implosion of DASCH and the unknown amount of corrupted data, an image came to mind of computer towers hulking in a corner: structures that contain information as inaccessible as the forgotten past. I think of the stories of these women finally given prominence and see a parallel

emergence. Data and history are inextricable. With a new incarnation of DASCH, objects and subjects are connected, as they always have been. How close in proximity these two layers rightly are, the true distance between them barely noticeable, unless you look at the object itself. Jennifer's 2018 essay identifies ways that the erasure of Leavitt's markings risks losing the emergence of Leavitt's discovery, the *how* of it. I am grateful to the people who have helped hold open the space Jennifer locates—the space of searching, the space of finding. It is the same space I try to activate with the labor invested in my own art making: the evident process. That is where the science, the profundity of noticing, resides.

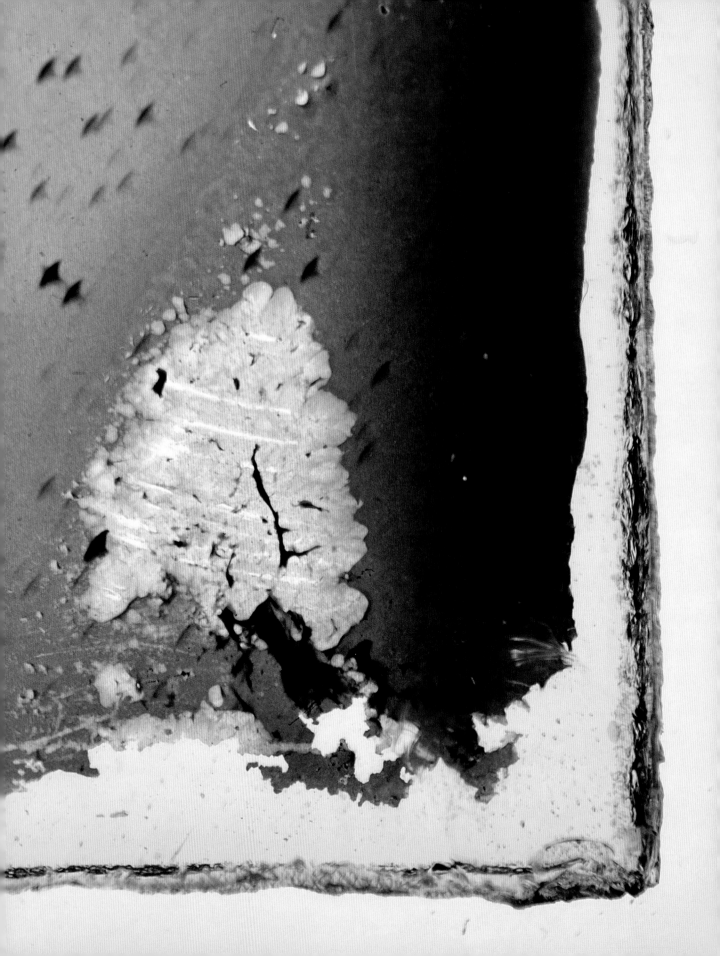

Waiting
to Be Seen

THE ART AND SCIENCE
OF PRECOVERY

Jennifer L. Roberts

Henrietta Leavitt was a new kind of historian working in a new kind of past: a celestial past that had just begun to reveal itself in a glass archive of the heavens. As an astronomer at the dawn of astrophotography, with access to the largest glass plate collection in the world, Leavitt built her knowledge not from the stars themselves, but from the silvery artifacts they left behind in the stratified emulsions of the plate stacks. As she learned how to interpret this stored starlight, Leavitt became an archivist, a chronicler, an archaeologist—a biographer of stars.

With her transformative research, Leavitt was a pioneer of time domain astronomy. Along with the other Harvard Computers, she showed how archival methods could make new kinds of astronomical objects discoverable and new kinds of cosmological insight possible. Her expertise in variable stars, for example—not just her discoveries of them, but also her subtle analysis of their nature and distribution—could only have developed from the plate collection and from the qualities of attention that she brought to it as an archive. Observing variables inherently involves an act of historical reconstruction: no variable star can be discovered on a single plate or in a single glance. Its identity is held in suspension among all the instances of its observation. Each variable star that Leavitt discovered was tracked across multiple plates, sometimes a very great many: a note in *Harvard Circular* no. 120 mentions a variable star in the constellation Centaurus that she chased across 256 different plates. I imagine Leavitt walking through the aisles of the stacks, pursuing these stars, stalking each one as it silently wormed its way through the historical record.

It's important to emphasize that in almost every case, when Leavitt pulled a plate from the stacks and located the variable star she was studying, she was the first person to notice it there. The camera had recorded its presence, but it had not been *seen* until Leavitt came looking for it. Leavitt and the other Harvard Computers were among the first to develop the new powers of latency that photographic collections afforded for astronomical science. The photographic plate was a new and philosophically puzzling kind of observational object—one that not only recorded the information that the astronomers operating the telescopes and designing the studies intended to gather, but also captured a whole array of accidental information that would not be truly *observed* until and unless it was later recognized as being worthy of attention. When Leavitt located the trace of a variable star on a glass plate negative, she was not just performing a clerical transcription of a star that was already self-evidently there; she was pulling it out of the realm of the unseen and bringing it to light.

In this subtle work Leavitt developed a practice that would become more and more fundamental to astronomy as the years went on: the process now known as *precovery*. Precovery involves the retroactive discovery of latent objects in archival data. In many fields of astronomy, precovery is now standard practice—a faint comet is spotted in the outer solar system by a survey telescope, or a

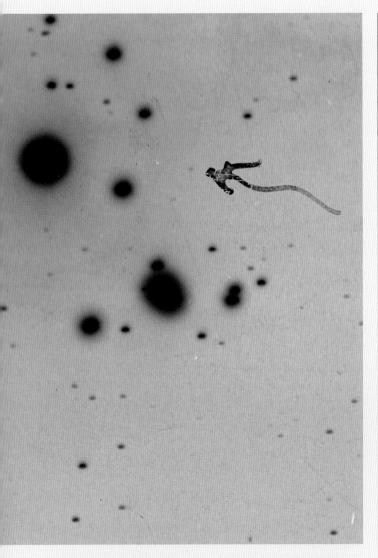

Photograph by Jennifer L. Roberts of negative glass plate A1271 of the Orion Nebula that shows a faint star of interest adjacent to bright stars in Orion's sword.

PRECEDING PAGE:
Photograph by Jennifer L. Roberts of the corner edge of negative glass plate A2837 (see pages 196–197 for full plate).

supernova in a distant galaxy suddenly lights up in the corner of a Hubble image capture. The asteroid or supernova has technically just been discovered (that initial capture is known as the "discovery image"), but astronomers need to consult the prior states of the object in archival images in order to understand what they have seen, particularly noting how it has moved or changed. So a search begins. Astronomers comb through databases, camera chips, hard drives, and photographs (including, sometimes, the oldest glass plates) in hopes of spotting the previously unnoticed object. When it is found in an archival image, usually in the form of a faint dot, blur, or streak at the edge of visibility, the trace of the object is known as a *precovery image or precovery observation*. As explained by Marco Micheli and coauthors in a 2015 paper on asteroid tracking, what is discovered in the archive is "a serendipitous observation of an object before its actual discovery, taken at a time when the object was still unknown." In precovery, the object is meaningfully seen for the first time, despite having been visible all along. It was recorded by the camera during the period of exposure, but it was *not attended to* until later, when its significance became apparent.

Precovery has become an essential practice for astronomers who need to understand the behavior of objects that are variable, ephemeral, or rapidly moving in relation to the Earth. It is a crucial tool in the study of all kinds of variable stars, as well as, for example, for monitoring asteroids. Asteroids are fast moving, small, faint, and incredibly difficult to track because each has its own peculiar orbit. When an asteroid is first spotted, its initial discovery image is essentially useless by itself. The asteroid must be observed across many different images in order that the shape of its orbit can be calculated and its future path predicted. But continuous telescopic observation of asteroids is usually not possible because asteroids tend to fade out of sight quickly, becoming lost objects. So, in order to prolong the arc of their observations, astronomers look into the past, searching for previous apparitions in the archive. (This is the astronomical vocabulary: "prolonging the arc" of observation of "lost objects"

by way of archival "apparitions." Astronomy is the most poetic of the sciences in its habits of nomenclature.)

The Harvard Computers, working with the plates, were among the first modern asteroid trackers. In November 1898 the observatory was asked to search its plates for evidence of a new asteroid recently spotted by German astronomer Carl Witt. The object appeared to have an unusual, Mars-crossing elliptical orbit that might bring it close to Earth, but its trajectory could not be calculated precisely without further information gleaned from its historical apparitions. Williamina Fleming, working from a rough estimate of the asteroid's trajectory, made an exhaustive search of the plate collection. Moving systematically through the archive, she worked by stacking two plates of the same region taken at different times; while the stars would be doubled by this superposition, the asteroid would appear faint and alone, having registered on only one plate because it traveled so quickly. Fleming had to search plates corresponding to fully 3 percent of the entire sky before finally locating the asteroid on an exposure taken June 5, 1896, and confirmed on additional plates taken on June 4 and June 5. Fleming's search process was described in *Harvard Circular* no. 36 as "laborious and fatiguing" but it is important to recognize that there was nothing rote or automated about her observational work. Her attention had to be fully engaged over every millimeter of the hundreds of plates she searched—she could not reduce the intensity of her attention on any plate—because she did not know where she would find that faint single dot. Each successful identification allowed Fleming to narrow her search, leading to a cascade of subsequent finds on more than twenty other plates in the stacks. This allowed the orbit to be

computed much more precisely. The asteroid—the first near-Earth asteroid ever discovered and even today the second-largest—was given the name Eros. Fleming's precovery work helped establish Eros as one of the most pivotal asteroids in the solar system for astronomical science. In 2000 it was the first asteroid to be landed on by a space probe.

Searching the archive, looking for objects unnoticed when first recorded but later recognized as significant—it all sounds perfectly logical on the surface, but the more you think about it, the stranger this process becomes. Just what is the status of that dot or smudge, skulking in the archive before someone finds it, before it is precovered? It is just a speck of emulsion hiding in a sea of dots on a photographic negative, or a tiny streak of pixelated light on a single frame of sky survey data. Before precovery it is meaningless, residing in a field of observation that was organized to look for something else. It remains in this murky state until someone finds it, imbues it with value, and links it to an observational arc. This is what Leavitt did for the variable stars that had left their dark light on glass plates. She found them and connected them, pulling them into the history of astronomy. Under her eye and her hand, each dark blotch in the emulsion became a stitch in a bright arc of understanding.

The process of precovery doesn't follow the teleological route we like to associate with scientific progress, where discoveries build on each other in neat, unidirectional sequences. You can hear it in the temporal wobble of the word itself: *precovery*. It evokes *discovery*, with all its firstness and priority, but the prefix *pre* suggests an even more anterior anteriority, some kind of double firstness. The term, like the process it names, ultimately conveys a fundamental indecision about priority itself

Negative glass plate I10321 with the asteroid Eros identified (markings were subsequently removed by DASCH), 8 × 10 inches. Exposure of 10 minutes made with the 8-inch Bache telescope on December 27, 1893, Harvard Boyden Station, Arequipa, Peru.

Astronomical Photographic Glass Plate Collection, Harvard College Observatory.

and about the progressive structure of scientific knowledge. Precovered objects—all those variable stars, asteroids, minor planets, and supernovae found sitting in the archive—do not obey the rules of standard chronology. Their emergence into knowledge and significance is not an event but a process, elongated in time and constantly reversing direction. A speck of emulsion precovered on a plate exposed in the past is certainly part of that past, like an archaeological object, yet it does not sit neatly there; the only reason it could be located in the past is because it was recognized as significant in the future, long after the exposure was taken. And when astronomers discover a new asteroid or variable star, that object is not fully present in its discovery image, either. It is more like a clue that sends the observer back into the archive's past, yet again switching chronological polarity; past and future point at each other, forming a circuit of reciprocal meaning.

This process cannot be properly represented by historical narratives that render scientific knowledge as a progressive series of discoveries made by individual scientists. And indeed, the act of precovery (an act that is now integral to astronomy writ large) destabilizes the entire historiography of the discipline in ways we have not yet fully processed. For example, Edwin Hubble's discovery image of a Cepheid variable in the Andromeda Galaxy—an image synonymous with the discovery of the Andromeda Galaxy *as* a galaxy, and the discovery of galaxies in general, and of Hubble's towering status as the discoverer of these things—could be described as a precovery image of a variable that Henrietta Leavitt had already discovered. Hubble described that Cepheid as "unmistakable"; he knew what he was seeing because she had already identified its importance. In that respect, Leavitt discovered the significance of Cepheid variables, and Hubble prolonged the arc of her observations. This is not to say that one of them—Hubble or Leavitt—has to be the discoverer and one the precoverer. The point, rather, is that science is a collaborative practice and that those positions are necessarily entangled. They interact with each other in a process of reciprocal insight.

Contemporary astronomy is an increasingly archival discipline. Pickering's insight about the value of keeping a record of the sky, and the Harvard Computers' demonstration and cultivation of that value, have been validated over and over again. We now have multiple large-scale sky surveys that generate startling amounts of data that only make sense to gather and store if the data is assumed to be a resource for future attention—future precoveries. Much of the new science generated by space telescopes, such as the Hubble and the Webb, is pursued through studying the image archive of the telescope rather than produced by experiments that direct live telescope observations. And one reason that astronomical research is now so thoroughly beholden to data science is because it needs to be able to design ways to navigate a vast dataverse of stars that rivals the true celestial sphere in its sheer scale. Astronomical observation is now distributed between humans and automatic recording devices, among whole communities of human observers as well as a fleet of unpersonned telescopic observatories, and is held in common by algorithms, plate stacks, hard drives, server farms, glass, ink, gelatin, and silicon. In and among these surfaces and networks any unitary moment of achievement or discovery becomes impossible to localize. In negotiating this shift, astronomers have had to begin developing new ways of assigning agency and credit to important achievements. They have

increasingly had to reduce their dependence on the old logics of possession and priority (who has the data; who recorded the object first) in favor of intention, and, notably, attention (who first recognized the data as significant and who examined it in the archive most carefully). In other words: attention is discovery.

When Henrietta Leavitt helped establish the values and practices of precovery, she helped inaugurate this complex model of history, this poetics of time. While she was finding quiescent variable stars on old plates, she was also founding a new field of astronomy that implicitly recognizes the distributed nature of knowledge acquisition as a process that arises from attention and care to images, records, and archives. She was also helping to found a new astronomy based on the preservation of images that inherently contain serendipitous objects whose significance cannot yet be perceived or even imagined. The point of time domain astronomy is the preservation of latent apparitions that might someday prove worthy of attention, even if we can't imagine how. And so, via precovery, we arrive at the DASCH project and all the latent apparitions on Harvard's glass plates. Time domain astronomy presumes that things that seem insignificant now may turn out to be significant in the future. This assumption is baked into its very core, and it is baked into the rationale for the DASCH project, which aims to maximize the accessibility of the Harvard plate collection for future astronomers who might mine it for new insights.

The problem with the first phase of the DASCH project was that in the course of more efficiently cultivating this core value, DASCH immediately betrayed it. Confronted with the full array of materials and markings that make up the Harvard College Observatory's plate collection, DASCH proceeded as if only the photographic information were worth preserving. It assumed that a speck of silver exposed to starlight through a telescope could prolong the arc of some future inquiry, but an inky arrow or numeral deposited by a female astronomer could not. The DASCH project did not recognize the potential precovery significance of these astronomical inklings, so it erased them. But once you assume that an archive should be preserved for the purpose of supporting future investigations currently unimaginable, it becomes illogical to compromise any aspect of that archive. The very fact that the value of the Computers' notations could not be known, that they seemed invisible or accidental or expendable, should have automatically triggered their preservation according to the ethos of precovery. And how ironic that much of the ink erased in the name of precovery was the archival record of the development of precovery itself. Those ink circles, arrows, dashes, letters, and numbers are the traces that Leavitt and other Computers left as they built the methods of a new structure for astronomy—a new astronomy that photographic precovery allowed.

The debate surrounding the archival ethics of DASCH—a project whose principles have dramatically evolved during the writing of this book—is often represented as a clash between historians and astronomers, members of two distant, distinct cultures whose value systems are incommensurable. But perhaps it is more productive to describe this moment as an eruption of conceptual turbulence from what is actually a *convergence* of systems. As astronomy has become more and more archival, and as the practice of precovery has become an essential one of its methods, it has developed a set of logics and beliefs that closely resemble those of historians, especially revisionist historians. Both

Photograph by Jennifer L. Roberts of the Orion Nebula on negative glass plate B193, where the warping of starlight makes each star appear as a crescent moon. Exposure of 53 minutes made with the 8-inch Bache telescope on December 11, 1885, Harvard College Observatory, Cambridge, Massachusetts.

astronomers and, for example, feminist historians work by retroactively recognizing the significance of archival traces unnoticed or deemed insignificant in the past. In both cases, an archival trace is used to prolong an arc, a story important to tell. The arcs of these two stories may seem to curve through totally different universes (certainly through different academic departments) but the Harvard plate collection is proof positive that these universes are colliding. And it isn't just that astronomy has wandered unwittingly into the realm of historical scholarship. In a case of what we might call convergent disciplinary evolution, it has arrived here on its own conceptual path. After all, it was astronomers who came up with the rich and strange concept of precovery. It's a word that eerily describes—better, to my mind, than any term historians have coined—what it is that historians do when they draw new stories out of archival records.

Before Anna Von Mertens had ever heard of Henrietta Leavitt, she made a series of conceptual quilts that feature star trails of the past. (This is how I found out about Anna; I saw the series presented in a literary magazine and was immediately transfixed). Each quilt, in a pattern of hand-stitched celestial arcs, shows the movements and positions of the stars as they passed over a particular place at a particularly catastrophic moment in history: the Battle of Antietam; the assassination of Martin Luther King Jr.; the fall of the Twin Towers on 9/11. The predictable pattern of the stars is undisturbed by the carnage and trauma below; the arc of the stars and the arc of history bend away from each other, never touching. But the power of the work is that in and through it, the arcs do touch: Anna stitches them together, makes their intersection

visible. She demands that we consider what it means to live in a cosmos that holds both of these histories. No wonder she responded so strongly to Henrietta Leavitt's own handwork on the glass plates at Harvard. On those plates, stitched between the front and back surfaces of the glass, the emulsion and the ink, Leavitt's history, women's history, human history, converge with celestial history. Leavitt tied her own time to the time of the stars. In fact it was her time, measured out of the early twentieth century in dashes of ink, that helped set the stars in motion for us, that made their curve through time visible. Leavitt's work demands that we consider what it means to live in a cosmos where these two time domains converge.

To honor that convergence, and to learn from it, we need to save space for its revelations, for those flinty sequences when insights cross over between domains. Precovery is one of those spaces. Astronomical objects (specks of silver suspended in emulsion) passing unrecognized through the human record suddenly become meaningful and curve into contact with human time. Human objects (specks of ink on glass) passing unappreciated through the astronomical record suddenly become meaningful and curve into contact with cosmic time. We need to save space for curves, for flight, for unexpected movement in the celestial archive. Dark specks of data need the freedom to warp into new arcs and take flight into new orbits. They need to be seen as Leavitt saw them: leaning into time, slipping, always about to slide into a new, unforeseen story. And that capacity for unforeseeability that precovery depends upon is more important than any specific set of stories that the archive might generate. So the archive cannot be flattened, cannot be scrubbed down to a singular class of data; it must be preserved in all its inconvenient dimensionality,

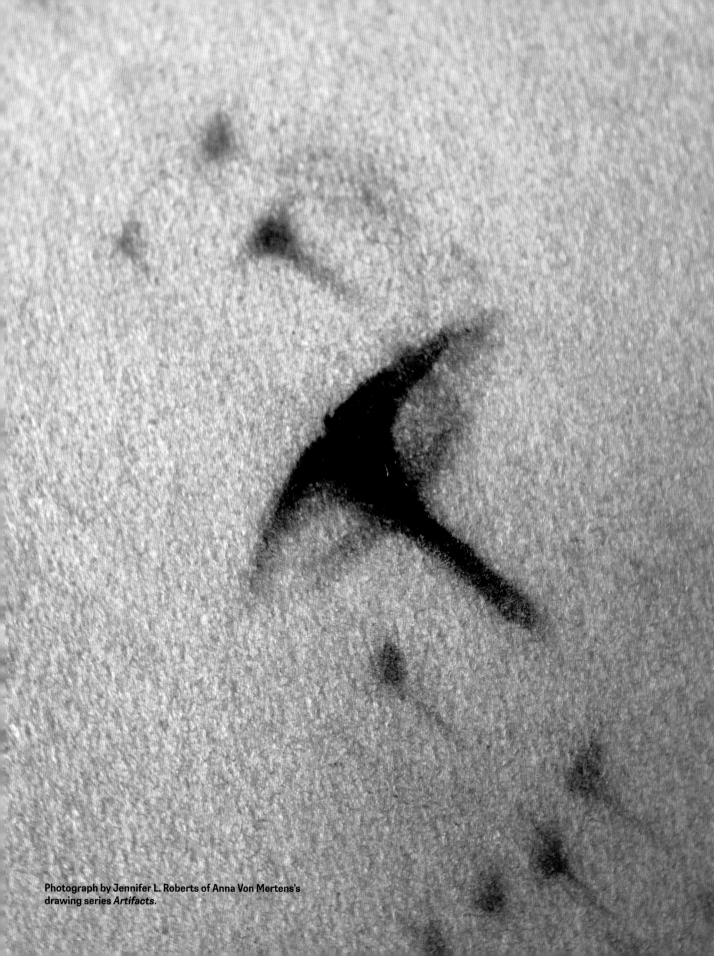

Photograph by Jennifer L. Roberts of Anna Von Mertens's drawing series *Artifacts*.

its elastic materiality, its unruly obliquity.

What might that look like? While I was taking photographs for this book, I found it down low, at raking angles, where the ink and emulsion that had become mere data suddenly seemed full of raw potential again—textural, topographical, irreducible. And I found it in Anna's *Artifacts* drawings. I met them at the corners, where, in sheeny deposits of graphite, she drew the stars that had been distorted by the curvature of the telescopic lens. These distorted stars, strange black shapes that resemble insects or birds, are found on almost every plate in the collection but have never been part of anyone's calculations, anyone's stories, not even Leavitt's. (In her logbooks Leavitt often disqualified measurements that came from stars too close to a plate's edge.)

These warped stars are just "artifacts," a term synonymous in astronomical lingo with "insignificant."

They are the stars in the photographic field that have no observational value; in fact they interrupt the practice of astronomical meaning making. But Anna saw them and helped me see them, and in doing so she transformed them from *artifacts* in the scientific sense (objects that prevent or evade insight) to *artifacts* in the historic sense (objects that produce it). Her stars hold together these two meanings of the artifact, and the worlds of science and history. In doing so Anna shows us the shape of an elastic, responsive archive that preserves its *insignificant* marks in all their potentiality. The artifacts glide toward the corners in a fantastic taxonomy of winged blurs and flying streaks, warping the surface of the archive, hinting at a whole fleet of unimaginable stories that can yet be drawn from its celestial depths. One of those stories, of course, is the story of Leavitt herself, right there on the plates where she left it, ready to take flight.

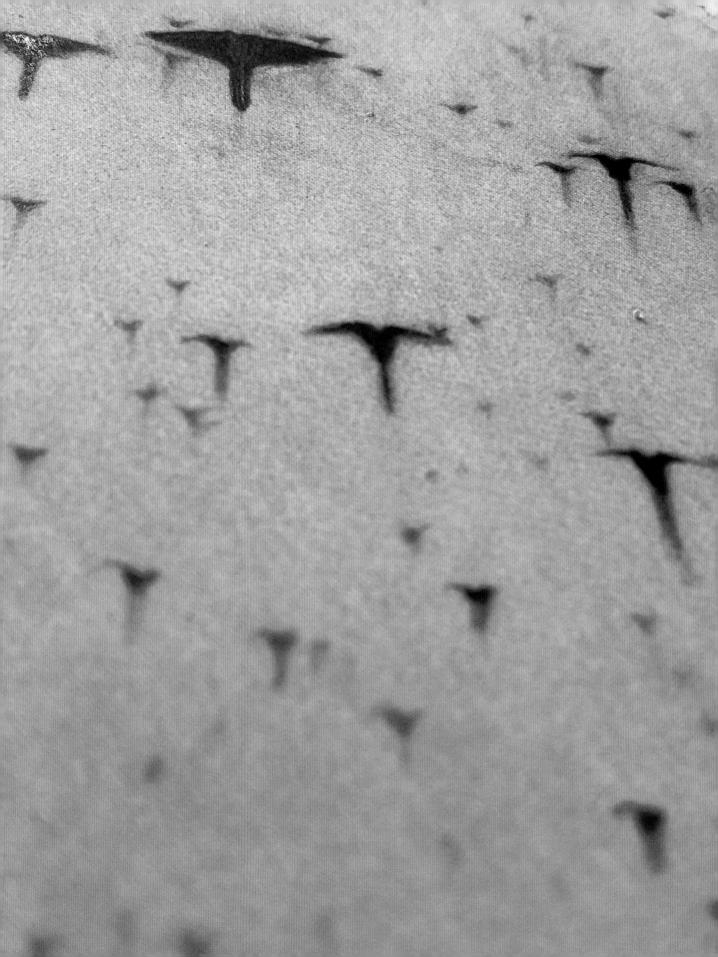

ABOVE:
Anna Von Mertens's drawing _Artifacts (Plate AX3309 magnification, Achernar)_.
Graphite pencil on paper, 30 × 22 inches, 2019.
Photo by Gary Arruda, Studio 141 Photography.

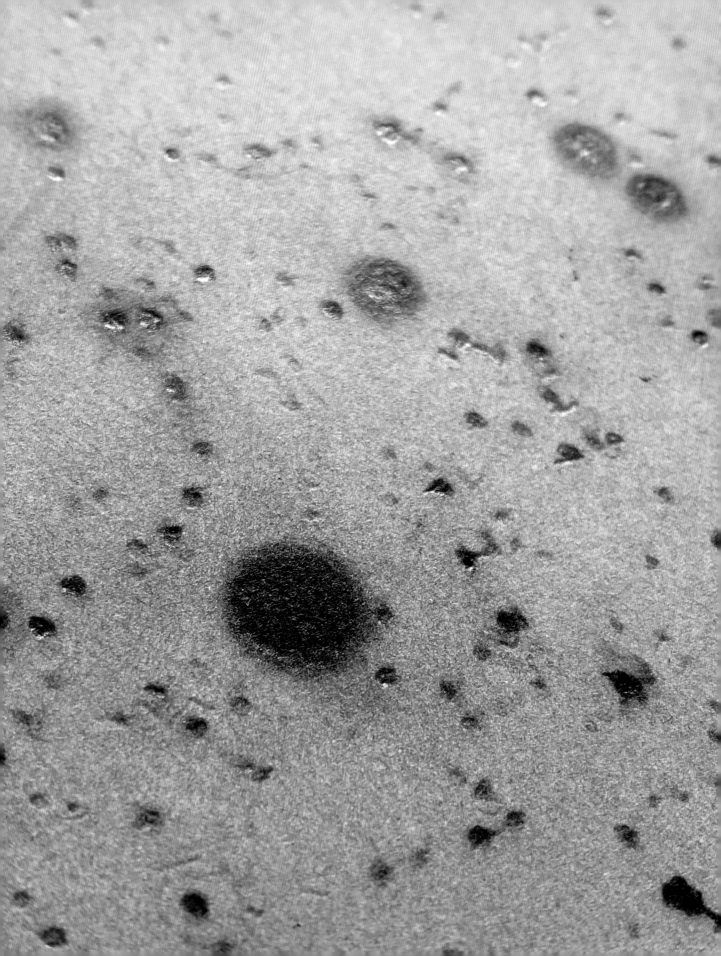

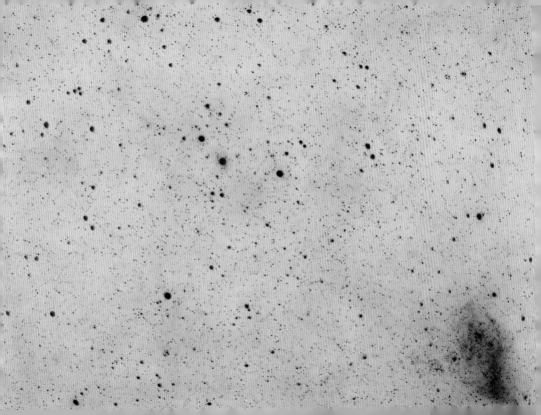

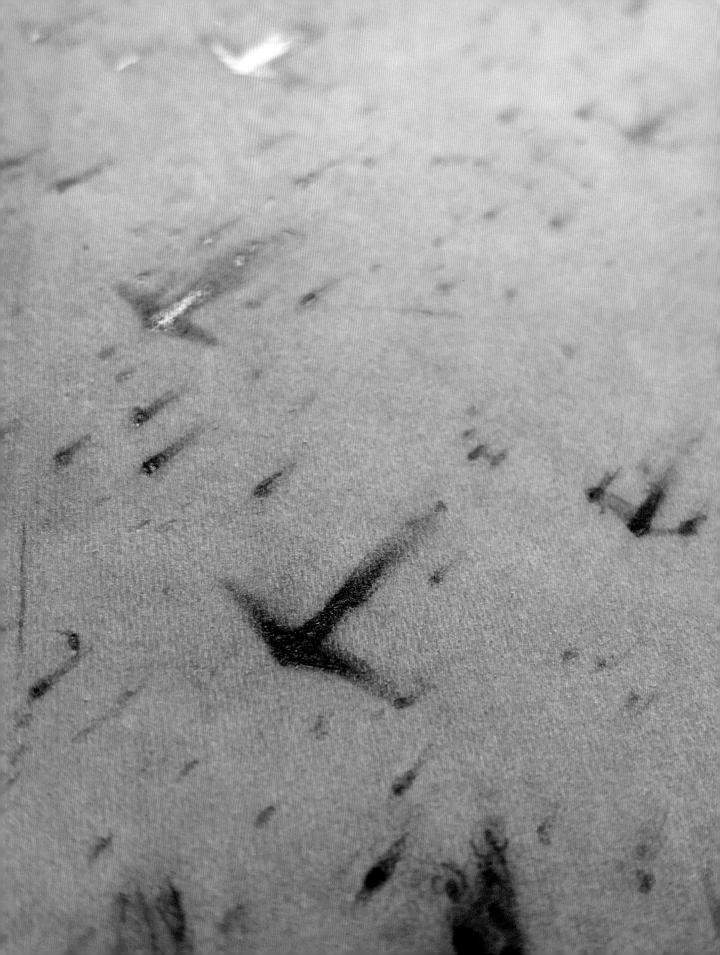

New, Confirmed,

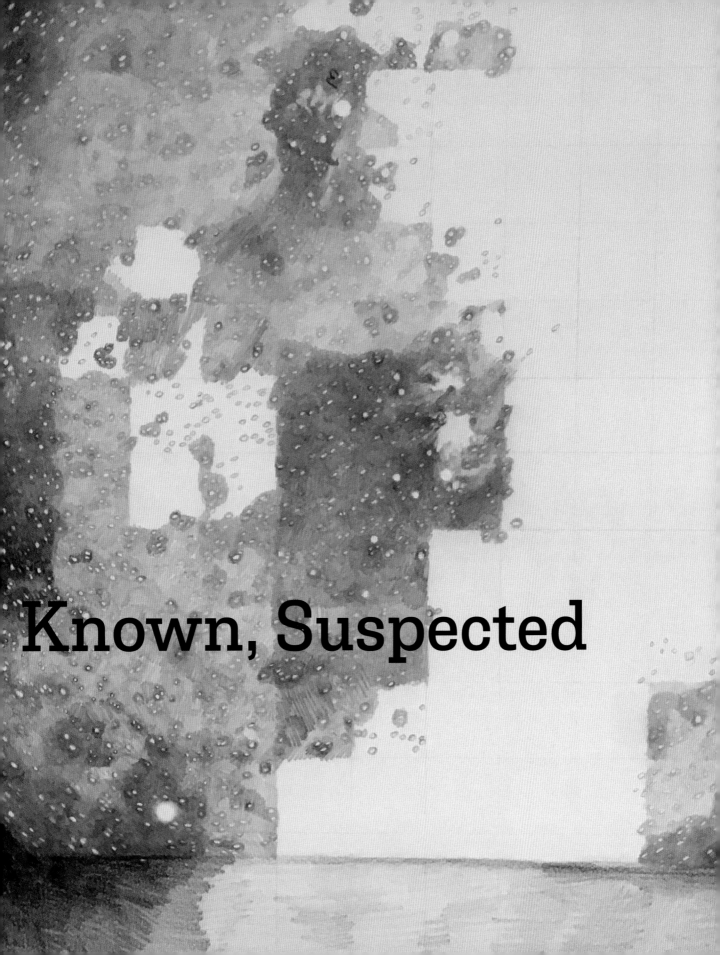

Known, Suspected

Opening one of Leavitt's logbooks (the red-bordered label on the cover of this particular logbook reads "XXII Discovery of New Variables. Cont. in Bk. 40 H. S. L."), I find myself on page 35, the number stamped in the upper-right-hand corner. The date written at the top is Tuesday, May 28, 1907. Here, Leavitt records her variable findings from the superposition of negative plate AC2593 with positive plate D12679 (made from negative plate AC5446). She makes a note about one of her found variables having been previously discovered by Williamina Fleming, "but on the plates examined by her, the range was considered too small to justify announcement." For each of the three newly recognized variables she is tracking that day, Leavitt illustrates a reminder of their location by sketching a small group of stars in the left-hand border of the page and circling the discovered variable at the center of each sampling of stars. Amid her two columns, "Br" (bright) and "Ft" (faint), in which she lists plate numbers and averaged estimated magnitudes, Leavitt notes that one of these new variables' periods is probably long; more plates and more evidence are needed to determine that variable's full length of pulsation. For another, whose dimming pattern indicates that it belongs to a class of eclipsing binary variables, Leavitt writes, "Evidently of the Algol Type, Faint on very few plates." Leavitt describes two variables as "re-discovered," surfacing the continuously shifting line between the overlapping realms of the known and unknown. Here Leavitt is, sorting through the pieces, constructing knowledge. At the bottom of the page she summarizes: "Total: 3 new, 1 confirmed, 5 known, 0 suspected." Discovery, truth, familiarity, wonder.

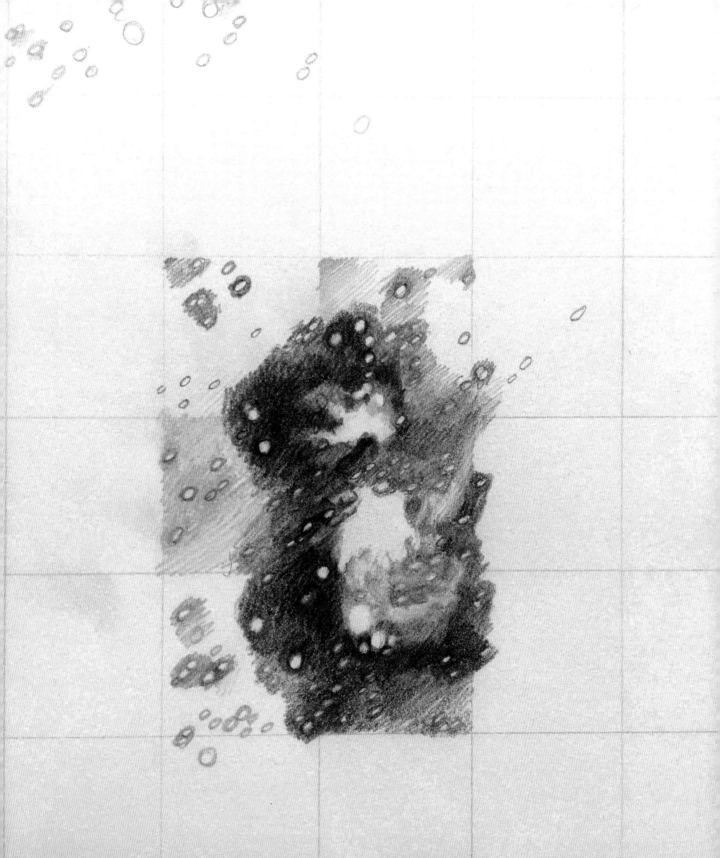

THIS PAGE AND PRECEDING PAGE:
Details of Anna Von Mertens's drawing (in process) of *Negative and Positive Plates B20667 and D16409, Nebula in Orion, Oct 26, 1897*.

Photos by Anna Von Mertens.

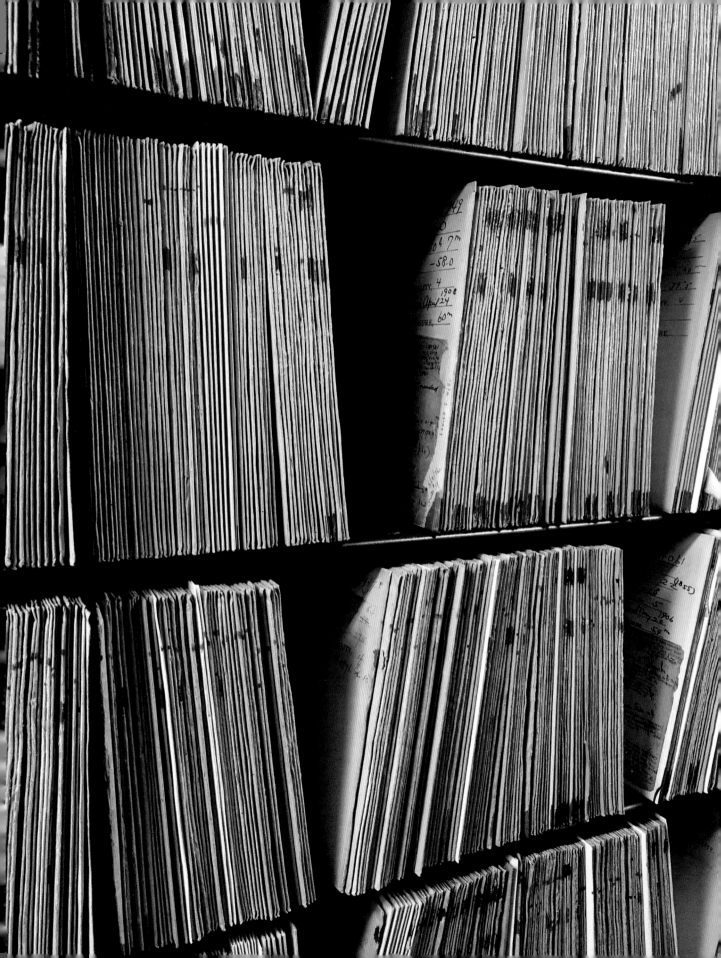

Notes

Source materials are acknowledged in the text when feasible. Additional resources are organized here for clarity, recognition, and appreciation.

The 2018 exhibition *Measure* and accompanying catalog that I developed at the Harvard Radcliffe Institute with the support of John Kramer, Jennifer L. Roberts, and Meg Rotzel is the foundation for this project. Excerpts from Jennifer's essay "Open Span" (*Measure*, Harvard Radcliffe Institute, 2018) are reproduced with permission from Jennifer L. Roberts and the President and Fellows of Harvard College.

Few primary sources from Leavitt remain, but where she left her mark there is plenty of evidence and plenty of information about who this woman was and what she did. I am grateful to the Harvard College Observatory, the John G. Wolbach Library at the Center for Astrophysics | Harvard & Smithsonian, and the Harvard University Archives for generous access to these materials.

The many volumes of Leavitt's astronomical logbooks, which I reference extensively in my introductory essay and touch on throughout the book, are held at the Wolbach Library. Scanned versions of these volumes—made possible by Wolbach's Project PHaEDRA initiative, which was supported by the Harvard University Library Imaging Services and ongoing efforts of the Smithsonian Transcription Center—can be found online, along with all of Leavitt's published papers, through the remarkable resource of the Smithsonian Astrophysical Observatory/NASA Astrophysics Data System: Go to https://ui.adsabs.harvard.edu/ and search in the author field for "Leavitt, Henrietta S."

Any letter written by Leavitt cited in this book comes from one folder in the Harvard University Archives (Records of the Harvard College Observatory

Plate stacks, Harvard College Observatory.
Photo by Anna Von Mertens.

Director Edward Charles Pickering, UAV 630.14, box 140, folder 36, Harvard University Archives). Also residing in the archives is Leavitt's "Record of Progress" (Astronomical notebook kept by Henrietta Swan Leavitt, 1912–1919, UAV 630.412, Harvard University Archives), identified as such in her handwriting on the opening page. This leather-bound journal—not dissimilar in appearance from Annie Jump Cannon's numerous personal diaries, which are also held in the archives—is a record of Leavitt's daily astronomical activities and research. As an example of her investigations from a page dated October 16 (1912), Leavitt notes discussions with Pickering and writes, "the work of this observatory for the last thirty years might be described as the determination of the effective wavelengths of the stars" because a star's spectrum influenced assessed magnitudes so dramatically. Leavitt and Pickering agreed that for accuracy any published standard magnitude (photometric or photographic) should include a color index for that star or its spectrum. Leavitt's entry makes obvious that not only was she able to consistently identify and measure the black flecks that signified stars, but she was also able to understand the complex factors affecting how starlight made those shapes. Was Leavitt directing her own research? Was she happy in her work? Was she good at it, or great? This volume answers all of these questions.

I found Leavitt's voice in the many issues of the *Harvard College Observatory Circular* and the *Annals of the Astronomical Observatory of Harvard College* (copies of which are held at the Wolbach Library and also accessible online through the Astrophysics Data System search recommended above) in articles that list her as author and some that are cued up by Pickering and handed off to Leavitt with the opening line "The following remarks have been prepared by Miss Leavitt." I cite numbers for the circulars and years of the annals in my writing, so I won't list all of her papers here as they are far too numerous. In addition to the greats—"1777 Variables in the Magellanic Clouds" (*Annals*, 1908), "Periods of 25 Variable Stars in the Small Magellanic Cloud" (*Harvard Circular* no. 173, 1912), and "Adopted Photographic Magnitudes of 96 Polar Stars" (*Harvard Circular* no. 170, 1912)—here are just two examples of Leavitt's wide-ranging areas of research: Leavitt created color indices for stars of the same spectral class, trying to determine if there was a causal relationship between the reddening of stars and increased faintness ("Spectral Class and Magnitude in Harvard Standard Regions," *Harvard Circular* no. 230, 1921); and when announcing Leavitt's recent discoveries of variables ("Twenty-two New Variables in Carina," *Harvard Circular* no. 115, 1906) Pickering noted that "the conditions under which they were discovered must be considered," otherwise the data is not representative or useful—a cursory search and an intensive survey would produce different quantitative results. This paper demonstrates how Leavitt tracked what percentage of the

variables she had independently found in a region were new discoveries versus variables previously identified, one of the many factors she considered when estimating the density of variables in each region.

The staff of the Harvard College Observatory became a family, as is touchingly evident in the obituaries they wrote as testaments to one another. Each is a jewel of respect and affection, such as Solon Bailey's encapsulation of Henrietta Leavitt's character and achievements (*Popular Astronomy* 30, no. 4 [1922]). Edward Pickering's obituary for Williamina Fleming (*Harvard Graduates' Magazine*, September 1911) recognizes her indomitable presence at the observatory, as both a skilled administrator and a brilliant astronomer. Excerpts of Pickering's obituary were reprinted in the February 1912 issue of *Monthly Notices of the Royal Astronomical Society* as part of their acknowledgment of the loss of their honorary member. In response to Pickering's listing of Fleming's published astronomical discoveries, the author (Herbert Hall Turner, signed H. H. T.) wrote, "The most casual inspection of these specified volumes fills us with admiration for the amount, the effectiveness, and the novelty of Mrs. Fleming's work."

I was tempted to reprint every word of Annie Jump Cannon's piercing tribute to Edward Pickering (*Popular Astronomy* 27, no. 3 [1919]), so well did it represent the man, the Harvard College Observatory, and the astronomical community of Pickering's day. Regarding Pickering's attitude toward the female observatory staff, Cannon writes, "He treated them as equals in the astronomical world." And of their shared dedication as observers, "The years were now crowded with exhilarating work." Cecilia Payne-Gaposchkin's obituary for Annie Jump Cannon is equally poignant (*Science* 93, no. 2419 [1941]). One legend of astronomy writing about another. Payne-Gaposchkin was not effusive, yet this is how her tribute to Cannon ends: "She was the happiest person I have ever known." This echoes Bailey's obituary, which has amid the details of Leavitt's accomplishments this surprising sentence about a woman who had committed her life to quiet focus: "She had the happy faculty of appreciating all that was worthy and lovable in others, and was possessed of a nature so full of sunshine that to her all of life became beautiful and full of meaning."

When possible, I tried to follow individuals through their own words, most notably *Cecilia Payne-Gaposchkin: An Autobiography and Other Recollections* (1996), which lends vibrancy to the lives of the Harvard Computers. Also insightful were Harlow Shapley's *Through Rugged Ways to the Stars* (1969), as well as Shapley's *Galaxies* (1943), Dorrit Hoffleit's *Misfortunes as Blessings in Disguise: The Story of My Life* (2002); Edwin Hubble's *The Realm of the Nebulae*

(1936); a collection of Annie Jump Cannon's diaries (Annie Jump Cannon Papers, HUGFP 125.2, box 1, Harvard University Archives); Williamina Fleming's Chest of 1900 diary (Journal of Williamina Paton Fleming, Chest of 1900, HUA 900.11, box 2, Harvard University Archives); and Edward Pickering's Chest of 1900 diary (Journal of Edward Charles Pickering, Chest of 1900, HUA 900.11, box 3, Harvard University Archives). Useful and revealing were exchanges documented in the Harvard University Archives, in particular letters between Antonia Maury and Pickering (Records of the Harvard College Observatory Director Edward Charles Pickering, UAV 630.14, box 169, folder 10; also UAV 630.14, box 143, folder 9) and letters between Pickering and Shapley (Papers of Harlow Shapley, HUG 4773.10, box 107). Fleming's 1893 speech prepared in advance of the Chicago World's Fair and titled "A Field for Woman's Work in Astronomy" was published in volume 12 of the journal *Astronomy & Astrophysics*.

The American Institute of Physics (AIP) oral history interviews at the Niels Bohr Library & Archives, College Park, Maryland (and generously available on AIP's website at https://www.aip.org/history-programs/niels-bohr-library/oral-histories), are an incredible resource for understanding science, science history, and scientists. Standouts include David DeVorkin's 1979 interview with Dorrit Hoffleit, David Zierler's 2020 interview with Wendy Freedman, Charles Weiner and Helen Wright's 1966 interview with Harlow Shapley, and Owen Gingerich's 1968 interview with Cecilia Payne-Gaposchkin. Many thanks to the AIP Niels Bohr Library and Archives for permission to reprint an interview excerpt from DeVorkin and Hoffleit's conversation on August 4, 1979, in this book.

Two comprehensive histories of the Harvard College Observatory were cornerstones of my research: Solon Bailey, *The History and Work of Harvard Observatory 1839 to 1927* (1931), and Bessie Zaban Jones and Lyle Gifford Boyd, *The Harvard College Observatory: The First Four Directorships, 1839–1919* (1971).

This book would not be the same without Dava Sobel's *The Glass Universe: How the Ladies of the Harvard Observatory Took the Measure of the Stars* (2016) and George Johnson's *Miss Leavitt's Stars: The Untold Story of the Woman Who Discovered How to Measure the Universe* (2005). In addition, Johnson's 2007 *New York Times* article, "A Trip Back in Time and Space," on the DASCH project and Sobel's "Remembering Henrietta Swan Leavitt" in the December 2021 issue of *Sky & Telescope* were helpful references.

Excellent thesis projects informed my writing, including Pamela Mack's 1997 Harvard University undergraduate thesis, "Women in Astronomy in the United States, 1875–1920." As part of her research Mack interviewed Margaret Harwood and Cecilia Payne-Gaposchkin, and Mack's reflections on those conversations during my May 5, 2022, interview with her offered unique insight. Additional scholarship from Mack illuminating how the Harvard Computers navigated the cultural and institutional limitations of their time include "Strategies and Compromises: Women in Astronomy at Harvard College Observatory, 1870–1920" (*Journal for the History of Astronomy* 21, no. 1 [1990]), and "Straying from their Orbits: Women in Astronomy in America," in *Women and Science: Righting the Record*, edited by G. Kass-Simon and Patricia Farnes (1990). Margaret Rossiter's *Women Scientists in America: Struggles and Strategies to 1940* (1982) is relevant to this work. Both Keith Lafortune's 2002 University of Notre Dame master's thesis, "Women at the Harvard College Observatory, 1877–1919: 'Women's Work,' the 'New' Sociality of Astronomy, and Scientific Labor," and Alex McGrath's 2019 Simmons College master's thesis, "'You Take Our Stars': Harvard Astronomers in Peru, 1889–1900," are fantastic. McGrath also wrote about Harvard College Observatory's history during his time as archives assistant at Wolbach Library, and his well-researched articles for the library's online *Galactic Gazette* include "Computers at Work: Astronomical Labor at the HCO at the Turn of the Century," "Drive and Joy: Annie Jump Cannon at HCO," "Annie Jump Cannon: Account of the Total Eclipse," "The First Computer: Williamina Fleming and the Horsehead Nebula," and "A Peculiar Sense of Proprietorship."

McGrath is not the only Harvard University staff member to be inspired by their contact with this material—both the physical archives and the stories of the women who studied those objects. Maria McEachern's *Galactic Gazette* profile on Fleming is titled "Every Star Speaks for Itself: Williamina Fleming and the Work of the Harvard College Observatory." Greatly appreciated are Lindsay Smith Zrull's efforts as former curator of astronomical photographs to identify 216 of the women who worked at the observatory in her article "Women in Glass: Women at the Harvard Observatory during the Era of Astronomical Glass Plate Photography, 1875–1975" (*Journal for the History of Astronomy* 52, no. 2 [2021]). Also appreciated are the efforts of Sara Schechner (curator of the Collection of Historical Scientific Instruments) and David Sliski (former Harvard College Observatory curatorial assistant) in building awareness around the original DASCH initiative in their paper "The Scientific and Historical Value of Annotations on Astronomical Photographic Plates" (*Journal for the History of Astronomy* 47, no. 1 [2016]).

The following records and profiles of individuals who worked at the observatory were especially informative: Oberlin College's alumni records for Henrietta Leavitt (1885–1888); Harlow Shapley's letter to Leavitt dated May 22, 1920 (Papers of Harlow Shapley, HUG 4773.10, box 106, folder L, Harvard University Archives) as well as letters between Shapley and Leavitt's mother after Leavitt's death (Harvard College Observatory Records—Shapley, UAV 630.22, box 10, folder 8, Harvard University Archives); Dorrit Hoffleit's "Henrietta Swan Leavitt," in *Notable American Women, 1607-1950: A Biographical Dictionary*, edited by Edward T. James, Janet Wilson James, and Paul S. Boyer (1971); the online Vassar Encyclopedia's distinguished alumni entry for Antonia Maury (class of 1887); Howard Plotkin's "Edward Charles Pickering" (*Journal for the History of Astronomy* 21, no. 1 [1990]); Sue Bowler's "Annie Jump Cannon, Stellar Astronomer" (*Astronomy & Geophysics* 57, no. 3 [2016]); Paul A. Haley's "Williamina Fleming and the Harvard College Observatory" (*Antiquarian Astronomer* 11 [2017]); and Alan Hirshfeld's "Williamina Fleming: Brief Life of a Spectrographic Pioneer, 1857-1911" (*Harvard Magazine*, January/February 2017).

Understanding the innovative photographic techniques used to establish standard magnitudes was a particular challenge. Like many, I thought magnitude work was as dry as dust until I got deep into it, and then realized this was some of Leavitt's most radical labor. I began with Leavitt's published works: "The North Polar Sequence" in the 1917 *Annals* and *Harvard Circular* nos. 150, 160, and 170 were particularly useful in addressing methodologies, challenges, and solutions. Mount Wilson Observatory astronomer Frederick Seares published numerous technically precise articles, including "The Photographic Magnitude Scale of the North Polar Sequence" (*Astrophysical Journal*, October 1913), "Photographic Photometry with the 60-inch Reflector of the Mount Wilson Solar Observatory" (*Astrophysical Journal*, May 1914), and "Photographic and Photo-Visual Magnitudes of Stars Near the North Pole" (*Astrophysical Journal*, April 1915). Also helpful was J. B. Hearnshaw's *The Measurement of Starlight: Two Centuries of Astronomical Photometry* (1996). But the clouds truly parted when I read Edward Skinner King's *A Manual of Celestial Photography: Principles and Practice for Those Interested in Photographing the Heavens* (1931). Many thanks to Allison Pappas and Jennifer Roberts for bringing this amazing book to my attention. Chapter 18 is titled "Action of Light on a Photographic Plate." How delightful is that? Also revealing is Leavitt's letter to Pickering dated February 1, 1910 (Records of the Harvard College Observatory Director Edward Charles Pickering, UAV 630.14, box 140, folder 36, Harvard University Archives), that is eight entire pages of suggestions for ways to achieve desired photographic results. Her letter is nearly a manual in itself.

The following sources proved particularly useful on specific topics: David DeVorkin, "Steps toward the Hertzsprung-Russell Diagram" (*Physics Today* 31, no. 3 [1978]), "Community and Spectral Classification in Astrophysics: The Acceptance of E. C. Pickering's System in 1910" (*Isis* 72, no. 1 [1981]), and "Extraordinary Claims Require Extraordinary Evidence: C. H. Payne, H. N. Russell and Standards of Evidence in Early Quantitative Stellar Spectroscopy" (*Journal of Astronomical History and Heritage* 13, no. 2 [2010])"; Lorraine Daston and Peter Galison, *Objectivity* (2007); R. Brent Tully, Hélène Courtois, Yehuda Hoffman, and Daniel Pomarède, "The Laniakea Supercluster of Galaxies" (*Nature* 513 [2014]); Shea Hendry, "The Work of Knowledge: Glass Plate Photography and the Harvard College Observatory" (December 9, 2021, https://arcg.is/1GzPrL); and John Lankford and Ricky L. Slaving's two excellent articles "Gender and Science: Women in American Astronomy, 1859–1940" (*Physics Today* 43, no. 3 [1990]) and "The Industrialization of American Astronomy, 1880–1940" (*Physics Today* 49, no. 1 [1996]).

Many of the resources cited above informed the writing of Rebecca Dinerstein Knight's and Jennifer L. Roberts's essays—as did many shared trips to the plate stacks, Harvard University Archives, and Wolbach Library. Additional sources for their essays include the Harvard College Observatory Visiting Committee's report "The Work of a Woman Astronomer" (*Popular Astronomy* 20 [1912]) and James Fenton's essay "A Lesson from Michelangelo" (*New York Review of Books*, March 23, 1995). Several issues of the *Harvard Circular* were central to Jennifer's essay, including "The November Meteors in 1898" (*Harvard Circular* no. 35 [1898]); "Witt's Planet" (*Harvard Circular* no. 36 [1898]); and "Variable Stars in the Nebula of Orion" (*Harvard Circular* no. 78 [1904]). Grace Agnes Thompson's article "Some Unusual Discoveries of Variable Stars at Harvard Observatories" (*Popular Astronomy* 13 [1905]) provided excellent historical context, as did James Falese and David Sliski's three-part series on the detection of asteroid 433 Eros for Wolbach Library's online *Galactic Gazette* (August 2022). Scientific papers providing background on precovery practices and asteroid detection include NASA, "Near-Earth Asteroid 433 Eros (Adapted from the NEAR Press Kit)"; Carlos E. López, "Astrometry with Virtual Observatories" (*Astrophysics and Space Science* 290 [2004]); Marco Micheli et al., "NEO follow-up, recovery and precovery campaigns at the ESA NEO Coordination Centre" (*Proceedings of the International Astronomical Union* 10 [2015]); Duncan Steel et al., "AANEAS: A Valedictory Report" (*Australian Journal of Astronomy* 7, no. 2 [1997]); Ovidiu Vaduvescu, et al., "Mining the CFHT Legacy Survey for Known Near Earth Asteroids" (*Astronomische Nachrichten* 332, no. 6 [2011]).

Supplementing my interviews with Wendy Freedman, and in addition to sources listed above (in particular, George Johnson's *Miss Leavitt's Stars* and Shapley's *Through Rugged Ways to the Stars* and *Galaxies*), the following informed my essay on the centrality of Cepheids in modern and contemporary cosmology: Leavitt's articles in *Harvard Circular* nos. 188 and 230 on experiments to study how the color of starlight affected photographic results; letters between Shapley and Hubble (Records of Harvard College Observatory Director Harlow Shapley, UAV 630.22, box 9, folder 3, Harvard University Archives); Robert P. Kirshner, "Hubble's Diagram and Cosmic Expansion" (*PNAS* 101, no. 1 [2003]); Ronald L. Voller, *The Muleskinner and the Stars: The Life and Times of Milton La Salle Humason, Astronomer* (2016); Ian S. Glass, *Revolutionaries of the Cosmos: The Astro-Physicists* (2006); and Harlow Shapley's and Heber Curtis's published versions of their papers for the Great Debate (*Bulletin of the National Research Council* 2, no. 11 [1921]). Marcia Bartusiak's *The Day We Found the Universe* (2009) was a valuable reference in particular for the evolving theories of cosmology in the 1920s.

I end this recognition of sources returning to Leavitt's words, selecting a page in her logbooks where she is reflecting on the materials at hand. In volume 12, as she considers the quality of a sequence of A plates used to make her landmark discovery, Leavitt writes on page 41, dated March 14, 1905:

> The series of plates A6860 to A6990 are remarkably good. Apparently a plate of two hours exposure, under the most favorable conditions show nearly all that can be seen on one of five hours exposure. The images, if seen, are more easily measurable than those of longer exposure. Crowded regions are better resolved. On plates of longer exposure, if the focus is sharp, the presence of stars doubtful on other plates can be confirmed, on account of the stronger images. There seems, however, to be little advantage in this respect, unless the guiding is very exact. The longer exposure, at least for crowded regions, is a distinct disadvantage unless the images can be kept sharp; otherwise they run together into a confused mass. On the other hand, a plate of four or five hours exposure, of the very finest quality, is invaluable for reference.

Contact print from a folder labeled "North Pole" in a box of sequence charts related to Henrietta Leavitt's work standardizing photographic magnitudes for her North Polar Sequence.

Photo by Jennifer L. Roberts.

—16S

b 20 ✗Y

e W

d 22 ✗Z

e 19 ᵥ

—17T #θ A3P

Contributors

João Alves is Professor of Astrophysics at the University of Vienna. His research focuses on the origins of stars and planets; he has published more than two hundred peer-reviewed papers on the topic. Alves was a European Southern Observatory fellow working with the Very Large Telescope in the Atacama desert and director of the Max-Planck/CSIC Calar Alto Observatory in southern Spain. In 2018, as a Harvard Radcliffe Institute fellow, he led the team that discovered the Radcliffe Wave, a star-forming gas structure 10,000 light-years long in the close vicinity of the Sun. Alves is Letters Editor-in-Chief of *Astronomy & Astrophysics*. He also has an asteroid named after him: (215044) Joaoalves.

Rebecca Dinerstein Knight is the author of the novels *Hex* (Viking, 2020) and *The Sunlit Night* (Bloomsbury, 2015), the bilingual English-Norwegian poetry collection *Lofoten* (Aschehoug, 2012), and the forthcoming nonfiction collection *Notes to New Mothers*. Her screenplay adaptation of *The Sunlit Night* premiered at the Sundance Film Festival and is now a major motion picture. Knight has reviewed restaurants for the *Village Voice* and novels for the *New York Times Book Review*, and her essays have appeared online in the *New Yorker*, *Paris Review*, and *New York Times*, among others. A graduate of Yale University and New York University's MFA Program in Creative Writing, she is currently at work on a new Edwardian-era screenplay.

Jennifer L. Roberts is the Drew Gilpin Faust Professor of the Humanities at Harvard University, where she teaches art history with an emphasis on the interface between the arts and the natural sciences. She is the author of numerous books and essays on American art and science from the eighteenth century to the present, and she has curated exhibitions in modern and contemporary art at the Harvard Art Museums and the Harvard Radcliffe Institute. Her recent book projects include *Contact: Art and the Pull of Print* (Princeton University Press, 2024),

and, with artist Dario Robleto, *The Heartbeat at the Edge of the Solar System: Science, Emotion, and the Golden Record* (forthcoming).

Anna Von Mertens received an Alfred P. Sloan Foundation Public Understanding of Science and Technology book grant in support of this publication. Her 2018–2019 exhibition *Measure*, presented at the Harvard Radcliffe Institute, traveled to University Galleries of Illinois State University and Allen Memorial Art Museum at Oberlin College in 2023. She is the recipient of a Smithsonian Artist Research Fellowship at the Smithsonian Astrophysical Observatory in Cambridge, Massachusetts, where she studied dark matter as a structuring force in our universe, and a United States Artists Fellowship in Visual Arts. Her work is in the permanent collections of the Allen Memorial Art Museum at Oberlin College; Berkeley Art Museum; Museum of Fine Arts, Boston; RISD Museum; Smithsonian American Art Museum's Renwick Gallery; and Tang Teaching Museum at Skidmore College. Von Mertens is represented by Elizabeth Leach Gallery, Portland, Oregon.

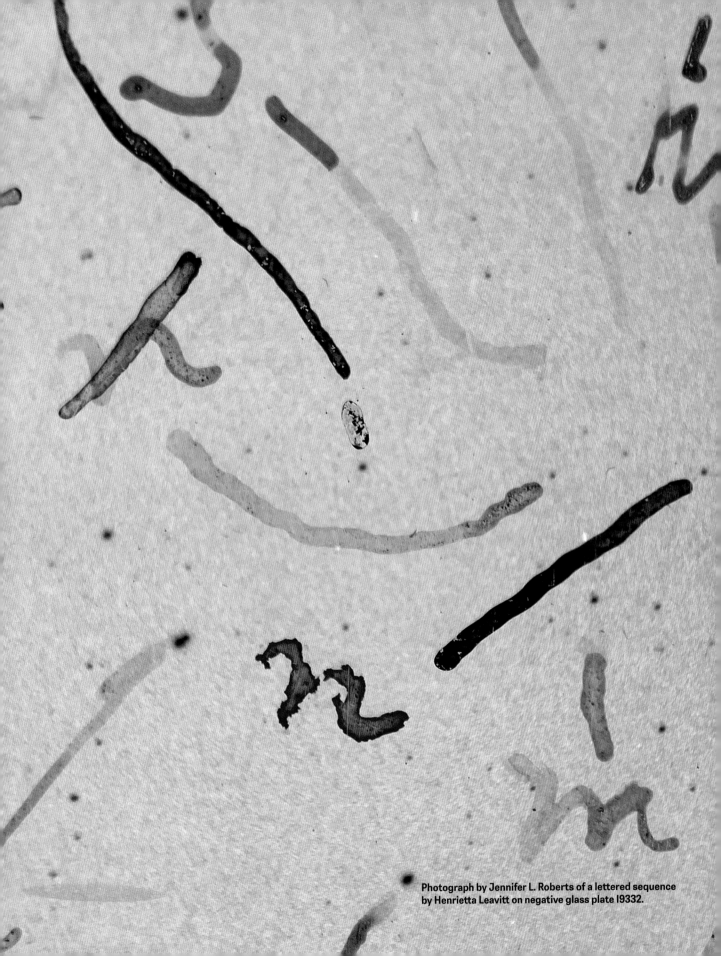

Photograph by Jennifer L. Roberts of a lettered sequence
by Henrietta Leavitt on negative glass plate I9332.

Acknowledgments

I am grateful for the generous, meaningful support from the Harvard Radcliffe Institute, MIT Press, and Alfred P. Sloan Foundation's Public Understanding of Science and Technology program that helped bring this project into being.

Thank you, Meg Rotzel, for supporting my exhibition project *Measure* at the Harvard Radcliffe Institute in 2018.

Thank you, Kendra Paitz, for bringing Henrietta Leavitt's story and my artwork to University Galleries of Illinois State University. Thank you, Lisa Lofgren, for supporting my 2023 exhibition there, and thank you, Jade (Minh Hà) Nguyễn, for your excellent installation photography.

Thank you, Andria Derstine, for the opportunity to show my work at the Allen Memorial Art Museum at Oberlin College. Thank you for bringing Henrietta Leavitt back to Oberlin's campus.

Thank you to everyone at Elizabeth Leach Gallery. Your steadfast support of my work, and the warmth and intelligence with which you support that work, and working artists, is remarkable.

So much gratitude for everyone at the plate stacks, past and present, especially Lisa Bravata, Anne E. Callahan, Thom Burns, Elizabeth Coquillette, Monica Haberny, Sarah Lavallee, Samantha Rose Notick, and Lindsay Smith Zrull. Thank you for helping maintain the welcoming generosity of the Brick Building. How treasured is every one of my visits there.

Ed Copenhagen at the Harvard University Archives once wrote at the end of a long email, "I am sorry for such a detailed email." I told him that made me laugh. I am grateful for the many details Ed provided that have enriched this book.

Banner for Anna Von Mertens's 2023 exhibition *Henrietta Leavitt: A Life Spent Looking* at the Allen Memorial Art Museum at Oberlin College.

Allen Memorial Art Museum. Photo by John Seyfried.

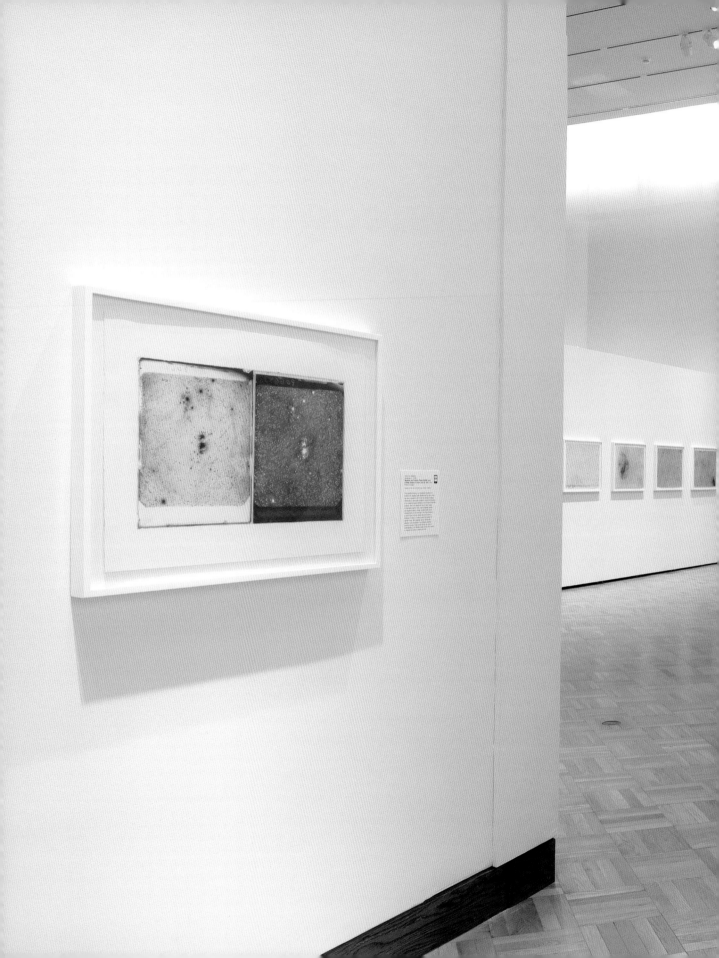

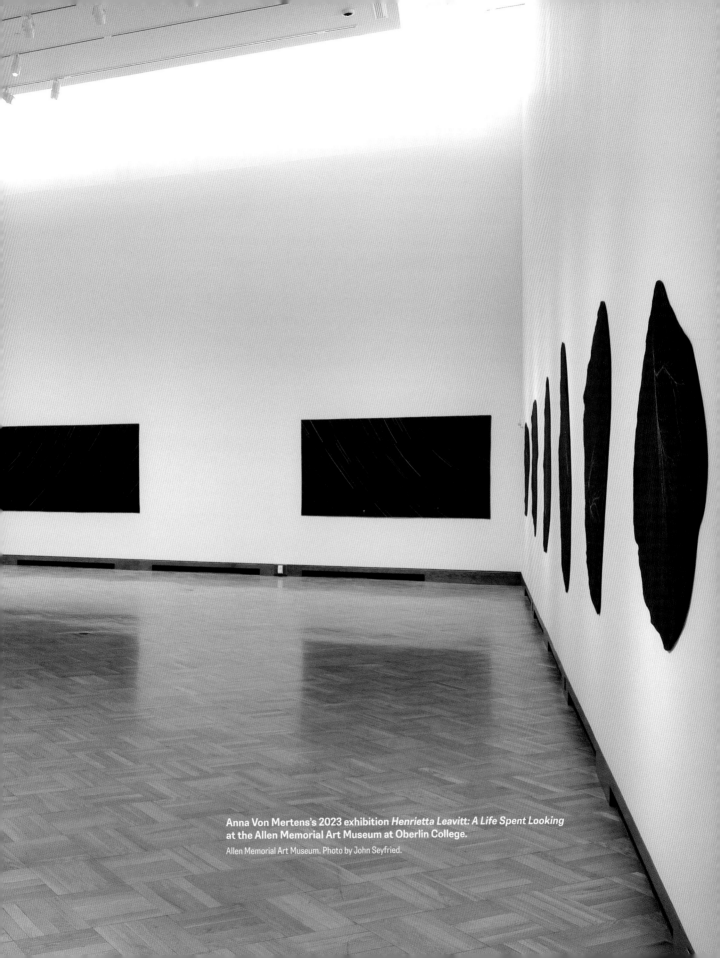

Anna Von Mertens's 2023 exhibition *Henrietta Leavitt: A Life Spent Looking* at the Allen Memorial Art Museum at Oberlin College.

Allen Memorial Art Museum. Photo by John Seyfried.

I think only Maria McEachern could rival Ed with her informative emails. I have learned to ask Maria only important questions; her written responses are heart-felt, and so thorough—fully annotated, in fact—I don't want to waste her time. Thank you, Maria, for your correspondence. And thank you for sharing your Mount Auburn Cemetery pilgrimages with me, and all that represents.

Thank you, Gala Bent, for allowing me to quote from and speak to your poem *Song for Vera* (originally published in concert with the 2016 exhibition *9e2*, King Street Station, Seattle, Washington), and for singing the names of women that deserve to be sung.

Thank you to the people who shared their scholarship, expertise, perspective, and wisdom in conversations that helped shape this book: Daina Bouquin, Thom Burns, Nico Carver, Sarah Lavallee, Pamela Mack, Emily Margolis, Purvang Patel, Benjamin Sabath, Sara Schechner, David Sliski, Peggy Wargelin, Peter K.G. Williams, and Lindsay Smith Zrull.

Thank you, Thomas Fine, P. Ann Haley, Paul A. Haley, and Samantha Rose Notick, for your help identifying the Harvard Computers in historical photographs, an important way these women remain seen.

Thank you, Alyssa Goodman, for knowing how important this story is, and making sure it gets told.

Thank you to my acquisitions editor, Katie Helke, for believing in this book from the get-go.

Thank you, Johanna Arnone, for being an excellent reader. (Is there anything better than an excellent reader?) Thank you for making this book better.

Thank you, Dava Sobel and George Johnson, for writing books that I was in dialogue with throughout the writing of my own. Thank you for our conversations during the making of this book. Thank you for helping tell these facts, tell these stories.

Wendy Freedman, thank you for being an example of what I hope a scientist can be. Thank you for so generously sharing your process and insights. Thank you for seeing Leavitt all these years.

Thank you, Rebecca Dinerstein Knight, for early conversations that led to this book's proposal. Thank you for the enthusiasm with which you love both people and ideas.

João Alves, I hold our exchanges—of questions, emails, observations—as the precious things that they are. Thank you.

John Kramer, I am grateful for your presence in this book. It is there on every page.

Thank you, Jennifer L. Roberts. It is impossible to thank you enough. Your invitation to develop a project at Radcliffe helped me affirm the ways I wish to investigate as an artist. You engage fully and deeply with subjects and objects, and it is an honor and a delight to attempt the same alongside you. I feel incredibly lucky that our fascinations so thoroughly overlap, and that you are willing to stare at and think about and figure out what it is we are trying to see. Thank you for your brilliance and kindness, in glorious, equal measure.

Thank you to my developmental editor, Matthew Christensen, who tended to this story with the utmost respect. Thank you for seeing what needed to be seen and knowing how to see it.

Thank you, John Knight, for your wise, informed perspective. And for your knack of knowing when something's gotta go.

Thank you, Laura Keeler, for your skillful copyediting. Verbs are your superpower.

Thank you, Justin Kehoe, for shepherding this project to the finish line.

Thank you, Shalini Satkunanandan and Sanjay Narayan, for being such intelligent, willing, and generous friends.

Thank you, Henry Walters, for caring about light's long expeditions.

Thank you, Mom, for showing me how to look and write.

Thank you to my family for recognizing how much this project means to me, and supporting it wholeheartedly. To Chris, the partner of a lifetime—I love you. Hayden and Rhys, I love you, too. You three are my home base.

7.9

8.1

8.5

9.0

9.6

9.3

9.9

10.1

This drawing is rather out of scale, but should suffice for identification

am 257

Fourth Sequence

7.5

7.9

8.0

8.4

9.0

9.2

9.7

9.9

10.0

ns

**Detail of page 57 of Henrietta Leavitt's logbook *Measures of Comparison Stars.
Small Magellanic Cloud. H. S. L.* (volume 14, page dated April 19, 1905).**
Photo by Anna Von Mertens.

Images very sharp + difficult to measure